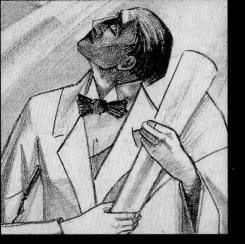

Wendingen

A Journal for the Arts, 1918-1932

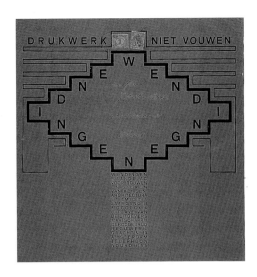

Princeton Architectural Press

New York

Introduction **Ellen Lupton** Essay **Alston W. Purvis**

Martijn F. Le Coultre

Wendingen

A Journal for the Arts, 1918–1932 ■

Princeton Architectural Press
37 East Seventh Street
New York, NY 10003

For a catalog of books published
by Princeton Architectural Press,
call toll free 800.722.6657 or visit
www.papress.com.

Published simultaneously in The
Netherlands by V+K Publishing,
Blaricum.

For V+K Publishing:
Design Jan Johan ter Poorten,
Corine Teuben and Cees de Jong
Translation Alston Purvis,
Photography Arthur Martin,
Nederlands Architectuurinstituut
archive/collection H. Th. Wijdeveld

For Princeton Architectural Press:
Editor Mark Lamster
Copy Editors Nicola Bednarek,
Judith Koppenberg
Special Thanks Nettie Aljian,
Ann Alter, Amanda Atkins,
Jan Cigliano, Jane Garvie,
Clare Jacobson, Nancy Later,
Anne Nitschke, Lottchen Shivers,
Jennifer Thompson, and Deb Wood
of Princeton Architectural Press–
Kevin C. Lippert, publisher

Library of Congress Cataloging-in-
Publications Data for this title is
available from the publisher

ISBN: 1-56898-276-3
Printed in Belgium

Contents

Introduction Ellen Lupton

Looking back at the twentieth century, one sees in *Wendingen* a compelling model of design practice, singular in the intensity of its focus and the originality of its aesthetic form. Nothing in the evolution of avant-garde art and design matches the sustained and impassioned visual inquiry of this magazine. Yet while *Wendingen* is a unique ocurrence in the history of design, at its core is an approach to form, content, and publishing that helped generate and nourish the modernist discourse. From El Lissitzky to Le Corbusier, the most influential thinkers of the early twentieth century determined that progressive art requires equally progressive forms of dissemination.

This idea remains vital today, as the media of publishing evolve and unfold within the technological greenhouse of our new century. Contemporary artists, designers, and architects are trained to recognize the power of print and digital media in articulating the edges of theory and promoting the evidence of practice. To succeed in today's world, artists continually engage the systems of publishing. In the best instances, the printed page or luminous screen serves not as a secondary document but as the site of original production. Such works – now as in the early twentieth century – allow the ideas of a single practitioner or a small coalition of artists and writers to reach an international public.

H. Th. Wijdeveld was at the center of *Wendingen,* providing its editorial leadership and its visual direction. This book is a tribute to Wijdeveld's astonishing achievements, revealing his immersion in the international avant-garde and, at the same time, his independence from the "ism's" that swept across the global art world during the life of his journal. *Wendingen* honored Dutch architects such as Michel De Klerk as well as such international figures as El Lissitzky, Eileen Gray, and Frank Lloyd Wright.

Wijdeveld utilized the mechanics of typography in a manner at once lyrical and deliberate. Employing the centuries-old technology of printing from individual relief characters cast in lead, Wijdeveld constructed dense borders and original letterforms out of small pieces of printing material. Where needed, he instructed the printer to cut new shapes to fill specific positions within his precise decorative schemes. Wijdeveld's covers for *Wendingen* as well as his letterheads, posters, and other ephemera constitute a unique body of typographic experiment. Unlike the soaring spaces and dynamic forms explored by El Lissitzky and Piet Zwart, Wijdeveld's landscape of print is emphatically flat and static. Within this framework, he explored the endless possibilities of combination with intense determination.

In the 1920s and 30s, the German critic Walter Benjamin attacked the conventional view of authorship as a purely literary enterprise. Foreseeing a time when "the precision of typographic forms has entered directly into the conception of ...books," Benjamin predicted that the writer would soon compose his work with a typewriter instead of a pen. "One might suppose," he added, "that new systems with more variable typefaces might then be needed." [1]

Such "new systems" are, of course, ubiquitous today in the form of software for word-processing, desk-top publishing, and Web authoring. These tools have altered the tasks of both designers and writers, enlarging their powers and expanding their role in the editorial endeavor.

H. Th. Wijdeveld is among the early practitioners of this expanded mode of authorship. *Wendingen,* a vital participant in the art of its own time, is flush today with renewed vitality

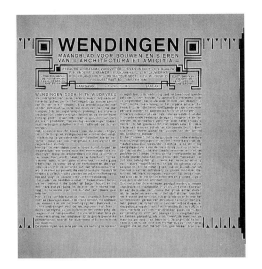

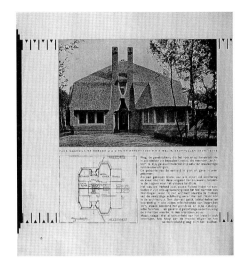

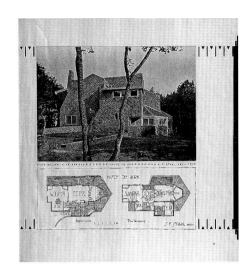

and relevance. Due to the diligence of its initial supporters as well as later collectors, issues of *Wendingen* are available for study by the public in selected museums and libraries around the world.

 The publication of this volume allows for more casual contemplation, enabling a broader audience than ever before to witness *Wendingen*'s remarkable evolution. Its example burns ever bright.

1 See Walter Benjamin, "The Author as Producer" and "One-Way Street (Selection)" in *Reflections: Essays, Aphorisms, Autobiographical Writings*, Peter Demetz, editor (New York: Schocken Books, 1978).

1-1

1-8

1-8

One Man's Vision Alston W. Purvis

In January 1918, three months after the appearance of de Stijl, the Amsterdam art society Architectura et Amicitia began the publication of the magazine *Wendingen*. The Dutch architect Hendricus Theodorus Wijdeveld was the principal force behind the project and served as its designer, and, until his resignation in 1925, its chief editor. Ostensibly, it was a monthly publication devoted to architecture, construction, and ornamentation, but its actual impact was far broader. During the next fourteen years it would become a forum for contemporary issues in many sectors of the arts.

Born in 1885 at The Hague, Wijdeveld died in 1987, the oldest living Dutch artist. Largely self-taught, he received his initial training as a draftsman at the age of fourteen in the studio of Petrus J. H. Cuypers, architect of the Rijksmuseum and Central Station in Amsterdam. While there, Wijdeveld was intrigued by anecdotes about the architects J. L. M. Lauweriks and Karel P. C. de Bazel who had worked for Cuypers until May of 1895, when they left to open their own studio. They were part of a group known as the "Decorators," book designers who used ornament as their central theme. Both had important roles in the Nieuwe Kunst movement, the Dutch version of Art Nouveau, which flourished roughly from 1893 through 1904. In addition to having disagreements with Cuypers over design philosophy, Lauweriks and de Bazel were involved with the Theosophy movement, which was antithetical to the Catholicism of Cuypers.

In 1905, Wijdeveld went to England where he remained for three years. There he met Eric Gill and became acquainted with the work of William Morris. Later, after a brief period in Lille, France, he joined a group of young architects who soon became known as the Amsterdam School. As with de Stijl, the Amsterdam School was never a cohesive group, beyond the fact that the main figures had all worked in Cuyper's studio. There were no regular gatherings and no established or written philosophy. Instead, they were united through their common interest in "decorative" architecture.

By the turn of the century, architects had already made important contributions toward the typographic arts. There is a clear correlation between architecture and typography. As the architect builds with stone, wood, and steel, the graphic designer uses typographic material and other visual elements. The architect determines the appropriate place for windows, doors, and other parts of the building, as the typographer assigns the positions of letters, words, paragraphs, and lines. In The Netherlands, there was not only Cuypers, de Bazel, and Lauweriks but also the Amsterdam architect H. P. Berlage, and later Piet Zwart and Theo van Doesburg who were also involved with architecture. One of the first significant book designs in nineteenth-century France, *Les quatre fils Aymon* (1886), was designed by Eugène Grasset, an architect.

Lauweriks went to Germany in 1904 and from 1908 to 1909 published the short-lived magazine *Ring* in Düsseldorf and Hagen. It was in this publication that the sources of *Wendingen* originated. In 1916, Lauweriks returned to Amsterdam where he and Wijdeveld often got together in the circle of Architectura et Amicitia. This venerable society, founded in 1855, played an important cultural role. Its membership was not only comprised of architects but also engineers, artists, artisans, technicians, and public servants. It was instrumental in organizing lectures and exhibitions, establishing pricing standards, and publishing circulars and magazines. Besides *Wendingen*, the group's other major contribution was the magazine *Architectura*, which first appeared in 1893. A prelude to *Wendingen*, the "Driebond" issue of *Architectura*, published on October 6, 1917, was intended to forge an alliance between industry, business, and art. Wijdeveld designed the cover, which showed the symbolist influence of Nieuwe Kunst and a fresh integration of text and decorative elements. *Wendingen* was often debated at Architectura et Amicitia during meetings in 1916 and 1917, and

1-(11/) 12 .D
not numbered
complimentary copy

1-2.d.1

actual plans for the publication were put forward at a gathering on October 24, 1917. A principal motivation was a need in The Netherlands for a magazine where modern Dutch architecture and other issues in the arts could be reproduced and discussed. Although Wijdeveld was clearly the most enthusiastic, Lauweriks, one of the editors of *Architectura* at that time, actively participated in the discussions. It was soon established that contributions should be accepted from other organizations and that the magazine should embrace all of the arts. Though no name was put forward, Wijdeveld came to the meeting prepared with a mockup of the magazine. Lauweriks initially proposed that the design be left to the editors, and also suggested that it address Dutch intelligentsia in general, not only the members of Architectura et Amicitia. He stressed that more attention be given to the visual side than to the text, that only the best quality printing be used, and that the decorative arts be included. Except for the issue of leaving the design to the editors, Wijdeveld basically agreed with Lauweriks' ideas.

Wijdeveld was unsuccessful in getting Lauweriks directly involved with the actual publication of *Wendingen*, as Lauweriks felt he had already fulfilled most of his ambitions. Nevertheless, his imprint is there, and he and Wijdeveld had many discussions about appropriate design approaches. *Ring*, which contained many of the antecedents of *Wendingen*, was often cited as an example.

The name *Wendingen* was conceived by Wijdeveld, and he later reflected on its arcane origins. Years earlier, while hiking in Northern Italy, he encountered a road worker who casually turned a stone slab on its head while referring to it as "the whole world." Later, while reading Nietzsche's *Umwälzung aller Werte (Upheaval of All Values)*, Wijdeveld compared the Italian road worker with Nietzsche whom he called a "repairer of the roads of life." He then translated "Umwälzung" as "Omwentelen" (rotating) which eventually evolved into *Wendingen* (turnings or upheavals). To Wijdeveld, *Umwälzung aller Werte* represented the iconoclastic mood in Europe after the human waste of the First World War and the social chaos and intellectual and artistic upheaval in its aftermath. Ideally, *Wendingen* would unite the intellectual differences of artists and architects who would find a common purpose in the magazine.

In December 1917, *Architectura* ceased publication, only to reappear in 1921, and the first number of *Wendingen* appeared in January 1918 with a limited edition of 650 copies. From 1918 until the end of 1932, 116 numbers would be issued.

Finding a publisher was difficult. Most of those asked were uncomfortable with the large double square format, the complicated binding method, and the unorthodox typography. Also, some were indignant that architects had the audacity to think they knew anything about printing and publishing. It was to be an expensive undertaking, especially with paper being printed on only one side and hand binding. Finally, Henri Wiessing, a political and literary writer, agreed to be the publisher, and his printer, the Electrische Drukkerij "Volharding" in Amsterdam, imported a new press from Germany to accommodate the large format. Five printers would be used throughout the publication including Joh. Enschedé in Haarlem. At the beginning of 1927, the printer became the Amsterdam firm Ipenbuur & van Seldam who would continue through the final issue. As with any publishing venture, profitability was an issue, and in spite of Wijdeveld's objections, Wiessing succeeded in having advertisements included.

The initial editorial board consisted of the Chairman J. Gratama, H. A. van Anrooy, J. Blaauw, P. H. Endt, P. J. Kramer, E. J. Kuipers, J. L. M. Lauweriks, R. N. Roland Holst, M. J. Granpré Molière, and Wijdeveld. Except for Roland Holst, all of the board members were architects. Wijdeveld was the only one who was paid; he received an honorarium of 250 guilders per month, out of which came expenses. From 1918 until 1925, he served as chief editor, and the magazine's official mailing address was Wijdeveld's own house.

In the first issue, Wijdeveld made it clear that *Wendingen* would approach subjects other than architecture. The first numbers addressed a combination of art topics, but soon afterwards each number followed a particular theme. Of the latter, thirty-one were devoted to Dutch architecture, and the issues between 1918 and 1925 gave much attention to the Amsterdam School and those with similar sentiments. After 1927, there would only be sixteen numbers devoted to architecture. This was due to competition from *Bouwkundig Weekblad Architectura*, a new architectural magazine formed by a merger between *Architectura* and *Bouwkundig Weekblad*, journal of the Dutch Association of Architects.

Among other topics, ten numbers are devoted to sculpture, eight to theater and dance, three to poster design, three to stained glass, three to glass and ceramics, six to the graphic arts, five to interiors, and one to statistical design. There were also issues on the work of Jan Toorop and Johan Thorn Prikker, the paintings of Lyonel Feininger, the realist painting of Pijke Koch and Carel Willink, Russian icons and Italian Renaissance painting. Austrian art and German architecture were included, but German Expressionism and French Cubism were curiously omitted. For the most part, *Wendingen* would remain essentially a Dutch publication.

Whenever the applied arts were represented, they were disciplines related to architecture such as furniture and interior design and stained glass. This supported one of the original objectives, artistic unity. However, there were also issues on the glass and ceramics of Chris Lebeau and the industrial design of W. H. Gispen who later became celebrated for his metal furniture and lighting designs.

Most of the issues devoted to sculpture depict this medium as it pertains to architecture, and only in later issues on the work of Ossip Zadkine and Antoine Bourdelle is sculpture approached as an independent art form. Sculptors more frequently shown are those who produced large pieces for public buildings such as Hildebrand L. (Hildo) Krop.

The format of *Wendingen* was 33 x 33 centimeters compared to the 30 x 23 size of *Ring*. The double square format for the page spreads was based on the Japanese tatami mat proportion, and rice paper was sometimes used. The influence of *Ring* is immediately obvious. Although smaller, the same sans serif Grotesque typeface is used. Another similarity is the Japanese method of binding where pages are printed on one side, folded and left uncut at the edges, and then sewn in the block book style with raffia. Also, in *Ring* there was a place reserved for advertisements, although there were fewer in number than in *Wendingen* and they were set according to Lauweriks' rigorous design

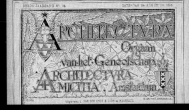

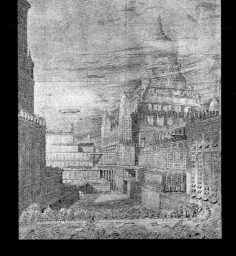

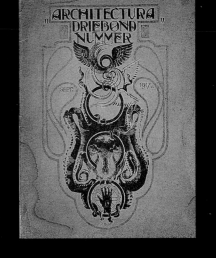

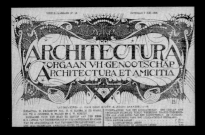

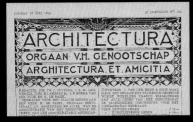

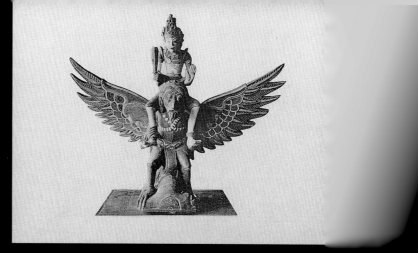

ZEITSCHRIFT FUER KUENSTLERISCHE KULTUR
ERSCHEINT ALLE 2 MONATE
IM RING-VERLAG VON ERNST PIEPER DUESSELDORF
ZWEITES HEFT DEZEMBER 1908

▼ 3. HEFT ▼
FEBRUAR
▼ 1909 ▼

THE WILLOW MOULDERS AND THE PEACH WILL DIE,
THE SUN WILL SET AND ONCE THE POOL RUN DRY,
YET BEAUTY LAST, AND YET A HEART BE FOND
OF SONGS ETERNAL
THE VOICE FROM BEYOND

J ▪ W ▪ SCHOTMAN

DE EENZAME OPGANG

constraints. Although advertisements in *Wendingen* had to fit within an established grid, advertisers were free to use their own designs whether they conformed to the *Wendingen* style or not. They were not only confined to the back of the magazine but faced the title page as well.

Another similarity to *Ring* is the use of thick vertical rules on the outside margins. During the first year, Wijdeveld also used triangular dingbats as decorative elements, even down to the same size as Lauweriks. In spite of these similarities, it was clear that *Wendingen* was an entirely different magazine. The typography of *Ring* never changed after the first issue and followed an inflexible grid. The layout of *Wendingen* was far more expressive and less confined to one rigid system, and ornaments were used with greater freedom.

The use of a Grotesque sans serif text type was in line with the current tendency toward clarity. It was also more harmonious with ornaments and constructed letters. The first commercial sans serif appeared as early as 1816 when William Caslon IV published his Two-line English Egyptian. However, with a few exceptions, a sans serif was considered inappropriate as a text type due to the absence of serifs to visually connect the letters. To use what was considered by many to be a crude and ungainly typeface in an intellectual endeavor such as *Wendingen* was a radical step.

Because of the liberal use of ornaments, Wijdeveld's style has been called a progeny of Nieuwe Kunst. Both displayed an exuberance, exalted artistry, and attempted an all-encompassing control of form. They shared an enchantment with the art of the Dutch East Indies and a fascination with its culture, especially design forms such as batik. However, instead of undulating lines and flourishes, Wijdeveld used solid shapes constructed from right angles, consistent with one of the Nieuwe Kunst approaches.

Early in the fall of 1917, Wijdeveld went to Leiden in an attempt to involve van Doesburg with *Wendingen*, then in preparation. Van Doesburg declined in a letter the next day, and it was no coincidence that the first issue of *De Stijl* appeared in October 1917, pre-empting *Wendingen* by three months. Van Doesburg liked to be first, and given his inclination toward self-promotion, it is quite possible that he moved up the publication date of *De Stijl* to have it appear before what he deemed a possible competitor, *Wendingen*.

Like Wijdeveld, van Doesburg was also influenced by Lauweriks. He soon, though, followed his own path toward spirituality and purity while maintaining abstraction as a central structural theme. Wijdeveld advocated expressionism, individualism, and mysticism and remained faithful to the decorative approach, while van Doesburg went in a more progressive direction. With the January 1921 issue, the design of *de Stijl* changed radically as van Doesburg renounced all decoration for the Constructivist route. *de Stijl*, though, continued to show the influence of Lauweriks' typography from his 1909–1914 period. Words are emphasized through letter spacing and a sans serif typeface is often used. Even the design of van Doesburg's rectangular typeface has its origins there.

The typography of *Wendingen* passed through several phases. Some changes are obvious and others barely noticeable. Although there is a profuse use of decoration, titles in the first edition are still set in conventional type. With the third issue (1-3) a separate title page is added for information such as the table of contents. There are two typographic variations in the last issue of 1918 (1-11/12) devoted to the sixtieth birthday of the artist Jan Toorop. The second title page is expanded to become an asymmetrical double spread with a liberal use of white space. On an extra dedication page, an additional characteristic of Lauweriks' typography after 1909 is employed, the building of letters using printing composing material. Toorop's name is constructed from rectangular shapes, the first indication of what would become known as Wijdeveld Typography, the *Wendingen* style and the Linear School.

Beginning in the second year (2-1), entire words are built from simple rectangular display case pieces as a mason would use bricks, giving his designs an austere character. The results have the

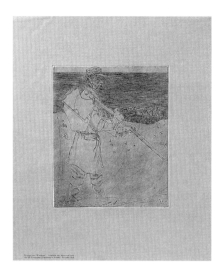 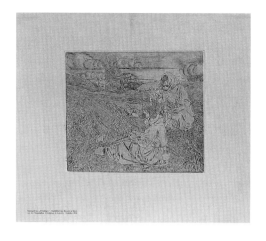 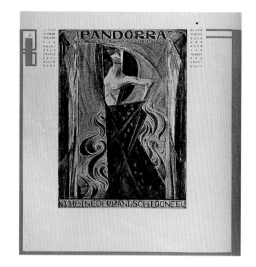

solidity of buildings and strongly suggest the brick architecture of the Amsterdam School. Since they are derived from the same material, this also creates a unity between text and decoration. At times, though, it is a forced harmony, and legibility suffers. The decorative elements on the inside spreads follow similar stylistic changes and replace the triangular dingbats borrowed from *Ring* in the 1918 edition. The number of each issue, also constructed out of rectangular shapes, is now placed in the center of the title page, and on the inside spreads folios are enclosed within typographic brickwork.

1- (11/) 12 D 4

1- (11/) 12 D 3

2-5

In the more expensive hard cover issues, advertisements are excluded. Instead of having them face the title page, a large gray mass is constructed from rectangular blocks, augmenting the architectural structure. This begins with (3-5), an homage to the Hungarian periodical *Magyar-Iparmüvèset*, and in this issue there is also a temporary change when the opening *Wendingen* page and title page are combined in a single unit. Supporting the theme of the issue, the text is hand-written in Hungarian with the other language of the issue in the standard Grotesque typeface. An additional color green is used to print the ornaments, advertisements, and constructed letters. After this brief diversion, the typography returns to what is now the familiar Wijdeveld style.

In the first 1921 issue (4-1), letter constructions are simplified, and an elegant dedication page is designed for Willem A. van Konijnenburg, the theme of this number. Another subtle change takes place with the fifth series. The word *Wendingen* on the opening page is permanently moved to the title page. The names of the issues' subjects replace it in the same *Wendingen* style, giving Wijdeveld an additional opportunity to experiment with fabricated letters. Beginning with the third 1924 number, (6-3) the printer Enschedé temporarily introduces a standard version of the sans serif type face.

Other variations occur in the first of the Frank Lloyd Wright issues, the seven part series extending from the third through ninth numbers of the seventh edition (7-3/4/5/6/7/89). Wijdeveld was determined to have this series surpass all others, and used it as a showcase for his typographic skills; at this time *Wendingen* reached its height both in design and content. The opening spread is especially elegant, a classic of typographic balance with an unusual use of an initial letter. Wright himself designed the title page for the first of the series (7-3). He was pleased with the publications and found them "very well done indeed." He kept them next to his desk, and they were bound according to his own design.

Editorial disagreements led to a lapse in publication at the end of 1926, and *Wendingen* did not appear again until Spring 1927. Although he remained in charge of the Wright series, Wijdeveld

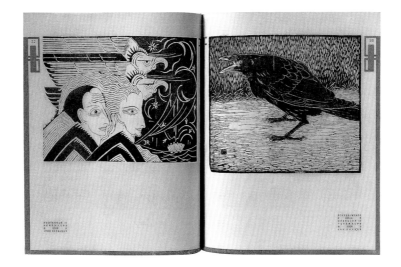

resigned at the end of 1924 over policy issues, especially what many considered to be excessive 2-6 expenses. One member even wanted the magazine cut by fifty percent. H. C. Verkruysen assumed 2-7/8 his editorial role, and Wijdeveld's direct involvement with the magazine ceased. Without his guidance and enthusiasm, there were soon signs of a lack of direction, and many of the earlier themes are repeated. Although Wijdeveld's name was no longer listed among the editors, he was still given credit for the typography. This, though, was a nominal role, and the same typography is used for all subsequent issues. Abruptly, issue themes are no longer constructed from rectangles, and the word *Wendingen* is simply repeated in the same design on both the title page and opening spread.

Wijdeveld's typography did not always reflect the *Wendingen* style. His 1918–19 posters for the Stads Schouwburg (Municipal Theater), dominated by large single woodcut images, are quite different in approach. In addition to *Wendingen*, he designed a limited number of books, bindings, stationary, posters, invitations, bookplates, diplomas, alphabets, vignettes, ornaments, and other printed pieces. Published in 1927, one of the most successful examples of Wijdeveld typography is J. W. Schotman's *Der Geesten Gemoeting*, a book about Japanese fairy tales and Chinese legends. On the binding are Chinese forms constructed in the Wijdeveld manner, and here his typography attains a new level of refinement. Other notable pieces are his 1929 poster for the Internationale Economisch-Historische Tentoonstelling (International Economics and History Exhibition) and the 1931 poster for the Frank Lloyd Wright Exhibition. Both posters have strong architectural overtones.

An entire range of contemporary Dutch art of the 1920s was displayed on the *Wendingen* covers. The artists were seldom compensated, and often the covers were simply a convenient venue for them to show their work. It was never stipulated that a cover had to conform to the magazine's content, and although there is no single theme, no chronological sequence, and no stylistic development, seen as a whole there is a spiritual unity. The covers exhibit almost every style imaginable and vary between the majestic, the mundane, and the bizarre, and part of their attraction is this very diversity. There are, though, some discernible stylistic threads that connect them. One is the square 33 x 33 centimeter format, and, with the exception of a few issues, the design extends to both the front and back. There is never a standard masthead, and the name *Wendingen* is always incorporated on an equal par with the ornaments and images with the lettering usually being designed by the artists. Often evident is a fascination with art of the East, and, among other

manifestations, this influence is represented through the use of vertically stacked letters, suggesting Chinese characters.

There are recurring themes, which sometimes overlap. First, there are those that more closely reflect the *Wendingen* style. Three were designed by Wijdeveld himself. His cover for the Erich Mendelsohn issue (3-10) is constructed from type material but also shows the imprint of the East Indies. The one for the Eileen Gray number (6-6) is little more than a mirror image of the title page. By far his most dynamic cover design is for the Frank Lloyd Wright series, an interpretation of Wright's architecture in typographic terms.

Also related to the *Wendingen* architectural style are covers by H. A. van Anrooy (1-6), Jan Duiker and Bernard Bijvoet (4-12), Anton Kurvers (5-7), Margaret Kropholler (4-4/5), Willem M. Dudok (6-8 and 11-11/12), Julius M. Luthmann (7-11/12), Pieter L. Marnette (8-11), Willy Wouda (9-1), and J. Zietsma (11-4). Dudok's elegant covers skillfully reflect in typographic terms his own architecture, especially his remarkable design for the Hilversum City Hall number (11-11/12).

Another category is one heavily influenced by forms and batik patterns of the Dutch East Indies. These include Michel de Klerk (1-2), Toon Poggenbeek (2-2), Johan Luger (2-6), Hendrik A. van den Eijnde (3-8/9), Fokko Mees (7-10), and J. ten Klooster (9-5). Although de Klerk was one of the chief exponents of the Amsterdam School, his *Wendingen* covers are in another realm. The one for the second issue (1-2) is a curious blend of images contrasting a protective totem figure with a cryptic shadow of the Sphinx. C. J. Blaauw's festive cover (1-4) can be seen as a glorious finale to Nieuwe Kunst. The title *Wendingen*, intermeshed within swirling forms, resembles a trumpet's blare.

There are those that relate to eastern Symbolism. Roland Holst's cover for the May 1918 issue (1-5) is loaded with Masonic signs, a recurring *Wendingen* theme. It has even been suggested that the 33 x 33 centimeter format is related to the 33 grades of the Masonic order. Crystals, symbol of a higher geometric order, reappear as motifs. Wijdeveld considered them to be the "raw material for the building of temples,"[1] and here we see Iram, the supreme architect, clasping a temple model while standing between two pillars in the middle of a crystal.

Samuel Jessurun de Mesquita's surrealistic 1918 lithograph recalls the dream-like images of Odilon Redon (1-10). His enigmatic cover with an owl (or condor) in the shape of a W is another elusive *Wendingen* mystery which defies interpretation. Van Konijnenberg's 1921 lithographic cover (4-1/2) is one of the most abstract, again using a crystal as a motif. De Bazel's creation for the first issue of 1919 (2-1) is one of the more esoteric of the entire series. Reflecting his association with the Theosophical Society, a large swastika dominates the arrangement. Along four sides it reads, "in the beginning is the word, and the word is God, in him is the life, and the life is light." In Bernard Essers' 1924 design (6-11/12) for the crystal issue, a serene barefoot woman in a black dress walks through a landscape of jagged, menacing crystal forms while holding a small, glowing one in her hands.

A few covers are both directly and indirectly inspired by Chinese motifs such as Lauweriks' design for the first *Wendingen* number (1-1). However, this design also refers back to Lauweriks' earlier designs for the Werkbund Exhibition, which came to an end with the outbreak of the First World War. De Klerk's design theme for the third number of 1921 (4-3), an issue devoted to East Asian art, consists of the Chinese characters for "Chinese Art." On the left, *Wendingen* is stacked as with Chinese characters.

Some covers directly relate to the topic. The covers of Jan Sluijters are by far the most sensuous. His lithograph on modern dance (2-5) is an enticing nude holding a rose, and Roland Holst's nude for the shell issue (5-8/9) refers to Botticelli's *Birth of Venus*. Tjerk Bottema produced the sensuous drawing for the February 1920 Gustav Klimt issue (3-2) where two nude female bodies meet in an embrace. This is a clear reference to Klimt, even down to his signature and use of gold leaf.

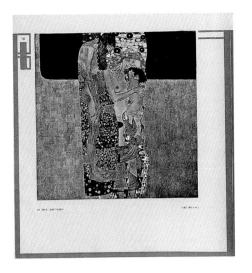
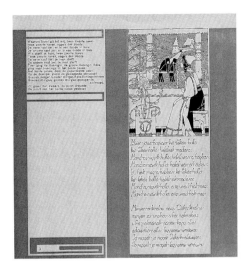
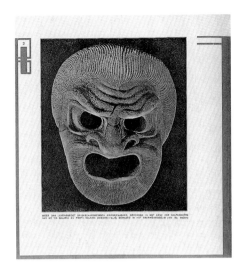

Toorop's contribution to the *Wendingen* covers is his 1919 lithograph (2-9/10). Showing a Catholic nun between two masks, it resembles a stained glass window. De Klerk's 1920 lithograph (3-4) depicts a swirling bird's nest and a beehive, which suggest the subject of the issue, apartment buildings. Johan Polet's cover on high-rise architecture (5-3) is a Cubist interpretation of the subject with the lettering used as architectural elements. Essers' cover on book plate design (5-10) is a straightforward illustration of the issue's content. Jessurun de Mesquita's woodcut for the 1923 issue on government architectural projects (5-11/12) shows J. M. Luthmann's radio tower at Kootwijk. Frits Lensvelt's symmetrical design for the International Theater Exhibition issue depicts a stage with the lettering incorporated into the design as building blocks. Martina (Tine) Baanders' symmetrical cover on the architecture of de Klerk (6-9/10) depicts a building constructed from type within a landscape. Arthur Staal's cover for the issue on airplane photography (11-5) shows the silhouette of a plane above a typical Dutch quilt-like landscape. The ceramist Andries D. Copier is far ahead of his time with his extraordinary design for the "Leerdam" glass issue (11-10). Using only a single circular line, he presents the subject using the most minimal means.

3-2

3-5

3-6/7

Expressionist woodcuts form yet another category. Krop designed a total of six covers in this medium, and of all the artists he was one of the most consistent. In his 1925 woodcut devoted to his own monumental sculpture (7-2), he represents himself standing next to a massive sculptured head. His last three covers (9-9, 10-11, and 12-5) are idealized standing portraits of Thorn Prikker, Zadkine, and himself. Jessurun de Mesquita's woodcut for the Russian Theater issue (10-10) clearly illustrates the subject. Johan Polet's woodcut cover (8-1) depicts a jubilant sculptor. The woodcut by Jan Havermans (6-1) resembles a menacing gargoyle, implying the architectural sculpture theme of this issue.

There are also covers that seem to fit into no category at all. In C. A. Lion Cachet's lithograph for the eighth issue (1-8), the name *Wendingen* is lost in a swirling mass of lines, and the only reference to the magazine is a calligraphic W in the center. His woodcut cover for number (7-8) again uses a W as a motif. Several by Jessurun de Mesquita present only examples of his own drawing style (5-1; 8-4/5, and 8-9/10). Van Konijnenberg's first cover (1-11/12) is a Cubist inspired lithograph of four figures for an issue on the monumental paintings of Toorop. Essers' drawing for the January 1920 (3-1) shows, beginning on the left, the architects J. H. de Groot, Wijdeveld, and Essers pensively clasping some tools of

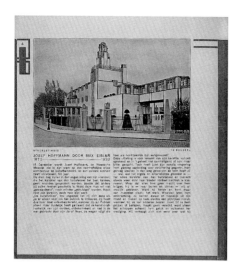

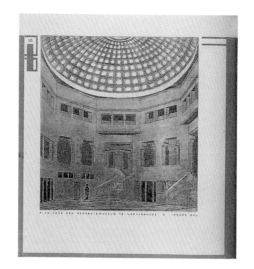

their trade. Lauweriks' design for an issue devoted to his own work is an odd one indeed. His face peers through a pattern of loosely drawn lines with *Wendingen* being worn like a headband.

3-8/9

3-11/12

3-10.d.1

El Lissitsky's 1921 design for the first Wright issue (4-11) is certainly one of the most well known of the *Wendingen* series. It is also one of the most uncharacteristic of all the covers; purely abstract, it relates to Wright's architecture only in the use of geometric forms. El Lissitsky also collaborated with *De Stijl* during the same period, but this is the only time that Constructivism is represented in *Wendingen*.

Huszár's exceptional 1929 cover (10-3) represents the only reference to *De Stijl*. Although Huszár had severed his connections with *De Stijl* in 1921, the lettering on the cover resembles van Doesburg's alphabet. The design denotes the content of this issue, the political murals of the Mexican painter Diego Rivera. The colors red and green resemble those on the Mexican national flag. Patterns made from geometric letters suggest friezes on Aztec architecture, and, composed from typographic elements, *Wendingen* is interpreted as a design motif.

Theo van Reijn's macabre design for the statue issue (12-9) seems to portend the death of the magazine. Framed on both sides by heavy hand-drawn letters, the face of a baby is superimposed on top of a skull. The drawing suggests that it was originally intended for an unpublished portrait number.

Wendingen typography had already become less popular by the late 1920s, largely due to Wijdeveld's resignation. This had diminished the magazine's spirit, and the repetitive typography beginning in 1927 soon became tedious. Also, the Amsterdam School itself was nearing its demise as the more traditional Delft School began to take precedence. One indication of a drop in interest was a dramatic decline in advertising. By the end, there are no extra pages used for this purpose, and advertisements appear only on the inside of the front and back cover. *Wendingen* was quietly laid to rest with the last issue at the beginning of 1933 (12-11/12).

Wijdeveld's singular style inspired both imitators and fervent opponents. Many were disturbed by *Wendingen*, and proponents of traditional typography considered it outright blasphemy. Also, using in an art magazine a typeface, which had for the most part been restricted to advertising, did not sit well with traditional typographers.

G. W. Ovink in *150 Years of Book Typography in The Netherlands* wrote, "While the people still lack some of the bare necessities of life, here comes Wijdeveld (Frank Lloyd Wright's paladin in The Netherlands), who in his magazine *Wendingen* brought decoration ad absurdum, making the artisti-

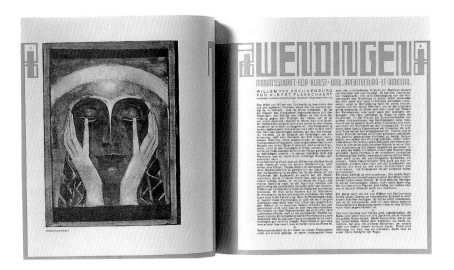

cally-minded élite lose their heads over his expensive, spectacular typographic constructions. This illegible rigid typography brought the entire art of printing into disrepute with average, sensible people....We are all now aware that Wijdeveld's typography and the whole Linear School (excessive use of brace rules) eventually expired of its own weaknesses."[2] The Dutch type designer Gerard Unger later dismissed *Wendingen* and the entire Amsterdam School as a "ponderous and earthy derivation of Art Nouveau and Art Deco."[3]

G. H. Pannekoek, Jr., in *De Herleving van de Nederlandsche Boekdrukkunst sedert 1910* (The Revival of Dutch Book Printing Arts since 1910) was undoubtedly referring to Wijdeveld when he wrote in 1925 "that today people all too often think – influenced by architects – that even though it is unreadable, a letter must be constructed from pieces of lead."[4]

In 1934, Jan Poortenaar, who designed what is probably the least interesting of all the *Wendingen* covers (10-9), wrote: "Mutilation of letters was a mistake, as the letter was deprived of its essence under the delusion of giving it significance: a letter is, and continues to be, a sign which is comprehended by others, especially others than its creator."[5]

While Wijdeveld, van Doesburg, and others were investigating new approaches in typography, there were many who remained committed to the classical style. Leading this vanguard were S. H. de Roos and Jan van Krimpen, followed by J. F. van Royen and the two master printer-publishers from Maastricht, Charles Nypels, and A. A. M. Stols. They too sought to revive typography, but through a return to exacting standards respectful of tradition. Their guidelines included harmony and balance, symmetrical layouts, careful page proportions, correct letter and word spacing, single traditional typefaces in as few sizes as possible, letterpress printing, and, in rare cases, the use of decorative rules and borders. Their work displayed a Calvinist restraint when compared to *Wendingen*, which for them was the equivalent of a personal affront.

For de Roos, Wijdeveld was no less than a threatening adversary spreading a form of typographic plague. Referring to *Wendingen*, he wrote in 1924, "Really good typography cannot be achieved through inferior composition surrounded by yet another entanglement of lines, in the same way that a robe doesn't change a monkey into a church orator."[6] In the eyes of van Krimpen, the reader should never even be conscious of typography; the designer's single mission was to make reading as pleasurable as possible and never to come between the reader and the text. Although he

openly despised *Wendingen* as well as most of those connected with it, he did write the introduction for the 1923 issue on Dutch ex libris designs (5-10). Stols, though, was less derogatory and begrudgingly admitted that at least Wijdeveld's design for *Der Geesten Gemoeting* did have something to offer.

The Constructivists were also critical, and Piet Zwart condemned what he considered Wijdeveld's extreme ornamental solutions. Ironically, Zwart, had gained much from Wijdeveld. This impact is evident in his Vickers House designs during the early 1920s as well as in his early advertisements for the Nederlandsche Kabelfabriek.

At the end of 1928, Paul Schuitema contributed an article entitled "advertising" to the progressive Amsterdam magazine *internationale revue i-10*. Stating his convictions on the role of the modern designer, he wrote, "Yesterday was 'artistic, decorative, symbolic, fantastic, anti-social, lyrical, passive, romantic, aesthetic, theoretical, craftsmanship-like,' in other words 'art.' 'Today' means: 'real, direct, photographic, succinct, competitive, argumentative, active, actual, appropriate, practical, technical,' in other words 'reality.'" Both postures were represented with designs, and even though Wijdeveld also influenced Schuitema in the beginning, he relegated a title page from *Wendingen* to the past.

Wijdeveld's typographic style, which intrigued, surprised, and shocked his contemporaries, was actually an amalgamation and adaptation of many approaches which had already been explored. The Japanese method of printing and binding had been used by Dutch and English publishers around the end of the nineteenth-century when design from that country was in vogue. This can be found in several books from the Nieuwe Kunst period such as Theo van Hoytema's *Uilen-geluk* (1895) and *La Jeunesse Inaltérable et La Vie Eternelle* (1897) designed by G. W. Dijsselhof. The square format can be seen in some Art Nouveau books and *Ver Sacrum*, the publication of the Vienna Secession, which was in Wijdeveld's possession. In Lauweriks' designs during the period 1911–1914, there are letter constructions that resemble those in *Wendingen*, and there are also similarities in Huszár's *De Stijl* logo. However, even though the originality of *Wendingen* can be challenged, it consolidated and popularized methods that Wijdeveld had embraced.

The *Wendingen* Style was widely adapted, especially in Amsterdam where it was used in advertising, book, and magazine design. Even the conservative printing firm Joh. Enschedé in Haarlem displayed examples of the *Wendingen* style in their catalogues. Notable designers who would continue with the *Wendingen* style were Fré Cohen and J. Kuiler in their work for the Stadsdrukkerij (the Municipal Printing Office). Both managed to assimilate Wijdeveld's approach into their own and continued with the style long after Wijdeveld had ceased his involvement with the printed page in 1932. Others were Anton Kurvers, Chris van Geel, Pieter H. Hoffman, J. B. Heukelom, Huib Luns, Jacob Jongert, and C. de Haas. The Amsterdam Graphic Arts School also enthusiastically advocated the style.

Wendingen was one of the most progressive magazines of its time, a work of art in itself. It differed from other avant-garde publications such as *De Stijl* or H. N. Werkman's *The Next Call* in that it was a vehicle for the message rather than the message itself. Yet, through the introduction of architectural order and through applying the objectives of the Amsterdam School to typography, *Wendingen* provided a valuable bridge between nineteenth-century disorder and modern design. It succeeded within its intrinsic limitations but failed when its design possibilities were exhausted. Unlike Constructivism, which did provide the latitude for progenies, *Wendingen* typography was a limited reform in that it left little room for further growth once its goals had been reached. For this reason, in spite of the innovative typography and extraordinary covers, *Wendingen* never made a lasting imprint on design. In 1924, the philosopher R. G. Collingwood wrote that "in art, a school once established normally deteriorates it goes on." [7] The *Wendingen* style was no exception.

In spite of his many achievements in typography, Wijdeveld always considered graphic design a marginal profession when compared to architecture. However, his actual production as an architect

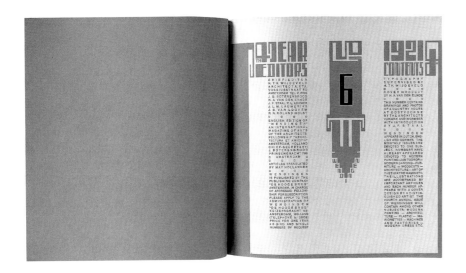

4-6 e

4-6 d

was limited, and much of it was never constructed. Ironically, typography, the craft that he considered a secondary pursuit, would be his most important legacy.

Although *Wendingen* met the need for a revolutionary new direction in design after the First World War, its physical characteristics did not fully support this end. The use of high quality paper and hand binding invariably tied it more to the arts and crafts movement. The first issues caused much excitement, and although many saw it as a wave of the future, its extravagant use of decoration continued to clash with the international trend toward restraint and functionality. Although linked to the modern era, *Wendingen* had its foundations in the fin de siècle culture of nineteenth-century Europe.

1 Wijdeveld, H. Th., 1926. *Wendingen*, 6-11,12.
2 Ovink, G. W., 1965. "110 Years of Book Typography in The Netherlands." In *Book Typography, 1815–1965 in Europe and the United States of America*, ed. Kenneth Day. Chicago: University of Chicago Press, page 269.
3 Unger, Gerard and Marjan. 1989. *Dutch Landscape with Letters*. Utrecht: Van Boekhoeven-Bosch bv grafische industrie, page 34.
4 Pannekoek G. H., Jr. 1925. *De Herleving van de Nederlandsche Boekdrukkunst sedert 1910*. Maastricht: Boosten & Stols, page 17.
5 Poortenaar, Jan., 1934. *Boekkunst en grafiek*. Antwerpen/Amsterdam.
6 Roos, Sjoerd H. de, 1924. *Kerstuitgave der Amsterdamse Grafische School*.
7 Collingwood, R. G., 1924. *Speculum Mentis, or The Map of Knowledge*. Oxford (Clarendon Press), page 82.

A Remarkable Magazine Martijn F. Le Coultre

Architectura et Amicitia

Wendingen originated in the Amsterdam society Architectura et Amicitia (A et A) established in 1855. This association had several local branches, among them being one in The Hague, which played an important role around 1920. An objective of the members was to strengthen mutual contacts between the younger generation of architects, and the first twentytwo members were either architects, construction engineers, or architectural draftsmen.

To help in realizing this objective, there were weekly meetings, which were sometimes combined with lectures. Moreover, competitions and exhibitions were organized, and a book and magazine portfolio was put together for circulation among members. From 1865 until 1892, the society's main publication was *De Opmerker* (*The Observer*), which, beginning in 1883, had the subtitle *Weekly for Fine Arts and Technological Science*. In 1893, *De Opmerker* was succeeded by the weekly publication *Architectura*.

As made clear by the subtitle of *De Opmerker*, by the 1980s, A et A was no longer a society devoted solely to architecture. The Fine Arts, albeit as they related to architecture, were considered to be at least of equal importance, and the membership was also open to artisans. Also, since 1882, the society had art loving and outside members as well.

To name a few, the membership included J. L. Springer (1850–1915), W. Kromhout (1864–1940), H. P. Berlage (1856–1934), K. P. C. de Bazel (1869–1923) and M. de Klerk (1884–1923). During the period 1880–1925, these members made a lasting impression on Dutch architecture. Membership averaged around 350, of whom close to 100 were active as "regular members." There were some who remained members for life, thus insuring continuity: Springer from 1868 until 1915, Kromhout from 1884 until 1940, de Bazel from 1891 until 1923, Berlage from 1897 until 1934, and de Klerk from 1909 until 1923.

From the very beginning it was stated in *Architectura* that attention would not only be given to subjects of interest to architects such as new building methods, building material prices, and information on architectural proposals, but that the applied arts would be addressed as well. *Architectura* was divided into technical and general sections. Regular subjects such as announcements and meeting reports were covered in the general section as well as subjects not directly related to architecture. In the sixteenth number of *Architectura* on April 22, 1893, a poster exhibition at art dealer van Gogh on the Keizersgracht in Amsterdam was covered at length by Th. Molkenboer (1871–1920).

J. L. M. Lauweriks' (1864–1932) poster for the 1894 A et A architecture exhibition exemplifies the place that, in the eyes of the members, architecture held as protector of the family household in society.[1]

Apart from a masthead designed by one of the A et A members, *Architectura*'s appearance received little attention until a special number in 1897. This was devoted to the work of honorary A et A member, P. J. H. Cuypers, on the occasion of his seventieth birthday, the first time that *Architectura* was used to honor an indvidual architect or artist. It was printed on wood-free quality paper and embellished with a large number of woodcuts by de Bazel.

In addition to *Architectura*, another magazine was published during these years under the auspices of A et A. *De Architect*, appearing from 1890 until 1915, displayed reproductions of contemporary and pre-twentieth-century art, design studies, and submissions to A et A sponsored competitions.[2] Beginning in 1881, the Maatschappij voor Bouwkunst (Architecture Society) also published the *Bouwkundig Weekblad* (*Architectural Weekly*). Later, the Maatschappij voor

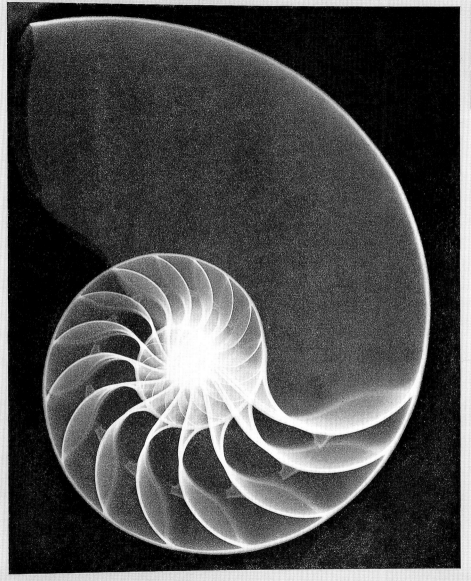

□ NAUTILUS □
□ POMPILIUS □
LINNÉ. OOK WEL
NAUTILUSSCHELP
(RöNTGEN-OPN:)

17

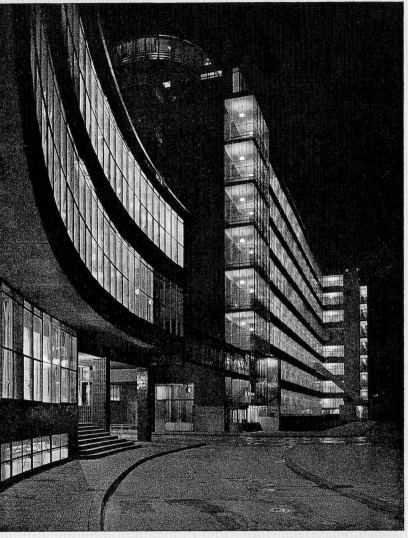

AVONDBEELD VAN KANTOOR EN FABRIEKSGEBOUW

Bouwkunst would merge with the Bond van Nederlandsche Architecten (BNA) (Union of Dutch Architects), a combination that would manifest itself as a professional society.

Moreover, prominent A et A members were involved in the establishment of the Nederlandsche Vereeninging voor Ambachts- en Nijverheidskunst (VANK) (Dutch Society for Crafts and Industrial Design) in 1904, the BNA in 1908, and the Heemschut Union in 1910. In addition, since 1867 zealous efforts were being made toward the realization of an architecture museum.

The Maandschrift voor Vercieringskunst (Decorative Arts Monthly), a more general magazine in the area of the applied arts, began publication in 1896. Among others, contributors included de Bazel, Lauweriks, and Berlage, and a new cover was designed and printed by lithography for each bi-monthly number. This rather lavish magazine was published by H. Kleinmann and Co. in Haarlem and saw only six numbers (one volume). It is noteworthy that attention was not only given to contemporary subjects such as the work of T. C. A. Colenbrander, Berlage, and C. A. Lion Cachet, but also to the middle ages and Asian art. In 1898, de Bazel and Lauweriks edited a successor to the *Maandschrift voor Vercieringskunst*, *Bouw en Sierkunst (Building and Decorative Art)*, but that magazine had a brief existence as well.

Not only were European developments around 1900 addressed in *Architectura*, but also the first New York skyscrapers were discussed and reproduced.[3] It was during this time that the concept of the house as a "total work of art" (Gesamtkunstwerk) originated, and the Stocklet House in Brussels by the Viennese architect Josef Hoffmann is a good example. Architects such as Berlage and de Bazel not only designed houses but also complete services and glass settings. Gesamtkunstwerk was later extensively addressed in *Wendingen*.[4]

11-2

Architectura devoted much attention to the 1914 Werkbund exhibition in Cologne. Also, there were initiatives in The Netherlands to establish a Dutch version of the Werkbund as an alliance between industry and art. Lauweriks, who had been active in the German city Hagen (Westfalen), home of the art patron Karl E. Osthaus[5], also contributed to the Cologne exhibition.[6] The Werkbund exhibition was forced to close early due to the outbreak of the First World War. The commentary in *Architectura* ended with the fact that the buildings were being used as emergency hospital.

In 1916, A et A gradually found itself in a crisis. While the devastating war in Europe was taking its toll from September 1914 until November 1918, in neutral Holland a movement emerged within A et A, consisting of young architects seeking a new beginning. Lauweriks had returned to The Netherlands from Germany in 1916, and many of the younger members saw an answer to the horrors ravaging Europe in the idealism of the Social Democrats and the rise to power of the Russian communists in 1917. F. M. Wibaut (1859-1936), Social Democrat, Amsterdam alderman and from 1918, patron and later honorary member of A et A, introduced plans for a large-scale extension of Amsterdam to help provide everyone with decent housing. He found a sympathetic ear among the younger architects of A et A not only because of opportunism, but because they were also trying to find solutions for the housing need.[7] H. Th. Wijdeveld (1885-1987), active member of A et A, designed a fantasy city of the future, which was published in *Architectura* in 1916. A 1927 review of the film *Metropolis* by Fritz Lang referred to this design: "The city Metropolis is an architectural fantasy, certainly not as good aesthetically as Wijdeveld's Millions City fantasy, produced 10 to 15 years ago, but the film is a technical wonder."[8]

Assignments for young architects such as de Klerk, P. L. Kramer (1881-1961), and Wijdeveld actually consisted of little more than the design of splendid facades, while the interiors of the houses were built by the construction firms following established patterns, scornfully referred to by critics as "apron architecture." This, though, did not seem to bother them: exter-

nal embellishment was the means to reach the average person. They built the "Gesamtkunst-werke" for their wealthy clients.

In 1916, the retiring chairman, P. J. de Jong, put forth his vision regarding the future of the society and especially how A et A must address the aesthetic interests of architecture, "now more than ever, since our society is the only general architecture group in the country." However, partly because of rising paper costs *De Architect* ceased publication in 1916.

In 1917, a younger board of directors took over under chairmanship of J. Gratama (1877–1947). Wijdeveld had been a member of the *Architectura* editorial board since 1915, and in 1917 was an acting board member and member of the commission for revision of the statutes. At that time, he proposed that the society concentrate its activities on the aesthetic side of architecture: promotion of architecture also included improving public taste. Promoting this objective, administrative power within the society was held by a group of around fourty active and talented regular members to whom the architect J. F. Staal (1879–1940) gave the name "Representative Members." In 1917, A et A had 484 members who were divided into the following categories: six honorary members, seven special honorary members, 182 regular members and donors, 238 outside members, fourtythree art-loving members, and eight organizations. One did not have to be an architect to be considered for membership. Although there was talk of balloting, all artists and those with an interest in architecture were welcome. The honorary members elected the first group of Representative Members by ballot.

One change sought by the younger avant-garde was bringing art, business, and industry together into the so-called "driebond" (tri-union) inspired by the German Werkbund. In September 1917, Wijdeveld took the initiative for the publication of a special *Architectura*[10] number devoted to the "driebond" ideal. He designed it himself and used it as a prelude for *Wendingen*.

Wijdeveld

To the Dutch Calvinist mentality in 1917, Wijdeveld appeared to be an extremely flamboyant, and thus sometimes misunderstood, visionary. This he would remain for the rest of his life. So it surprised no one when Wijdeveld, who called "plan the impossible" his life's goal, titled the booklet published about him in 1985, *My First Century*.[11]

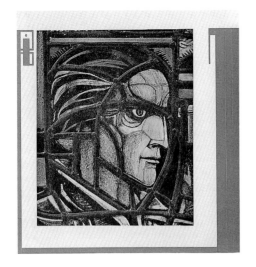

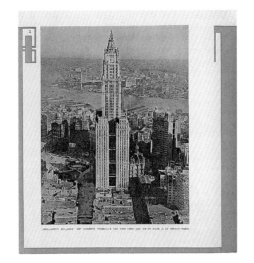

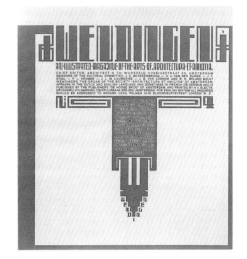

In the "driebond" number of *Architectura*, Wijdeveld indicated how a new magazine replacing *Architectura* and the already defunct *De Architect* could reach a larger audience and in this way contribute to the goal of improving public taste. However, the "driebond" number also addressed the fear of the commercial grasp on the independence of the artist.[12] On the cover Wijdeveld symbolically illustrated this danger: the octopus of business and industry attempts to seize art (the ring), which flies aloft.[13] A et A member R. N. Roland Holst (1868–1938) had referred to this danger earlier that year at the VANK sponsored exhibition, Art in Advertising, at the Stedelijk Museum in Amsterdam: "For today, nothing is more evident than strong integrity amidst encircling dishonesty." This holds true for the poster in the street as it *a fortiori* does for architecture.

5·1

5·3

5·4 E

Roland Holst, trained as a painter and draftsman, had from around 1900 become more and more interested in community art or art in service of society. Together with Henriette van der Schalk, whom he married in 1896, he became a member of the Social Democratic Workers Party (S.D.A.P.) in 1897. In 1918, he was appointed a professor at the Rijks Academy of Fine Arts in Amsterdam and in 1926 became its director. Through his membership on art committees and juries for art competitions, Roland Holst exercised considerable influence on young architects and artists.[14] From 1915 until 1926, he served as editor for *Architectura* and afterwards *Wendingen*.

Wijdeveld belonged to the younger generation of architects. Having a hereditary connection with architecture on both his mother's and father's side, at the early age of twelve he began working in the studio of the Amsterdam architect, J. van Straaten.[15] He taught himself English, and at the age of nineteen he went to England where he met his wife, Ellen Kohn. Returning to The Netherlands in 1907, he first worked with the architect L. M. Cordonnier in the building of the Peace Palace at The Hague. Afterwards, he continued working with Cordonnier for two years in France and in 1913 established himself as an independent architect in Amsterdam.

There he met Wibaut, alderman for housing in Amsterdam, and received the first assignments for the city's expansion plans. In a later letter about Wibaut, Wijdeveld reflected on that period: "An understanding of the relationship between man and mankind grew within me. I designed idealistic projects and began to write and give talks. Kees Boeke had established a society called The New Thought. Lectures were held, and speakers included Frederik van Eeden,

Just Havelaar, Adama van Scheltema, and Berlage. In 1915, I was also invited to give a lecture on Easter Sunday in the "Odeon" building on the Singel near the Koningsplein. The subject was "Illusions of the Coming Beauty." A lofty delivery...: "With wide open eyes we stared at the endless universe... the war with which Europe then struggled meant a brief time of chaos, but also a genesis, as it would be followed by a period of great culture, not only for one country or people but for the entire world." This presentation was filled with emotional explosives... a longing for Utopia at the edges of time and space." And with reference to a visit he and Ellen paid to Henriette (Jet) and Richard (Rik) Roland Holst where Wibaut and his wife were also apparently staying: "The conversation turned – how could it be otherwise – to the problems of the workers movement and the future society! Jet spoke about the progress of the Russian Revolution. She knew Lenin personally and believed in the victory of communism. I agreed with her view, and added, that through the equalization of rights and duties with regard to material things, society would function better for everyone, and that a much more radical approach must be followed to deepen ethical and cultural values."

And regarding his own views on architecture: "Through the frightful increase in population, the rapidly growing traffic, the changing notion of distance, I came to the conclusion that the city had reached an end as a historical phenomenon. Already in 1918, I had made drawing studies illustrating the future manner of living for the masses. I saw all of Europe as a well-ordered nature park filled with factories, workshops, schools, universities, and sport arenas amid woods, heaths, and fields. Among them, free and open, and separated from one another would be highrises. Units in which 1000 families could live, and in each high-rise there would be shops and... restaurants, schools, medical facilities, sport facilities; everything that one would associate with a well-ordered society. I called my plan "the Cityless City." I recall that he [Wibaut] admired my projects as far as the drawings were concerned, but as for the flood of ideas that I had for the coming century ... or centuries ahead – as time was for me unimportant – he considered my plans impracticable. He saw them more as dreams than reality."

Around 1920, Wijdeveld traveled throughout Europe and established friendships with Erich Mendelsohn, Adolf Behne, and Max Reinhardt in Berlin, Henri van de Velde in Brussels, Gordon Craig in London, and Amédé Ozenfant in Paris.[16]

In addition to his work as architect and editor of *Architectura* and later *Wendingen*, Wijdeveld designed posters and other printed matter. At first, these were still under the influence of Roland Holst, but later he arrived at his own means of typographic expression, which became known as the *Wijdeveld* or *Wendingen* style. Also, he designed stage sets and costumes, and, among others, he was responsible for the design of the 1922 *International Theater Exhibition* in Amsterdam and the Dutch exhibit at the 1925 *Exposition Internationale des Arts Décoratifs et Industriels Modernes* in Paris. In 1923, he and his friend Erich Mendelsohn traveled to Egypt and Palestine to study the history and ancient arts of that region.[17] Then, in 1931, he organized the first European Frank Lloyd Wright exhibition at the Stedelijk Museum in Amsterdam. During that same year at Wright's invitation, he visited Taliesin and gave lectures in New York City. He visited the Soviet Union in 1932 and gave lectures in Moscow, Leningrad, and Sverdlowsk to promote his ideal of an international work community. Essentially, this was aimed at having the youth of the world work together toward achieving new visions of life and modern art.[18] After a bad start in France due to a fire, this initiative would be realized in 1935 in the forests at the Lage Vuursche under the name "Elckerlyc."

"In 1917, during the last year of the war, I was obsessed by the idea of publishing a magazine devoted to all upcoming trends in the modern arts. I was intrigued by the word coming. The younger architects in Architectura et Amicitia shared these sentiments," Wijdeveld wrote in 1968.[19]

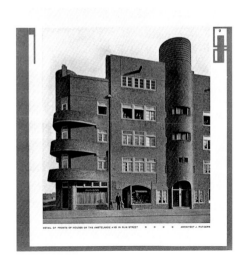

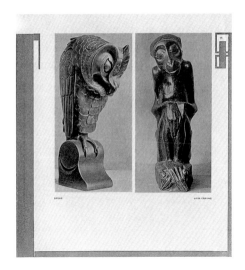

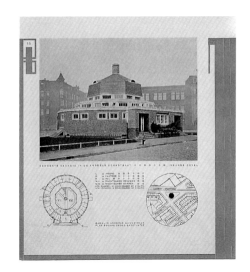

However, some who did not share those sentiments were Theo van Doesburg (1883–1931) and his associates who were united through "de Stijl." On December 20, 1916, van Doesburg gave a lecture for A et A on "The Aesthetic Principles of Modern Art." After the lecture, H. C. Verkruysen (1886–1955) opened the discussion saying, "I have sat here for the entire evening listening to nonsense." [20]

5-4

5-5/6

5-7

Quite a lot has already been said about the relationship between de Stijl and the Amsterdam School. Wijdeveld summarizes it in a letter to his friend Jan Wils (1891–1972), who in the early years of *Wendingen* had been an active member of The Hague branch of A et A as well as being attracted to the ideas of van Doesburg: "Even though you worked with van Doesburg, you provided a link between *De Stijl* and *Wendingen*, because you understood that the intellect cannot work without the heart." [21]

Wijdeveld reminisced in a 1978 letter to G. Fanelli: "I went to see Theo van Doesburg in Leiden with a proposal for him to join our group. I remember how we talked for over an hour about diverse subjects while at the same time discussing the manner of cooperation. We would contribute feeling, melody, and harmony. He would bring rhythm, sound, and abstraction. He said that he would think about the collaboration. The next day, I received a letter of refusal which I still have. Later, it appears that he, after having written the letter, raced to a nearby printer and placed an order for his own publication. [22] A few weeks later the first number of *De Stijl* (October 1917) appeared."

During the time that Wijdeveld, de Klerk, Kramer, and Roland Holst sat on the editorial board, *Wendingen* was synonymous with the line of thought of the young Amsterdam architects who belonged to what in 1918 became known as the "Amsterdam School" and in the 1920s was also called "the *Wendingen* group." [23] *Wendingen* was first and foremost the magazine of A et A, but it expressly addressed a wider audience to propagate the theories of A et A members, especially the Representative Members. The fact that *Wendingen* could exist and further have twelve volumes appear successively was, as far as finances were concerned, thanks to the support of the A et A members and donors. Between 1918 and 1923 the number of A et A members and donors increased from 480 to 650, largely because of *Wendingen*'s success. When the remaining stock of magazines was auctioned in 1934, it was not without reason that it was stated in the auction

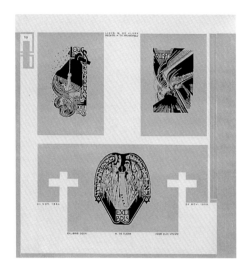

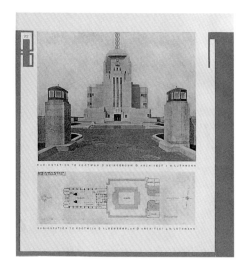

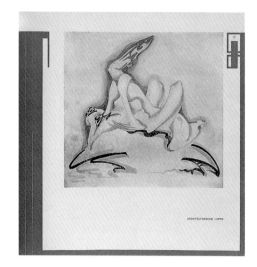

catalogue that the C. A. Mees firm stopped publication due to the withdrawal of the society's subsidy. In fact, about half of the *Wendingen* Dutch language edition went to A et A.

5-10

The influence of *Wendingen* as a propaganda instrument for the Amsterdam School was mentioned in a review of number (5-4) criticizing the quality of the photo reproductions: "...one doubts that the morning tabloid *De Telegraaf* would accept something such as this. And some people dare to insinuate that *Wendingen* is an advertising piece for a biased clique of younger Architects! ..."[24]

5-11/12

6-3

A reference to this influence was also evident in a "protestation" by van Doesburg published in *de Stijl* 10/11 (1925) regarding de Stijl's exclusion from the 1925 Paris Decorative Arts Exhibition. Nelly van Doesburg recalled in 1952 how ambassador J. Loudon initially had praised de Stijl, but: "Malgré cet encouragement de l'Ambassadeur, le groupe de Stijl a été refusé par la commission générale en Hollande, étant donné que les membres de la commission générale étaient presque tous du groupe "Wendingen."" [25]

The Conjurer

Wendingen was Wijdeveld's spiritual child, and if for nothing else it would always bear his imprint in the innovative design that he gave to the magazine. It is implausible that Wijdeveld wanted to create a typographic school, as he never designed an alphabet or set of numbers. On the contrary: "Thus, the only thing which now has to be designed is the 5 of 1925 on the inside of the cover and the heading for No. 1 (...) Will you do your best?" wrote the publisher Mees to Wijdeveld on April 20, 1925. Obviously there was a need for a 5 that still had to be designed.

Wijdeveld created his letters from existing typographic material and further utilized that material in his *Wendingen* covers, stationary designs, ephemera, and posters. He would never consider using lithography when a printer was unable to produce the design through typographic means. Rounded-off corners had to be especially cast, and should a printer be unwilling to comply, Wijdeveld simply found another one.[26] W. M. Dudok (1884–1974) was less rigorous and did indeed permit his typographic covers to be printed by offset. The fact that Wijdeveld's designs often approached the borders of illegibility did not worry Wijdeveld in the least: such was the consequence of true artistic vision. Wijdeveld facetiously called himself a typographic conjurer, and the so-called Wijdeveld Typography or Wijdeveld School was later "unmasked" in

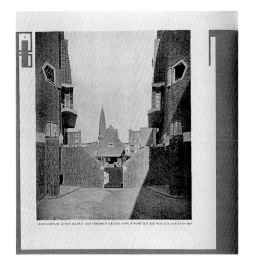

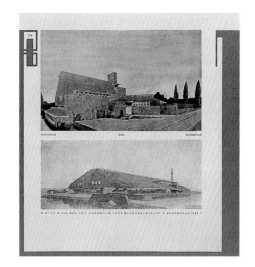

an amiable manner by the typographer S. L. Hartz (1912–1996). In his talk at the opening of a 1966 *Wendingen* exhibition, he said in jest but still quite serious: "Wijdeveld is a name in typography, and I really don't know why. He has never been involved with typography in any way. He utilizes typographic means to create art, certainly not the starting point of a typographer."[28]

In the early stages of *Wendingen*, Wijdeveld opposed the use of what he considered to be defacing advertisements, but for commercial reasons he had to give in. It is typical of him that he insisted on having the advertisements designed in such a manner as not to deface *Wendingen*. A prime example is the cover designed by H. A. van Anrooy for number 1-6. The advertisement on the back is completely integrated into the design.

The acclaim that Wijdeveld received for his design for Schotman's book, *Der Geesten Gemoeting*, clearly demonstrates that the Wijdeveld style was appreciated as an artistic form of expression. Also, *Wendingen* numbers submitted to the 1925 Paris Exhibition of Decorative Arts were singled out for praise.

Wendingen, Monthly Magazine for Building and Decoration

Wendingen's birth was no simple matter. At A et A meetings during the fall of 1917, there were discussions over its design and format. Ultimately, at the members meeting on September 12, 1917, Wijdeveld was given the go-ahead to begin negotiations with a publisher. This followed up with a discussion over the contract at the members meeting on October 24: A et A would contribute Dfl 7 per member, and each member and donor would receive a copy of the magazine. Moreover, Dfl 3,000 in startup capital would be lent to the publisher. Lauweriks insisted on having the entire artistic end left in the hands of the editorial board. Within financial limits the board of directors agreed with Lauweriks. J. Th. J. Cuypers (1861–1949), the son of P. J. H., expressed hope that the magazine would not be edited in such a manner that it would appear to be a textbook exclusively for colleagues: "The intellectual constituency in The Netherlands needs a magazine in which images of modern Dutch architecture and related arts can be found. Today the artistic perspective is represented solely by *The Studio*."

6-9/10

6-4/5

6-6

H. P. L. Wiessing

Finding a publisher during the war was not an easy matter, especially since any possibility of foreign sales was ruled out, and, in addition to this, the war situation had also generated a paper shortage. Ultimately, Dr. jur. H. P. L. Wiessing (1878–1961) was prepared to take on the challenge.[29] Member of the SDAP (Social Democratic Workers Party), Wiessing was at that time already an important figure in the Dutch literary and art world. He was chief editor and publisher of *De Nieuwe Amsterdammer, Weekblad voor Handel, Industrie en Kunst* (*The New Amsterdammer, Weekly for Business, Industry and Art*), better known as *de mosgroene* (*moss-green*). In this magazine, stances were taken against the war and for the principles of social democracy. Also, as enclosures it provided an impressive series of satirical prints by artists such as Piet van der Hem, Jan Sluijters, and Willy Sluiter. Wiessing was known to be headstrong. At the outbreak of the war in 1914, the owners of *De Amsterdammer* for months cautioned him to restrain his tone as chief editor. Characteristically, he decided not to follow this advice, and at the beginning of 1915 he began publishing *De Nieuwe Amsterdammer*. In addition to the *mosgroene*, Wiessing through his company "De Hooge Brug" published, among others, *De Bedrijfsreklame* (*Business Advertising*) and *Het Getij* (monthly literary magazine).[30]

Wiessing, the ever-radical socialist, would have felt a distinct affinity with the renewal ideas which were the foundations of *Wendingen*. Together with Kramer, Wijdeveld, Roland Holst, J. F. Staal, J. B. van Loghem (1881–1940), Hildo Krop (1884–1970), and de Klerk, Wiessing was a member of the Vereeniging tot Bestudering van Socialistische Vraagstukken (Society for the Study of Socialist Problems), which, around the middle of 1919, was renamed the Bond van Revolutionair-Socialistische Intellectueelen (Union of Revolutionary Socialist Intellectuals). Some members of *Wendingen's* editorial board were even communists.[31]

Clearly, relations between publisher on the one hand and the editorial board and society on the other were not strictly business-like. When the operation of *Wendingen* during the first years did not live up to expectations, A et A members were prepared to voluntarily contribute Dfl 5 each to cover previous losses.[32]

A Society Organ

"It is our intention to spread the word to the public as well as to foreign countries after the war" it stated in the minutes of the A et A members meeting on October 24, 1917. In support of that resolution, *Wendingen* was advertised in January 1918 with pre-subscription being an option.[33] It was quickly obvious that the edition was far too skimpy: the first eight numbers were quickly only available through book dealers. This was due in some part to new members who wanted to have the complete series. With this in mind, at the end of 1918, the publisher was ordered to print 100 additional copies to accommodate the increase in A et A membership.[34] Incidently, J. M. Luthmann (1890–1973) complained at a members meeting on December 12, 1918 that, with the appearance of *Wendingen*, which he otherwise praised, excursions, competitions, lectures, and exhibitions had been cast aside. As result, he considered life at the society to be at a low ebb.

As it was decided that *Wendingen* would also be circulated outside A et A, in-house announcements and technical reports would be sent as separate enclosures to members. This "Technical Section" or "Announcements" appeared during the first three years. Through *Wendingen's* great success, ties with A et A were diminished and through its irregular appearance many announcements simply became irrelevant. After having ceased publication at the end of 1917, *Architectura* took on a new life at the beginning of 1921. Wijdeveld remained associated with *Architectura* until 1928 and supervised its design. Even though it was decided in 1924 that *Architectura* would

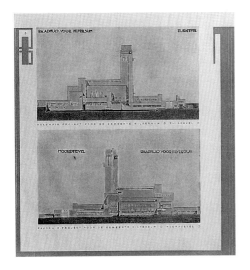

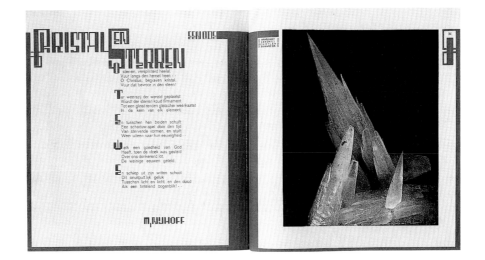

6-8

6-11/12

address the word and *Wendingen* the image,[35] *Architectura* was not to be granted a long independent existence: at the beginning of 1927 it merged with the *Bouwkundig Weekblad* (*Architectural Weekly*), periodical of the Bond van Nederlandse Architecten (Union of Dutch Architects), and combined they became the *Bouwkundig Weekblad Architectura* (*Architectural Weekly Architectura*).

The Chief Editor

Wijdeveld was not only the initiator and chief editor of *Wendingen*, he was also the soul of the magazine and the one who selected the subjects. However, he was not averse to proposals, provided they satisfied his lofty requirements. The crystal number (6-11/12) was proposed by Jan de Meijer in a review of the shell number (5-8/9),[36] and he followed Wils' suggestion for the publication of 6-6 (Eileen Gray).[37] Lauweriks as much said this,[38] and Kramer and Roland Holst also saw *Wendingen* as Wijdeveld's personal creation.[39] There are no signs of much input from his fellow editors, and, as evident in the annual reports of the *Wendingen* editorial board, there was little to be expected from other A et A members.[40] An example would be the realization of the Toorop number at the end of 1918. Roland Holst, editor, and as painter Representative Member of A et A, apparently had nothing to do with bringing this about. He wrote to Wijdeveld on December 2, 1918: "The Toorop number is *magnificent* and you have done a fine job, and it is for me personally a great satisfaction that my friends, the architects, brought this honor. The painter gentlemen could not manage something like this! They have large and rich societies attending to their small interests where you can further play billiards and drink bitters ... and slander. Tonight I dreamed about the Toorop number. I dreamed that I received four copies in four different colored wrappings, and it gave me much pleasure. But the actual pleasure is much greater. Many thanks for all that you did." Characteristic of the congenial atmosphere and Wijdeveld's personality is his reaction: "I did send him four examples. In four different wrappings." Also, a letter from J. F. Staal to Wijdeveld provides a glimpse of the mutual relations among those on the editorial board:

Wijdeveld!

The title WENDINGEN *(turnings) is opportunist and should be* OMWENTELING *(revolution). The direction: against the authority of one person, against romantic individualism. There is no need for ties with tradition,*

for Wendingen will find its own way through living individuals. There is no new art and no new religion, but instead a new philosophy (that of Marx); there is also science, although enslaved by capitalism. New art filled with tradition is as miserable as theosophy or anthroposophy. Futurism, cubism and dadaism are not art. I am for the machine, for the heartless implementation of economic necessity. I am for the creation of order (and many babies can be thrown out with the bath water), for mechanization, for order, order, order, no mystical hiding places, no asylum for dreamers; my old heart loves it, though, and I am happy in confusion and darkness. I love Palestrina and the Gothic, Bach and Rembrandt, Edgar Allen Poe and rotten bananas, and I am convinced that my understanding will end in the swamp of my ancient heart. Thus, I will deeply cherish the magazine that frees the bird of my heart from the cage of my ribs and beats it to death. This lamentation is only for the Chief Editor of Wendingen and absolutely not for the opinionated board, because in the editorial meeting I will still zealously support the – unaltered – continuation of the magazine which I gladly hold in the highest possible esteem. J. F. S. March 3, 1921 Specimen of a new typography, that comes to one point, that is NOTHING ![41]

The *Now and Then Wendingen* piece written by Granpré Molière in the July number of 1918 in the style of Zebedeus by Jac. van Looy is also emblematic.

Even though Wijdeveld originally performed his duties as chief editor pro deo, at the members meeting on May 30, 1919, he was voted an honorarium of Dfl 1,000 per year. At that meeting there was even talk of Wijdeveld stepping down as editor, but Kramer and J. H. de Groot (1865–1932) managed to prevent this. Moreover, Lauweriks had once served as a paid editor for *Architectura* in the period before 1904.

At the members meeting on October 23 of that same year, the honorarium was increased to Dfl 3,000. This was because Wijdeveld saw his income from his regular architectural work fall due to the amount of work he was doing for *Wendingen*. Otherwise, he would not want to continue as editor.

After all, preparation of the constantly changing covers and various themes was very time consuming and work intensive. In addition, Wijdeveld was prepared to continually provide new designs for *Wendingen*. This was not only for each volume but also for special issues such as the shell number (5-8/9) and the woodcut number (2-7/8) where the text was placed next to the images instead of under them. In the woodcut number there were other differences between the regular and deluxe edition as well. Those responsible for the production of these numbers were driven to despair, and on more than one occasion the end papers of the deluxe numbers were incorrectly bound. The fact that in the deluxe edition the first two opening pages were blank, and that this was the actual intention, was obviously too much for the binders who had to perform the task.

A more conservative policy was followed after Wijdeveld's resignation, and the typography was, in effect, frozen. The later covers were for the most part reproduced photographically with zinc plates replacing the heavy and expensive lithographic stones.

The Covers

At the A et A board meeting on November 14, 1917 it was decided to have twelve different covers. Designs for the covers would be delivered by the society to the publisher, and it was the chief editor's task to insure their quality. Having a new cover for each issue was nothing new. In 1896, the *Tijdschrift voor Vercieringskunst* (*Magazine for Decorative Arts*) had already appeared with new covers for each issue. Beginning in 1917, *De Bedrijfsreklame* (*Business Advertising*), also published by Wiessing, continually appeared with new covers designed by renowned artists. In a letter to Eileen Gray, Wijdeveld illuminated his ideas about a successful cover: "La couverture

1892 woodcut
C. A. Lion Cachet
2-7/8 d; D. 2

Prospects *Wendingen*
± October 1928, page 1 and 4

Prospects *Wendingen*
± October 1928, page 2 and 3

1916 *Architectura*

1920 *Wendingen* 3-5

1924 *Wendingen* 6-6

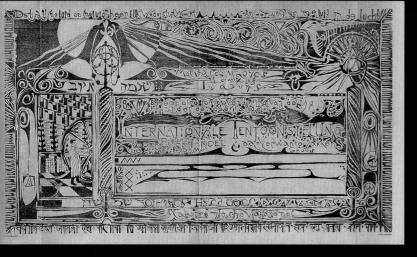

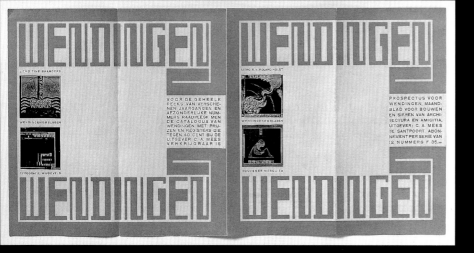

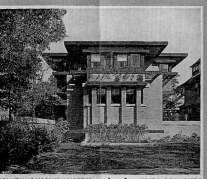

ARCHITECTUUR VAN FRANK LLOYD WRIGHT · UIT DE Nrs. 3—9 VAN SERIE 7
Deze 7 nummers werden vereenigd tot een omvangrijk boekwerk onder den titel
THE LIFE WORK OF FRANK LLOYD WRIGHT
De bandteekening werd ontworpen door dezen Amerikaanschen Architect zelf

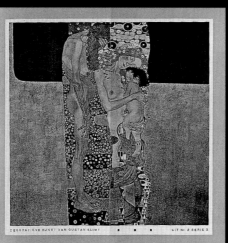

DECORATIEVE KUNST VAN GUSTAV KLIMT ■ ■ ■ UIT Nr. 2 SERIE 3

FRANKEERING BY ABONNEMENT.
A M S T E R D A M

DEN HEER JAN VAN DER LIP.
ARCHITECT.
VOORSTRAAT IIBIS.

9. UTRECHT.

ZEN-
DIN-
GEN

UITGEVERY: C.A. MEES. SANTPOORT
VOOR ZICH TIG! NIET VOU-WEN!

devrait être l'idée de couvrire, cacher, embrasser, comme par example on s'enveloppe dans son manteau." [42] Naturally, most of the covers were designed by Representative Members of A et A, and usually by those on the editorial board. In principle, a designer would receive "with thanks from the *Wendingen* editorial board," a woodcut made especially for this purpose by Wijdeveld in 1918, and an honorarium of some complementary presentation copies. [43] Outside designers such as El Lissitzky (1890–1941) were probably paid. [44] In each case, the writers of articles received an honorarium. As far as it is known, in only a few cases were designs rejected or in any case not followed through. Berlage, Honorary Chairman of A et A since 1916, designed the cover for his own number (3-11/12), but for some unknown reason a design by Jac. Jongert (1883–1942) was selected. Since the cover designed by Frank Lloyd Wright lacked the properly edited text, it was banned to the inside page and integrated into the existing Wijdeveld typography. A cover by Eileen Gray for her own number received no mercy whatsoever in the eyes of the chief editor, and the cover Finsterlin designed for his number was replaced by another of his (less spectacular?) designs.

In principle, the covers were intended to be works of art, or in other words, drawn by the designer on a lithographic stone or printed as an actual woodcut. This issue had already been raised by J. Th. J. Cuypers in 1917. [45] Preserved printing proofs are an indication of the constant searching for just the right color. Sometimes these proofs could also be purchased separately such as those for the Roland Holst covers. [46] In a few cases a painter, Jan Sluijters (1881–1957) for example, was unable to do the lithograph, and the drawing was transferred to the stone by a professional lithographer.

The first cover is by Lauweriks and relates to his designs for the Werkbund Exhibition, which was unfortunately forced to close early due to the outbreak of the First World War. [47] Many of the covers are symbolic in nature and there is only sporadic mention of any serious criticism of their artistic quality: in a review of the woodcut number (2-7/8), J. G. Veldheer (1866–1954) expressed his disappointment over the fact that the cover was produced through lithography and not as an actual woodcut. [48]

Press Voices

Press criticism of *Wendingen* came mainly from the BNA side, and in a piece published in *Bouwkundig Weekblad* (*Architectural Weekly*), there was a clear undertone of jealousy over the quality and success of *Wendingen*: "Wendingen has no pretension... Wendingen is nothing new and could also have appeared in the eightteenth-century..." referring to the Petrucci number (4-3) and "Blaauw presents him to the readers with that special kindness reserved for those who give the impression to be slightly nuts" about Finsterlin (6-3); and finally: "it is at some points scary, everywere nauseous," about the Eileen Gray number (6-6). [49] There is a more positive assessment of the one devoted to the work of the recently deceased de Klerk (6-4/5): "This work must be owned by every architect." [50]

Moreover, *Architectural Weekly* and *Wendingen* were competitors, and in *Architectural Weekly* attention was also devoted to international developments and to the applied arts. In 1923, an article was published about Wright's Imperial Hotel in Tokyo. [51]

Other press coverage was very positive. *Het Nieuws van den Dag* (*News of the Day*) wrote on February 14, 1918: *Wendingen* is not only well edited, but it is also splendidly designed. The square format has evidently its drawbacks. It is probably an expression of the extraordinary and sometimes weird ideas of the school of young architects. And with reverence to the Austrian number (8-9/10): "Also, this number is so lavishly illustrated and in all respects so finely produced, that one cannot conceive how it could be done better. *Wendingen* is decidedly the finest art magazine in the world. ... Also, this number of *Wendingen* is again a valuable possession." [52]

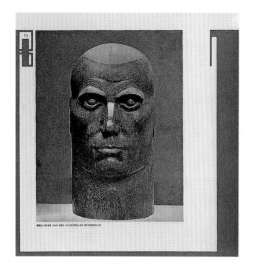

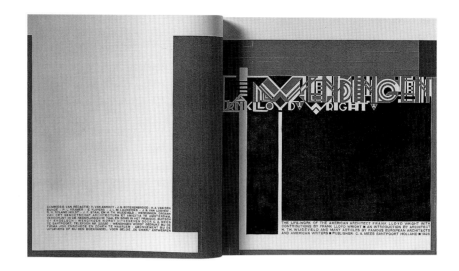

The Publishing Firm de Hooge Brug (1918–1924)

7-2

7-3 E

Sources on the period of the publisher Wiessing and his company de Hooge Brug are limited to the A et A archives, publications in the *Wendingen* Technical and Announcements Sections and later in *Architectura*. Information can also be found in Wijdeveld's own archives, but these were preserved only in fragments. In 1925, the *Wendingen* archives were handed over by Wijdeveld to the new editorial board and therefore to Verkruysen who died without issue in 1955.[53] Wiessing went bankrupt and the executor would have cleaned out his archives.

The publisher's unstable financial position would have much influence on *Wendingen's* appearance and relations between Wiessing and A et A. Because of Wiessing's continuing radical stances, the *mosgroene* had to trim its circulation considerably, and in 1921 practically went bankrupt. The magazine was then continued without Wiessing as *De Groene Amsterdammer* (*The Green Amsterdammer*). Also *De Bedrijfsreclame* (*Business Advertising*) ceased publication in the middle of the 1921 volume. "I still had *Wendingen* at my disposal, the most beautiful and greatest art magazine The Netherlands ever had: superbly guided by H. Th. Wijdeveld with the entire society of modern architects, Architectura et Amicitia, supporting us both in the background," Wiessing later wrote in his memoirs. Unfortunately, a financial injection of Dfl 16,000 specifically intended for de Hooge Brug to prevent Wiessing's bankruptcy had to be turned over to the printer of the *mosgroene*.[54] Wiessing did not go actually bankrupt at that time, but he no longer had any working capital for de Hooge Brug. *Wendingen's* publication delays in 1921 were largely due to the fact that the publisher could not pay the printer. Sometimes there was also economizing on paper quality as with the cover of (4-9/10) (theater) and the pages of (4-11) (Frank Lloyd Wright). With (5-3) (skyscrapers) the paper quality of the cover as well as the pages fell victim to cost-cutting. Naturally, this led to complaints from A et A. As a result, Wijdeveld even temporarily resigned as chief editor, finding the situation with the publisher to be unworkable.[55] A solution, though, was found through a generous gesture: the 1922 volume was cancelled and the freed funds (the volume had been paid for by subscriptions) were used to again place the magazine on a sound financial footing.[56] For the same reason, Wijdeveld later even relinquished part of his editor's compensation.[57] In the ironic 1921 *Architectura* annual report: "*Wendingen* is a magazine with the allure of dispassionate rest... *Wendingen* is a monthly magazine and wants to be a

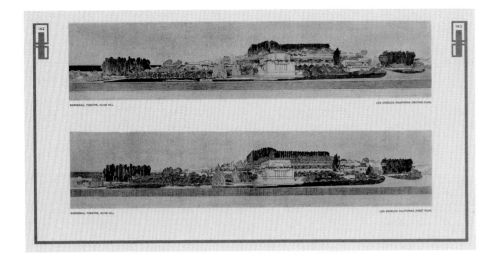

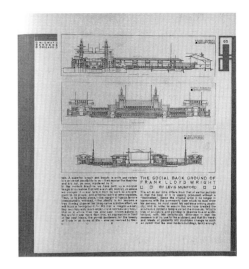

free magazine; *Wendingen* is a magazine and wants to be a book; *Wendingen* has an editorial board and acknowledges only one spirit"; and 1922: "it is all too easy to write a report about a volume that has not appeared."[58] No mention was made of the publisher's financial problems, even though for many that must have been abundantly clear.[59] As at the end of 1923 the problems reoccurred and the 1923 volume experienced yet more delays, it was decided to seek another publisher. As a result, editions of subsequent numbers such as the shell number (5-8/9) were held to a minimum.[60] De Hooge Brug went bankrupt early in 1924. The remainders were taken into consignment by the new publisher, C. A. Mees at Santpoort, obviously from the executor. In any case, the liquidation auction took place in 1934. Later Wiessing again appeared on the scene by writing introductions for the Diego Rivera (10-3) and Russian theater (10-10) numbers.[61]

Across the Borders: 1921

The problems with the publisher came at an inopportune moment, as *Wendingen* had just taken a major step in 1921. A separate announcement in the double number (4-1/2) stated that beginning with the 1921 volume, *Wendingen* would also be printed in English and German with special numbers also in French. International publications had been first discussed during the A et A members meeting on October 23, 1919. It was decided at that time that the woodcut number (2-7/8) would appear concurrently in English and German (which obviously did not happen), and there was also a proposal to publish more English translations.

Now that the international publications were being handled by a new and cheaper printer in Germany, the ever short of cash publisher had to pre-finance the international publications, whereupon it should be mentioned that as far one knows the French edition was never published. Costs in Germany got out of hand due to delays and the massive inflation (according to Wijdeveld the printer was soon writing his statements in millions) while the expected German subscribers also did not materialize.[62] In July 1922, presentation copies of the Petrucci number (4-3) were sent around in Germany in an attempt to attract subscribers. A response from the Hamburgisches Museum für Kunst und Gewerbe (Hamburg Museum for Arts and Crafts) was as follows: "I deeply regret that present conditions make it impossible for me to subscribe to the

7-9

7-5

work," and also the Oskar Schloss Verlag in Munich dropped their subscription referring to the "tragic German exchange rates."[63] From an advertisement it seems that a subscription to *Wendingen*, volume 1921, cost RM 300. Sending a postcard from Germany to The Netherlands at the end of 1921 cost 3 RM, 53 RM in July 1922 and in August 1922 it was already 300 RM, as much as the original one year subscription to *Wendingen*. From a preserved list of *Wendingen* numbers distributed in Germany at that time, it appeared that one had counted on an edition of around 600 copies.

Also, distribution in England and America did not proceed as hoped. There was no money for a proper advertising campaign, and through publication delays for some issues such as the theater number (4-9/10), the publisher was left stranded with a large inventory of unsold copies. As a result, the sequel issue "The Theatre as a Building," which was announced in number (4-9/10), never appeared. The German publications ceased after the Vorkink and Wormser number (4-6). The English edition continued through number 5-4, but stopped at that time. A continuation was deemed impossible by the publisher, unless the German Carl With would be given the power to translate the name and to add his own name among the contributors. Then publishing in more languages would be guaranteed. The board of directors intimated that they were not in favor of the "Germanization" of *Wendingen* or the addition of names of foreigners. Apart from the Frank Lloyd Wright series in English (volume 1925/26), later only one more foreign language edition would be published, the French version of (8-3). Moreover, contributions written in German, English, or French were usually not translated.

The Deluxe Edition

From the very outset, Wijdeveld probably intended to have a small deluxe edition. This originally French custom of having a deluxe publication "en tête" was for magazines an almost unknown phenomenon and again illustrated how much Wijdeveld made of *Wendingen*. The deluxe edition differed from the regular through the use of heavier artist quality paper. Also, beginning with (3-1) there were hardbound covers with the raffia binding usually replaced by a cord. Sometimes, such as with the woodcut number (2-7/8), the design of the inside spreads is also given more attention, and in the hardbound numbers advertisements are usually excluded. Eventually, the numbers beginning with (4-4/5) would have special end papers designed by Wijdeveld. In the beginning, differences between regular and deluxe editions were not that significant. Gradually, though, the contrasts became considerable as the quality of the regular numbers declined due to paper acidity and wear and tear from use. With some numbers, such as 4-11 and 5-3, it can even be feared that the regular editions will eventually be lost without conservation measures. That the first deluxe edition was for the Toorop number was due to the fact that paper was being rationed until after the armistice on November 11, 1918. Apart from special numbers such as the Toorop and woodcut numbers, deluxe editions were not advertised and were available only for the chief editor, authors, and cover designers.[66]

A letter from Mees dated August 7, 1926, first raised the possibility of a subscription to the deluxe edition through an extra payment of Dfl 10. Architect P. L. Kramer would take advantage of this opportunity.[67] It is interesting to note that Kramer had for years been a member of *Wendingen's* editorial board. That he was evidently not even aware of the existence of deluxe editions points even more to Wijdeveld's independent style of working. There are however indications that some libraries had subscriptions to the deluxe editions and that they were used abroad as visite cartes.[68]

In 1918, the *Wendingen* covers were larger than the inside pages[69] and thus hung over the edges. In spite of having them mailed in large envelopes designed by Wijdeveld for this purpose,

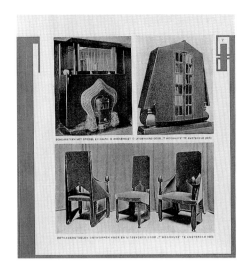

there were the inevitable complaints. As a result, the covers of the second volume had the same format as the inside pages. However, because the complaints continued, an opportunity was offered in May 1923 to have the issues already in possession of A et A members collectively hardbound: the more numbers submitted, the cheaper it would be. Unfortunately, because of this many numbers were damaged beyond repair: the advertisements were discarded and the covers were pasted on acid filled boards which often left them completely discolored. Editorial board members such as de Klerk and Staal had their series bound in this manner, which again indicates that deluxe publications were intended only for the chief editor.[70] When Wijdeveld resigned, his deluxe subscription was continued at the cost of the publisher Mees.[71]

7-10

7-11/12

The Publishing Firm C. A. Mees, 1924–1932

Through Wiessing's impending bankruptcy, the publication of *Wendingen* was actually taken over by the firm C. A. Mees beginning with the government buildings number (5-11/12). However, the formal transfer took place with the sculpture number (6-1). Mees was introduced by Wiessing at A et A on December 11, 1923.[72] The first A et A letter to Mees dates from January 30, 1924, but a week earlier correspondence was still sent to de Hooge Brug. The man from whom the firm got its name, C. A. (Conno) Mees (1894–1978), was an Asian specialist and had studied in Leiden. He married Mea Verwey (1892–1978), who had also studied in Leiden and as co-member of the firm was the driving force in the publishing house.[73] As daughter of the writer Albert Verwey, she grew up around artists such as Toorop and Roland Holst and knew as no one else the milieu in which *Wendingen* had originated and found its market.

Characteristic of the new publisher's energetic arrival on the scene was the decision to use a new printer for the last number of the fifth volume. In this way, the publication could free itself from Wiessing's negative inheritance. The society was not consulted in this decision, but the quality of the printing by de Volharding was below standard.[74] A et A would still be responsible for some honor debts from Wiessing's term as publisher. For example, the photographer of the shell number was still on the list of creditors due to the failure of de Hooge Brug.[75]

The Mees were aware of problems between the society and the publisher. Also, from the side of A et A, there was a need for clear schedules to avoid delays. Ultimately, this led to a contract,

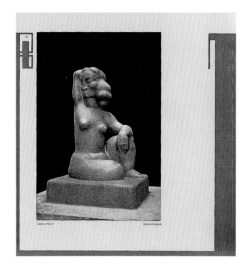 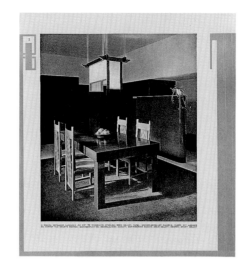

which was followed just as loosely as the contract with Wiessing. Mea Verwey later wrote to Wijdeveld: "It is a shame that I no longer have the *Wendingen* file. I suspect that I deliberately destroyed the letters and contracts during the occupation, as we had then maintained relations with the U.S.A., which was forbidden. I had the controllers come here, and later once a N.S.B.-er (Dutch Nazi Party member), who had his hands all over my publications. Thus, it was safer to get rid of the folder with all the American addresses. I never signed up with the Kulturkammer (Culture Chamber), and took in escaping Jews and other people in hiding. At that time there was still a central heating stove in which I could get rid of everything made of wood and paper!"[76] Only one package of correspondence was saved with a few pieces from the years 1924–28.[77]

8-1

8-2

8-6/7

Some clauses in the contract between A et A and the publisher can be reconstructed from the limited sources.

"The format, double-sided paper, kind of paper, cover, etc. cannot be unilaterally changed." (1925)

"Numbers can only be rejected by an arbitrator." (1925)

"A volume must consist of at least 10 numbers (with two double numbers) for a total of 228 pages (5 x 18, 3 x 24, 1 x 30 and 1 x 36 pages)." (1927)

"The numbers must regularly appear after a 5 week period for a single and after 6 weeks for a double number. Each day later will mean a penalty of Dfl 10,–." (1927)

As made necessary by Wijdeveld's resignation as chief editor, a new five year-contract was signed on April 1, 1927, and began with an edition of 1,300 copies.

Wijdeveld's Departure

As noted in the minutes of the 1924 A et A meetings, Wijdeveld had let it be known that his career as an architect had begun to suffer due to the time consuming work for *Wendingen*.[78] So why not stop now while *Wendingen* had reached a high point? He would like to continue devoting his energies to *Wendingen* but dreams of a magazine that also concerns literature and music. This was too much for the A et A board of directors, but *Wendingen* was still considered to be of vital importance to the society. It was ultimately decided that beginning with the 1925 volume, a totally new editorial board would take over and that subsequent numbers would be handled in

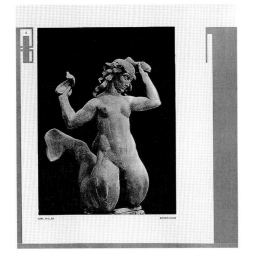

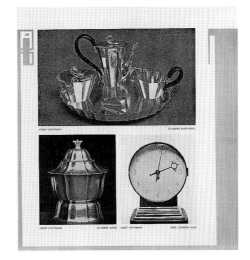

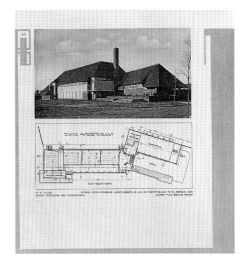

turns by one or more editorial board members. Verkruysen and C. J. Blaauw (1885–1947) would take care of the first two numbers. Wijdeveld reminded them that the preparation of a number demanded much time and that six subjects must be ready to insure that the publication does not fall behind due to a setback.[79]

Wijdeveld would still complete a number for the de Klerk series. Shortly after de Klerk's early death it was decided to publish in *Wendingen* a homage to his work and to combine the numbers later as a book. Four de Klerk numbers had already been published in the 1924 volume. It was an obvious decision to have Wijdeveld bring this project for his friend and fellow editor to a conclusion.

The Mees were not happy with these developments: they correctly felt that for a publication such as *Wendingen* the final responsibility must rest with one person. After the 1925 volume was ultimately concluded with long delays and largely edited by Wijdeveld, Verkruysen was appointed as the new chief editor. The architect J. J. P. Oud (1890–1963) wrote in a letter to Wijdeveld: "Dumb, that they let you leave *Wendingen*! I continue to greatly admire your work for this magazine: to me, a replacement seems to be nearly impossible. Your wish for a magazine to include the "arts" seems to me not only admirable, but necessary, *absolutely* necessary today."

The crystal number (6-11/12) brought to a close the last *Wendingen* volume prepared by Wijdeveld as chief editor. As editor and designer, he still retained his connections with *Architectura* which continued to publish interesting pieces.[80]

With the crystal number, devoted to the architecture of nature and with special contributions by leading poets, Wijdeveld demonstrated how he thought *Wendingen* should be used to bring the arts together. An earlier foretaste can be found in number 4-1/2 (Van Konijnenburg), which included a poem especially written for that issue by P. C. Boutens (1870–1943).

During 1925, the editorial board had misgivings as to how *Wendingen* would be continued without Wijdeveld. Mees then suggested that he continue on with Wijdeveld. In a letter to Mees dated September 9, 1925, Wijdeveld referred to this as an unexpected proposal and that he would accept the offer only "if *Wendingen* were to be abandoned freely and with good will by A et A." Moreover, in this letter Wijdeveld presented his own vision as to how Wendingen would later look under his direction:

8-8

8-9/10

9-1

"Thus, first the concept of Music and Literature...

Yes ... that is a principal point! I wish to maintain the idea of involving these arts in the Wendingen *series.*

Without that I will not continue ... but now I know there have been misunderstandings about this and suspect that you have no idea as to what I mean by this ...it would be too much to explain at length as to how the bonds between all arts can slowly in this way be closer, that they must be closer. Do not be afraid that my intention is to now suddenly and triumphantly bring in modern Dutch writers and musicians, even the good and old works will appear. For example, my intention is and was to publish one number per year with and about literature and one number per year with music. The remaining 10 issues would be devoted to Architecture, Sculpture and the Decorative Arts. At no time did I ever intend not to consult with others on Literature or Music.

Thus, I was and am prepared to select only the very best in the country from each art form. Moreover, I would include only those exceptional literary or musical expressions the publication of which you would undoubtedly applaud... and besides, the publication will not only concern text, but also the artistic union between the Decorative and Literary Arts. I don't know if I have given you examples of such numbers. Thus, some are as follows.

Imagine a selection of the most beautiful verses by Omar Kahyyan and a request to ten artists to illustrate them, woodcuts in two colors, for example.

That I call a Literature number!

Imagine the short, delicate play by Oscar Wilde "la sainte courtisane" designed with superb typography and illustrated with 10 scenery and costume studies.

That I call a Literature number!

For example, imagine the work of a Dutch poet, widely admired by the older Dutch poets Albert Verwey and Boutens but also by some younger poets such as A. Roland Holst and M. Nijhoff, designed in some colors by me (or another typographic conjurer), and thus becoming an act of respect for the poet.

That I call a Literature number!

Imagine a song accompanied by piano and viola and praised by four of our best Dutch musicians, and that a year before its appearance we have a good lithographer reproduce it in 16 pages with appropriate illustrations.

That I call a Music number!

Imagine 24 pages of music manuscripts from the oldest times until today and with an explanatory study written by a musician.

That I call a Music number !

These examples are already enough material for nearly 3 years.

You will have to agree with me, that Wendingen *must also eventually be of interest to People of letters and Musicians, and that Music and Literature should receive more attention among the Decorative Artists. Since this question concerns whether I will or will not continue in my task, I must fully address it here."*

From the letter, it further seems that Wijdeveld did want to stay on as editor and would then make himself fully available, but: *"my Editorship will mean my having a free choice of subjects and contributors, (naturally, I will gladly continue to discuss my plans with you)."*

This letter is typical of Wijdeveld: *Wendingen* is and remains his publication, and it appears now that he no longer has the freedom within A et A to which he had become accustomed. Above all, there was talk of a new design of the magazine. So there appears to be something strange going on with the already announced 1925 Paris Art Deco Exhibition number. This double number (there was also mention made of two separate numbers) would conclude the 1925/26 volume. On September 4, 1925 it was decided that Van Anrooij would take over the editing, but

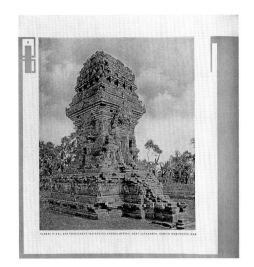

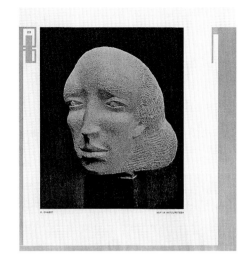

9-2

9-5

9-6/7

the minutes of the A et A board meeting on April 20, 1926 stated that the number would not be done because "Mr. Van Anrooij is acting very odd and seems unable to deliver the manuscript." As evidenced in correspondence saved by Mees, there seems to have been something else going on. Already on February 4, 1926, van Anrooij informed Mees that the text for the first number was ready. Earlier, on August 17, 1925, van Anrooij had already let Mees know that the editorial board had asked him to edit the last two numbers of the 1925/26 volume. Then, the reason for the non-appearance of the Paris numbers is different from the one given at the A et A board meeting. Van Anrooij seems not only to have asked the typographer Jan van Krimpen (1893–1958) to design the cover (which was the editor's right) but also the typography of the magazine itself. As publisher, Mea Mees-Verwey put her foot down with a reminder of a condition in the contract: the typography for a whole volume was to be decided between the chief editor and publisher. Moreover, she later wrote to van Anrooij: "The question remains that out of a feeling of reverence with regard to Mr. W., who for 7 years was founder and leader of this magazine, you could not retain having a next volume designed by this adversary van Krimpen, who with word and pen has continually denigrated Wendingen."[81]

Moreover, as chairman of A et A, Blaauw had raised the design of *Wendingen* as a discussion issue in September 1925.[82] He strongly felt that the typography should be changed and that only one cover per year should be used.[83] The board of directors later decided to ask Margaret Kropholler (1891–1966) to re-design the typography which would then be approved at the next meeting. The publisher, though, was adamant in retaining the old design and wanted no changes.

Also in later years, when any suggestions were presented to alter the format, binding method, or typography, the publisher successfully circumvented any such plans.[84] Even though as a board member Wijdeveld had voted against transferring the contract from Wiessing to Mees, a friendship between him and Mea Verwey developed and continued throughout their lives.

Crystals

It was especially due to this friendship that Mees and Wijdeveld were able to have a fruitful collaboration. An example is the realization of the crystal number. Its history is partially revealed in a letter dated April 4, 1925 from the publisher to A et A board member, J. Boterenbrood:

"The Crystal number, already a half year in production, will be completely printed after receiving the article by Mr. Wijdeveld which must be on the first page. If Mr. Wijdeveld does not have time or is in Paris, then the society must see that he is replaced. We lay claim to the maximum penalty of Dfl 150.— for the late delivery of the cover, typography and text. Data follows hereunder:

March 2 all plates for the Crystal number received (in the evening)

March 3 editor telephoned for the scrapbook.

March 4 telephoned by the plate maker Van Leer about the prints he mistakenly sent to us instead of to the editor who needs them for compiling the scrapbook. Prints sent immediately to the editor.

March 10 the Crystals scrapbook was received in the evening; minus last plate material for the poetry typography and cover and article by Wijdeveld.

March 11 last plate received, scrapbook brought to the printer.

March 12 Telephoned Wijdeveld, no one at home; a draftsman will deliver the message that we need the typography for the poems and the cover.

March 14 Printer's make-ready received. Brought to the editor in Bloemendaal who had to leave for The Hague, had no time, also no time on Sunday, so we brought it back home with us. Essers' woodcut for cover received and brought to printer.

March 15 Sunday.

March 16 Publisher to Wijdeveld in A'dam with make-ready for crystal number and paper samples for cover. Color must be extra black, paper can be Banzay: This was brought to the printer. He does not have the typeface designated by W. for the poems; and setting it in gray and in that particular manner will cost Dfl 50 extra.

March 17 Publisher to printer to discuss everything.

March 18 notice from printer stating that printing the woodcut is impossible: it is crooked. Printer asks if he can make a galvano. Wrote to W. that the printing is impossible but that we will first try another printer.

March 19 Woodcut retrieved from Enschedé and taken to another printer whose press is free on Saturday.

March 21 Saturday. Publisher with the woodcut to another printer, entire afternoon in the printshop to get it ready, etc. The plank is far too thin and has to be raised up with cardboard. It could not be done: the plank has no firm footing, and if it snaps, then the press is also broken. No printer will take that risk. A carpenter is brought on who will make a plank to place under it. (Please notice that all this is taking place on a free Saturday afternoon).

March 23 Plank returned from the printer at 9:00 o'clock, now completely unusable. It would go under the press as crooked as a hoop. Telephoned Enschedé to have them pick it up and make a galvano. Wrote to Essers. Called by Mrs. Wijdeveld, who says that it must be printed as a woodcut; that is the way it is always done – the planks come back broken but are still printed. Yes, madam, but this is satinwood and an expert has already warned us that it works too strong. It would be fine if the plank was thicker. Scrapbook returned by the editor to the printer with the request to have the revisions before 3:00 o'clock on Tuesday afternoon, as he has to go to Paris at 5:00 o'clock. Enschedé will do his best.

March 24 Revision just on time to editor.

March 25 An affirmative postcard from Essers (via Mrs. W) regarding the galvano. Called by printer who states that the editor has again completely changed the typography of the poems and that there will be very many extra correction costs. The editor wants to again revise as soon as he returns from Paris.

March 27 Revision sent. Editor not yet returned.

March 29 Sunday. Telephoned editor in Amsterdam. Has just returned from Paris and is busy with the revision. Will write the text tomorrow.

March 31 Have not yet received the W. text and revision.

April Galvano proofprint of the cover brought to W., who is not at home and the text is still not completed.

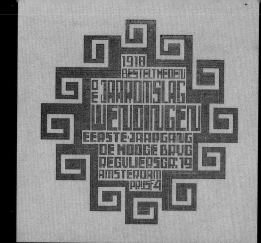

WENDINGEN

1918
BESTELT HEDEN
DE JAARGANG
WENDINGEN
EERSTE JAARGANG
DE HOOGE BRUG
REGULIERSGR. 19
AMSTERDAM
PRIJS 4

MET DANK
REDACTIE
WENDINGEN

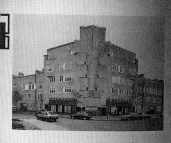

AANNEMER VAN DIT WERK

SPECIALISTEN IN:

BOUWBEDRIJF AL MEER DAN 100 JAAR
OUDEWAL — WARMENHUIZEN 02296-2944

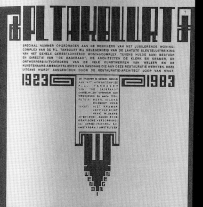

1923 1983

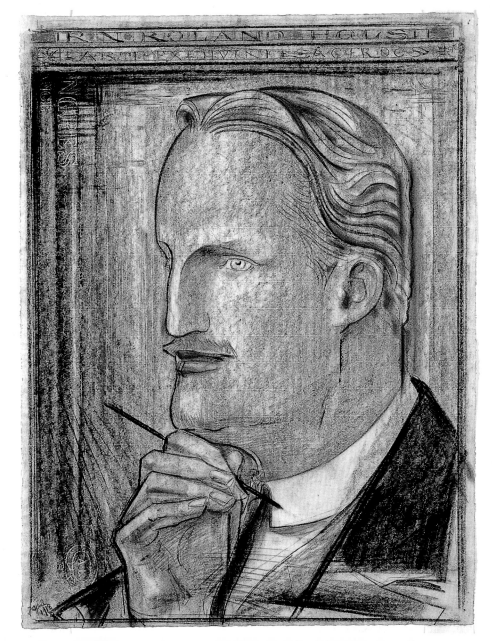

Another example of the cover sent directly to Essers.

April 3 Message from Essers: today I received the printing proof which is very well done. Telephoned Enschedé to ask if he has received the text or the revision. He has received the revision but the text has not yet arrived.

April 4 Editor telephoned about his text. Has been so busy, worked through the entire night, promises to see that the printer has the text on Monday.

You will have to agree with me, that the above report will in many respects be very instructive for the society. In the first place, it will convince you that publishing Wendingen is no sinecure and that after an initial learning period the publisher is equal to the task. In the second place, you can see that for this number important extra correction costs are mentioned (and with which number is that not the case?) and according to the contract, we cannot be held responsible."

For those who find all this disheartening, there are still more letters yet to come:

From a letter sent by (Ellen) Wijdeveld to Mees, dated February 10, 1925:

"To keep you up-to-date on the progress of the Crystal number, I inform you that the Van Leer firm has definitely promised the make-ready prints for this evening. Furthermore, I send you the contents of a telegram that I just received from Toorop. This is the result of visits, letters and telegrams from the beginning of November.

"Through indisposition and extremely busy activities have not yet begun cover – impossible to have it ready this month – could you not ask someone else – Toorop." Now What?"

From a letter sent by Mea Mees-Verwey to Wijdeveld dated February 18, 1925: "How is it going with the Toorop cover? His two-day consideration time is up. And do we now receive the scrapbook?"

On March 3, 1925 (Ellen) Wijdeveld wrote to Mees: "The van Leer firm has let us down with these make-readies, as some had to be rejected, and the scrapbook was also missing. Fortunately, that has been located, but, alas, my husband now has had to go to Paris and could not wait on van Leer. He is returning, though, tomorrow or the day after tomorrow (he also hopes to bring with him the article by Nijhoff, who is in Paris and has not yet sent it).... Also B. Essers, who is making the cover (a woodcut) has promised to have it finished within 10 days."

On April 13, 1925, Wijdeveld sent the publisher the last correction for his introduction *Architectural Fantasies in the World of Crystals*: "Easter is especially suitable for completing back work ... and to again improve many pieces which seem to fall short.... Such is the *Wendingen* matter a splendid Easter offering, and my decisions and promises ... gain fresh strengths sent to us by the Gods with the new blossums."

The reaction of Mea Mees-Verwey on April 14, 1925 left little to the imagination:

"Had I not been ill, I would have taken the piece to you and together with you put it into understandable Dutch: now we can do nothing other than correct the printing and writing errors and send it as soon as possible to the printer.

Look, Mr. Wijdeveld, among the 1100 people who receive Wendingen on a regular basis, there are a hundred whom you know personally and who will receive pleasure from such a piece, because they supplement your gestures and say: that's true Wijdeveld, but the remaining thousand subscribers won't be able to make heads or tails out it.... You know better than anyone else that the piece is filled with weaknesses, and I know better than anyone else that you have had neither the time nor rest for the writing of such observations. But ... had the space not been kept open, on our own responsibility we would have left your piece out, as the number has enough safe-conduct letters. We are being held responsible by the 100 of our personal acquaintances, from among the thousand or so subscribers, for the literary contributions in the magazines which we publish.

1918 W. A. van Konijnenburg, charcoal with chalk. portrait of R. N. Roland Holst, 62 x 48 cm

So shall we now then extend a hand after this Easter blaze? You have to admit that the offer demanded from 9-8
us is greater than the one demanded from you. We must apparently begin by writing off that Dfl 150 penalty
which we felt that we had a right to have. Then we must possess our soul in patience regarding payment by 9-9
the society for Architectura. And then we must be patient, for at the moment all of the editors are in Paris 9-12
or working on buildings. And then we must close our eyes as the conditions of the contract are violated.

But I'll stop. In the end, we consider Wendingen to be a beautiful magazine over which we have exerted
much labor and concern. We are proud of Dutch architecture and love our association with unpredictable
characters as some artists are, provided they allow us to ever so often make our standpoint known and our
rights felt with regard to that strong society which is always embodied in somebody else."

1927–1933 Verkruysen

During the 1920s, Verkruysen served as director of the School voor Bouwkunde, versierende
Kunsten en Kunstambachten (School of Architecture, Decorative Arts and Arts and Crafts) in
Haarlem. With his assumption of the chief editor's position and with the signing of the new con-
tract, *Wendingen* sailed into calmer waters. The business woman Mea Mees-Verwey kept a firm
grip on the contract to see that it was followed as closely as possible, although this was at the
expense of spirituality and innovation. As a result of the designer's departure, the extravagance
of a continually re-designed title page heading, first seen in number (5-1), was dropped. This was
an immediate accommodation for critics of this illegible outgrowth of the Wijdeveld style.

Wijdeveld would distance himself from *Wendingen* under Verkruysen: "*Wendingen* and its edi-
torial board were moving in a direction so repugnant to him that he (Wijdeveld) considered
Editors & Administration for idiots and crazies."[85]

Several subjects were already ready for the 1927 volume. At the combined board of directors
and editorial board meeting on September 11, 1925 it was decided to go ahead with the prepara-
tion of the following numbers: Farms by Wormser; the Dutch Windmill; Storefronts, to be com-
pleted by Zietsma after already half finished by Wijdeveld; Trends in German Architecture by
Carl With; Modern French Painting by Tjerk Bottema; Rädecker by Hildo Krop; Construction in
the West-Indies Neighborhood by Bruin, Westerman by Staal. Earlier, a number on de Bazel
edited by Roland Holst had been discussed.

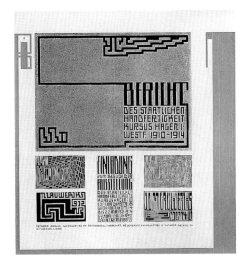

10-1

10-8

10-2

Probably inspired by the international success of the 1925/26 Frank Lloyd Wright numbers, it was decided to devote a series to Scandinavian architecture. Four separate numbers were to appear in English and later be bound as a book. However, because the Norwegian number was cancelled, the series was limited to three numbers. An English translation was supplied separately, and there is no indication that they were ever published as a book. In addition, Mees tried to explore international market possibilities by including English translations with other numbers. The new contract called for an edition of 1,300, and as evidenced by remaining copies in the 1934 liquidation auction, this was far too optimistic. The membership of A et A had gradually declined, and, as indicated by a drop in the number of advertisements, economic conditions left much to be desired. There were even numbers in which advertisements appeared only on the inside of the covers.

Under the new editorial board more space was given to modern topics. With the death of de Klerk and the stepping down of Wijdeveld, the Amsterdam School lost much of its influence. Also, a decline in interest in the Amsterdam School was indicated by the fact that many of the issues devoted to the work of J. F. Staal remained unsold while those on Dudok were so popular that one number had to be reprinted. The four Dudok numbers were bound as a book in 1932.

Also, there had been talk of anemia within the society itself. Verkruysen in the 1929 annual report: "As indicated by the above figures, this series consists of 5 numbers on architecture and one in which a large section is devoted to architecture, thus almost 6. With this, the writer hopes that the desires expressed at the last annual meeting to have more architecture in *Wendingen* have been met. Also the wish to see more work of foreigners was satisfied in 4 of the numbers... The editor wants to end this report by again requesting, (as with last year) your cooperation in helping to provide plans, ideas, names and anything which will contribute toward the success and improvement of the publication. So splendid a publication as *Wendingen*, with so many reproduction possibilities can have much significance as a publication of the Society. But its greatest significance will be when the spirit of the Society lives within it, accepting the fact that a spirit does indeed exist within the Society. If this spirit or soul or whatever one wants to call it is not functioning well but at the moment remains latent, then the editor of *Wendingen* hopes that the fire will blaze again soon and be strongly reflected in the Society publications."[86]

This assessment by Verkruysen makes the differences between him and Wijdeveld quite clear. Wijdeveld simmered with ideas and at the time of his departure as editor still had material for years to come. Verkruysen waited around for something to come from the members. At that time, life at the society sunk so low that a members meeting in May, 1929 had to be cancelled due to lack of attendance. In 1928, an important change occured in the A et A structure. After years of opposition against the "club within the club," the institution of the Representative Members was abolished. At the time of its demise there were fourtysix Representative Members including Berlage, C. J. Blaauw, W. M. Dudok, Jac. Jongert, W. van Konijnenburg, P. Kramer, W. Kromhout, Hildo Krop, A. J. Kropholler, Lauweriks, Roland Holst, J. F. Staal, and Wijdeveld.

How to proceed after Mees?

During 1931, as the expiration of the contract with Mees neared, discussions took place within A et A regarding *Wendingen's* continuation. The society wanted to proceed, but in no way did the board of directors want to remain with C. A. Mees and Mea Mees-Verwey.[87] Actually, relations between A et A and the publisher had cooled soon after the closing of the contract in 1927. The fact that in the years 1927–1932 *Wendingen* appeared more and more too late was the most important reason for the estrangement between the society and the publisher. So when the third number of the 1927 volume was already too late, Mea Mees-Verwey wrote on August 18 to the board of directors: "it was supposed to have been ... delivered on August 5: for every day that it is late you owe me the sum of 10 Guilders." Mees would collect quite a few penalties. In so many words, he said that with the new contract he had the society under his power and that he would also make use of it.[88]

Among the younger members seeking changes was the board member Arthur Staal (1907–1993, son of J. F.). In October 1931 the board of directors gave him the assignment to change the typography of *Wendingen* for up-coming volumes but without changing format, covers, or name. Arthur Staal was a great supporter of *Wendingen's* continuation and advocated changing the editorial board. Also, he proposed new subjects such as the work of Cassandre and Le Corbusier as well as autos and ships.[89]

Because only the experiences with Mees had been bad, in July 1931 the printer Ipenbuur & van Seldam was probed regarding continuing the publication. They appeared to be also publishers, but then under the name of Engelsch-Nederlandsche Uitgevers-Maatschappij (ENUM) (English-Dutch Publishers Society). Mr. Lak let it be known that he wanted to continue the publication under the name of ENUM on the condition that the society first had gotten rid of Mees. The contract between the publisher and printer would, though, still be in effect until December 31, 1931.[90] It was suggested to begin the new volume as 1933.

In October 1932, another publisher, A. H. Kruijt in Bussum, spontaneously announced that he wanted to continue the publication, but to avoid any problems with Mees, it was decided to go with a new publisher only after the last volume with Mees had been completed.[91] Since the last volume (1931) had only reached number 4 by the end of the contract with Mees in April 1932, it was unclear as to how the yet to appear issues would be realized. Ultimately, it was agreed that the last numbers would still be published by Mees. To cut down on costs, Mees was allowed to print part of the edition (probably not the part intended for A et A members) on a more inferior paper, and the size of the edition was held to a minimum.

When the last number finally appeared in February 1933, the situation within the society had changed: Arthur Staal was no longer a member of the board of directors and with him *Wendingen* lost an important advocate. At the members meeting on March 24, the agenda item, "discussion regarding the replacement of the magazine *Wendingen*" did not come up due to the

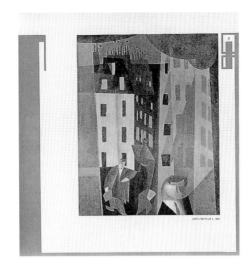
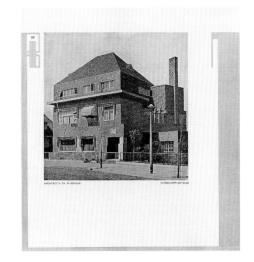

10-5/6

10-7

10-11/12

small attendance. It was gradually decided that it would be more sensible to have separate publications on special subjects. The following topics were suggested to begin in 1934: "Architectural Drawings," "High-rise buildings," and "Organs and Fairground Booths." Continuing *Wendingen* was no longer mentioned. Ultimately, over a period of around fourteen years, 116 numbers were published of which 109 were in Dutch, nineteen in English plus around eight with inserted English translations, three or four in German, and one in French.

Continuing *Wendingen* with Wijdeveld and Mees, which was still being considered in 1925, was out of the question. In fact, the issue was not even raised. By now, Wijdeveld had become totally involved with his more idealistic project, the International Work Community. Conno Mees and Mea Mees-Verwey were splitting up. Mea would later marry Dirk Nijland. On April 25, 1934 Mea Verwey continued the firm C. A. Mees as N.V. Uitgeverij v/h C. A. Mees (N.V. Publishers Formerly C. A. Mees). After the end of *Wendingen*, unsold numbers from the period until 1924 were auctioned by the de Hooge Brug bankruptcy executor on December 28, 1934.[92] Remainders from the Mees period were also auctioned. Remarkably, almost all of the numbers were still available. Sometimes there were several hundred and at other times only a few copies. Only the first nine numbers from 1918 and the numbers (5-8/9) (shells), (6-1), (6-3), (6-4/5), and (9-3/4) (Toorop) were missing. This came as no surprise, since the first numbers were available only through book dealers immediately after completion of the first volume. The shell number was one of the last publications of de Hooge Brug; with the new publisher, volume 6 began with a minimal edition, and the Toorop number was impounded due to a dispute over reproduction rights. Conspicuously, the Frank Lloyd Wright series was not offered up for auction. Because everything was not sold, the executor held a second auction on September 18, 1935, but publications after 1924 were not included. This time everything sold, and the biggest buyers were the publishers "de Torentrans" in Zeist, A. J. Roebert in The Hague and the book dealer Vloemans, also in The Hague. An extra fifteen cents was added for hardbound copies. In the copies bought by Roebert was stamped "now publication of A. J. Roebert."[93]

Editions and Distribution

The *Wendingen* editions began with 650 copies and quickly increased to around 1,300 with even

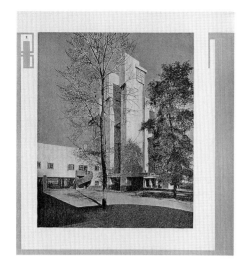
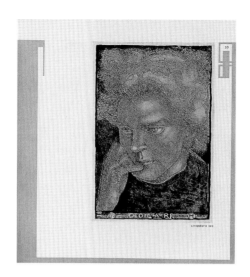
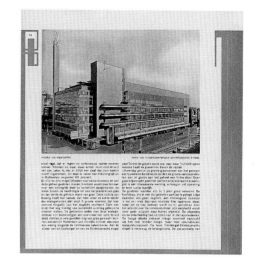

more for special publications. Out of the 1,300 copies, 1,100 were distributed directly and around 200 were kept to accomodate late orders. Of the 1,100, nearly half were sent to A et A members, although the mailing sometimes left much to be desired.[94] From the other half, the largest part (around 300 copies) were sent to reading societies, libraries, and institutions, enabling the edition to reach a larger audience.[95] The artist and poster designer Jan F. Lavies (1902) studied at the Koninklijke Academie van Beeldende Kunsten (Royal Academy of Fine Arts) at The Hague from 1916 until 1922 and recalls how each month they looked forward to the arrival of *Wendingen*.[96]

Already by the second volume there was talk of expanding the publication abroad. The Dutch actor Eduard Verkade (1878–1961), at that time living in England, offered to solicit subscribers for *Wendingen* there.[97] Also the name Cecil Palmer was raised, and he would become the distributor for the English publications. The contact with the publisher in Hagen, Germany, was probably because of Lauweriks. He had worked in Hagen until 1916 and would have gotten in touch with Osthaus again after the war. The Bauhaus and Jan Tschichold also had subscriptions, and at the start of the German edition around 550 copies circulated in Germany, Scandinavia, and Switzerland via German distributors.[98] In Berlin, Julius Springer took fifty in consignment, and the other Berliners, Ernst Wasmuth and Leonhard Preiss took 150 and fifty copies respectively. Then there were the American subscribers, and since A. Iannelli (1886–?) and the New York art dealer Albert Duveen, who had lived in Amsterdam, were A et A donors, they received *Wendingen* automatically. From a list dating around 1925, it appears that about fifty copies were circulated in the United States and Canada. Half went to book dealers, universities (Yale, Princeton, Columbia, and Illinois) and libraries (the Library of Congress, the New York Public Library, and the Lloyd Library in Cincinnati, Ohio), and the other half went to individuals, among them architects. From the list it is not clear if these were sample copies or subscriptions. However, it is known that Gerlof Verwey (1901–1999), living in New York in 1925, went to much trouble to arrange *Wendingen* subscriptions to help his sister Mea: "He went to all the important publishers and book dealers, but they all felt that it would come to nothing without extensive advertising."[99] Except for a much later number (8-3) intended for the Belgian market, nothing ever came of a French issue which had been announced in the Van Konijnenburg number (4-1/2). On October 10, 1923 Wijdeveld wrote to Eileen Gray: "WENDINGEN is well known and has sub-

11-3

11-6/7

11-8

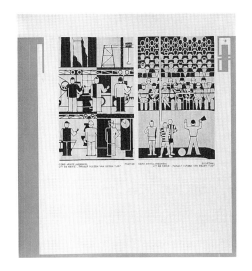 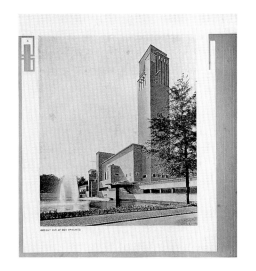

scribers throughout the entire world, but unfortunately very few in old old France!!" Wijdeveld had sent numbers to Le Corbusier before 1922. Also, he had first asked Le Corbusier to write the article for the Frank Lloyd Wright series[100], which was ultimately written by Mallet Stevens. Apart from that, it is interesting that although Wijdeveld was obviously in touch with Le Corbusier, he wrote referring to the Eileen Gray number (6-6): "It is strange that after trying for years to publish a modern "French" *Wendingen* number, I now finally succeed...with...the work of someone from Ireland."[101]

Wendingen was further distributed via the Tokyo Maruzen Company Ltd., and copies are also known to have been sold via the office of Kolff in Batavia (the present-day Jakarta). In addition, John Tiranti, a London book dealer specializing in architecture, handled the extra distribution in England. For the eighth Series there were twentyseven subscriptions in Spain.[102]

Special publications such as the Toorop number, the woodcut number, and the theater number are worth to be mentioned seperately. The one devoted to Toorop's sixtieth birthday was available in a special signed deluxe edition with an original etching. This sold out almost immediately, and encouraged by its success, a big edition of the woodcut number was printed with a large woodcut by Lion Cachet as a free enclosure. Even though this too was a success for the publisher, there appears to have been many unbound copies in 1934 that had not been sold. This mainly concerned the expensive deluxe edition. Finally, many copies of the theater number also remained unsold because it came out just after the exhibitions in Amsterdam and London had already taken place.

The gigantic edition of the Frank Lloyd Wright series during Mees' reign as publisher is also worth mentioning. Wright had hoped that the Chicago publisher Kroch would take 2,000 copies of the book, something that was taken very seriously. Wijdeveld had a special interest here, as he would receive a percentage of each book sold abroad.[103] Ultimately, Wright was not even able to pay for the hundred copies he ordered, and Kroch took in consignment only the 100 books ordered by Wright. This left Mees with at least 2,000 unbound copies, part of which Kroch would acquire after 1945. Little is known about the distribution via de Sikkel in Belgium in the period starting in 1927, but it would not have been many due to the overall reduction of *Wendingen* editions.

11-9

11-10

11-11/12

55

After 1934: Antiquarian Bookshop v/h C. A. Mees

After 1934, Mea Verwey put the old stock up for sale. It is known that before 1940 she sold items to The Architectural Book Publishing Co., Inc. and William Helburn, Inc. in New York City; to Kurt Palnitzky in Montevideo; and to Mr. Henri and his successor, The Craftsman Bookshop in Sydney, Australia. These sales concerned mainly the Frank Lloyd Wright books and publications on Dudok. Also, the de Klerk book sold especially well in Australia. For the 1931 Wright exhibition in Amsterdam, 150 of the Wright books were bound from old stock by van Bommel. Sometimes Mea Verwey also bought old numbers to complete a series. After the Second World War only a sizeable number of the unbound Frank Lloyd Wright books remained. It turned out easy to sell them, as Wright had become a celebrity in America. There is an existing letter from Mrs. Avery Coonley in which she asks if the book about the house that Wright built for her husband was still available to give as a present to her grandsons. Obviously, the Coonleys had originally received a copy of the book from Wright himself.[104] Mea Verwey wrote in 1962: "Since 1950, my publishing business has become an antiquarian bookshop for my own publications."[105]

Exhibitions, Summaries, and Reprints

After the Second World War and the period of reconstruction, there was a renewed interest in *Wendingen* during the 1960s. A first sign was the republishing in America of the Wright book with a foreword by his widow. As Wijdeveld came upon this after the fact, he was enraged that he was not consulted. More reprints would soon follow.

In Amsterdam an exhibition was held in 1966 at the G. H. Bührmann's Papier Groothandel N.V. (G. H. Bührmann's Paper Wholesaler) called *Wijdeveld's Wonderful Wendingen*.[106] Wijdeveld designed the invitation himself, and there was even talk of a revival of the Wijdeveld style. At the exhibition Wijdeveld met Willem de Ridder who had earlier had an exhibition at Bührmann devoted to his pop newspaper *Hitweek,* and later he received an assignment to design a cover for *Hitweek.* A year earlier on the occasion of his eightieth birthday, *Architectural Weekly* covered the work of Wijdeveld at length.[107] Ten years later *Forum*, the official magazine of A et A since 1946, devoted a special number to his typography, and Wijdeveld designed the cover.[108]

At the end of 1967, the American publisher Earl M. Coleman of the Da Capo Press in New York City sounded out Wijdeveld over the possibility of reprinting *Wendingen* completely and in its original manner. Wijdeveld's reaction was one of enthusiasm. Was not *De Stijl* just around that time being reprinted? He received from Mea (Nijland) Verwey, as holder of the copyright, the permission (as far as this was needed) to republish, and, while still alive, drummed up contributors and asked them to write a recommendation for a prospectus to be circulated in English and Dutch.[109] Among others, Dudok wrote: "To my knowledge, there has never been a magazine with such a splendid, especially such an individual form." Hermann Finsterlin wrote, "Through *Wendingen,* you have opened the door of the world for me." And Wils commented, "How we looked forward to each new number of *De Stijl* and *Wendingen.*" The prospectus was designed by Wijdeveld and ultimately appeared in 1971, but this effort was of no avail. Interest in the $1,100 advance subscription was not such that the publisher who was coping with some setbacks would risk it.[110] It was then suggested to have a reprint of only sixtysix numbers, but that plan also seemed to unfeasible. Wijdeveld was very disappointed and placed all his hopes on the Dutch publisher Forel, but nothing came of that either.

At the end of the 1970s, there was renewed interest due to the enthusiasm of the Italian G. Fanelli. This resulted in a 1982 exhibition in Florence with an accompanying catalogue.[111] In December 1982, the exhibition also came to the Princessehof in Leeuwarden, but a Dutch publication of the catalogue was not included, and they had to make do with a separate Dutch translation.

A smaller exhibition was held at the Building Center (Bouwcentrum) in Rotterdam in January/ February 1983. The book *Wendingen, Grafica e cultura in una rivista olandese del Novecento*, was published in 1986 with a text by G. Fanelli and others.[112]

12-1

12-4

12-7/8

There was a catalogue for a *Wendingen* exhibition in Darmstadt (in 1992), *Wendingen, 1918–1931, Amsterdam Expressionism*, but Wijdeveld, who died in 1987 at the age of 101, was not involved with this.[113] This was also the case when a *Wendingen* style catalogue was published for a modest exhibition at The Hague in 1994.[114]

Even though there have been steps in this direction over the years, we are still awaiting a Wijdeveld biography.

An inventory of the published numbers of *Wendingen* was first recorded in *Architectura* XXVI-25, June 17, 1922. Numbers which had already appeared were sought by later subscribers. Mees circulated a second summary as a small catalogue at the beginning of 1926 which was announced in *Wendingen* 7-6. Supplements for later volumes appeared in the form of separate pages.

1 The poster was reviewed in *Architectura*, 1894-2, page 10.
2 Bi-monthly publication of H. Kleinmann en Co. in Haarlem.
3 *Architectura* 1898-25, page 104.
4 See *Wendingen* 3-8/9.
5 *Architectura* 1914-27, page 221.
6 See the review in *Architectura* 1914-42, page 302 and *Wendingen* 1-5.
7 *Architectura* 1916-41, page 319.
8 *Bouwkundig Weekblad* (*Architectural Weekly*) 1927, no. 9, page 88.
9 Letter dated June 1968 from Wijdeveld to G. W. B. Borrie (copy in Mea Verwey Archive, University Library Amsterdam); also see *Wendingen* 5-4, page 18.
10 *Architectura*, 1917-39/40.
11 Wijdeveld continues to live on as a person through an extensive television interview conducted by Hank Onrust for VPRO on the occasion of his ninetieth birthday. The book was published in 1985 by the Ravenberg Press, Oosterbeek.
12 See the review in *De Nieuwe Amsterdammer*, November 10, 1917.
13 See the review in *De Nieuwe Amsterdammer*, November 10, 1917. This danger was addressed in reviews of the Cologne Werkbund exhibition in *Architectura*, 1914.
14 About Roland Holst. See for example, "R. N. Roland Holst" (*Dutch Poster Art*; 2) by Mieke Rijnders, Stadsuitgeverij (Municipal Publishing), Amsterdam 1992.
15 For Wijdeveld, see among others: *H. Th. Wijdeveld, 50 Years of Creative Work*, exhibition catalogue, Stedelijk Museum, 1953: *Time and Art*, H. Th. Wijdeveld, first in a series on the works of well-known Dutch artists, Rotting's Printing Works, Hilversum, Holland, 1947; and *Bouwkundig Weekblad* (*Architectural Weekly*) no. 19, 83rd volume, September 24, 1965.
16 Letter dated June 1968 from Wijdeveld to G. W. B. Borrie (copy in Mea Verwey Archive, University Library Amsterdam).
17 As mentioned in *Bouwkundig Weekblad* (*Architectural Weekly*) no. 19, 83rd volume, September 24, 1965.
18 See *Toward an International Work Community, a plan with 16 illustrations by H. Th. Wijdeveld*, C. A. Mees, Santpoort, Holland, 1931.
19 Letter dated June 1968 from Wijdeveld to G. W. B. Borrie (copy in Mea Verwey Archive, University Library Amsterdam).
20 See reviews with postscripts in *Architectura* XXV-2, 3 and 4. Also, see accounts in *Wendingen* 1-1.
21 Undated letter (Christmas 1968) in Wijdeveld Archive NAI.
22 This letter is not preserved in the Wijdeveld Archive NAI nor in the van Doesburg Archive RKD.
23 See *Wendingen* 1-7, page 3.
24 *Architectura* XXVII-20, June 2, 1923.
25 Letter from J. Loudon to van Doesburg dated November 20, 1923; letter from Nelly van Doesburg to Bruna Zevi, Meudon, April 13, 1952 (Van Doesburg Archive, RKD).
26 For example 7-3.
27 Letter dated September 9, 1925 from Wijdeveld to publisher C. A. Mees.
28 Opening talk at the exhibition Wijdeveld's Marvelous Wendingen, G. H. Bührmanns's Papiergroothandel (Paper Wholesalers) N.V., Amsterdam, November 4, 1966; Also see the commentary by Herman Hana in the series *Monografieën over Toegepaste Kunst in Nederland* "batik, bedrukte stof, klein lederwerk" (*Monographs on the Applied Arts in The Netherlands*, "batik, printed cotton, small leather work") W. L. & J. Brusse, Rotterdam 1925, pages 26–27. Also: Machiel Wilmink in *de Reclame* 1922, p. 30–32, 85–86 and 246.
29 Regarding Wiessing, see his autobiography: *Bewegend Portret* (*Moving Portrait*) Moussalt, Amsterdam 1960.
30 Also: "Het Bedrijf" (voor handel, economie en techniek) (The Business, for trade, economics and technology), the "Amsterdamse Gemeentelijke Woning-Courant" (Amsterdam Municipal Housing Journal) and the magazines of the Jaarbeurs (Industrial Fair) and the Nederlandse Biljart en Korfbalbonden (Dutch Billiards and Basketball Unions).
31 See Ype Koopmans, H. A. van den Eijnde, page 76.
32 See minutes of the A et A members meeting on October 10, 1918 and October 31, 1919.
33 See *De Bedrijfsreclame* (*Business Advertising*), January 1918.
34 Minutes of the A et A board of directors meeting on December 24, 1918.
35 Minutes of the general A et A meeting on December 19, 1924. *Architectura* XXIX-17, January 1925, page 35.
36 *Architectura* XXVIII-1, January 26, 1924.
37 See letter in Wijdeveld Archive, NAI.
38 Minutes of the A et A board of directors.
39 Minutes of the A et A board of directors meeting on March 20, 1925.
40 As published in Technical Section II-1 (concerning 1918), Technical Section II-12 (concerning 1919), *Architectura*, March 4, 1922 (concerning 1921), *Architectura*, April 28, 1923 (concerning 1921), *Concerto Grosso* page 52-55 (concerning 1924), *Bouwkundig Weekblad Architectura* (*Architectural Weekly Architectura*) June 23, 1928 (concerning 1927) and *Bouwkundig Weekblad Architectura* (*Architectural Weekly Architectura*) July 5, 1930 (concerning 1929).
41 Copies of letters from Roland Holst and Staal in Wijdeveld Archive, NAI. The letter from Staal is written in the form of a pyramid standing on its end.
42 Letter from Wijdeveld to Eileen Gray dated July 2, 1924, Wijdeveld Archive, NAI.
43 Annotation on a copy in the Wijdeveld Archive, NAI.
44 J. J. P. Oud, who was not a member of A et A, received an honorarium for his contribution to the Frank Lloyd Wright series (letter from Oud to Wijdeveld dated August 2, 1925). Author compensations are also mentioned in the minutes of the A et A board of directors meeting on September 11, 1922. According to a letter from Wijdeveld to Mees dated July 19, 1925, authors received in addition ten regular and five deluxe copies.
45 Minutes of the A et A members meeting on October 24, 1917.
46 Proofs and designs can be found in diverse public collections. For example, Wijdeveld, de Klerk, Arthur Staal are found in the NAI, Roland Holst and Otto de Kat in the Rijks Print Collections, and van den Eijnde and others in the Drents Museum. The cover by Roland Holst for the mask number was offered for sale by the Haarlem art dealer de Bois for ƒ 6,50 around 1923.
47 See *Wendingen* 1-5.
48 *De Nieuwe Amsterdammer*, December 13, 1919.
49 *Bouwkundig Weekblad* (*Architectural Weekly*), October 8, 1921; May 3, 1924; July 12, 1924 and October 11, 1924.
50 *Bouwkundig Weekblad* (*Architectural Weekly*), August 16, 1924.
51 *Bouwkundig Weekblad* (*Architectural Weekly*), November 3, 1923.
52 Undated clipping in the Mea Verwey Archive, University Library Amsterdam.

Jan Sluyters 1918,
cover design 1-9

Jan Sluyters 1919,
cover design 2-3
(dance)

Herman Finsterlin 1924,
"Architektonische Liebe"
cover design 6-3

ill. 4 t/m 8 J. Zietsma
1932, cover designs
12-11/12

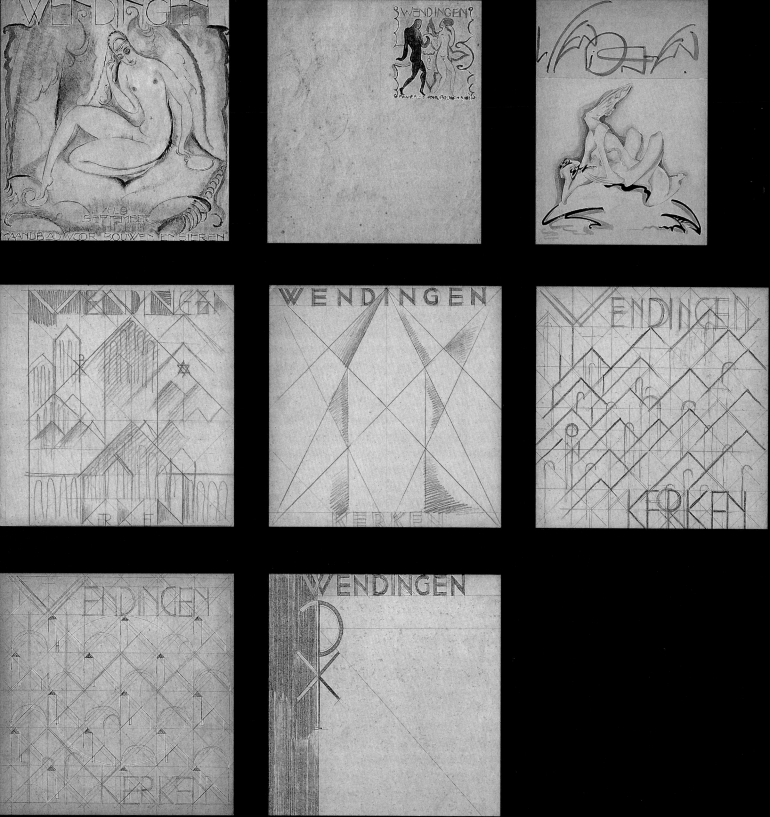

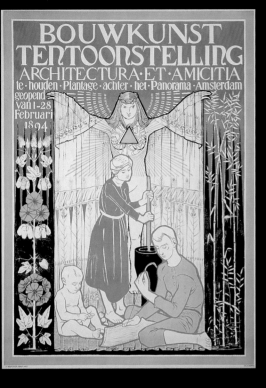

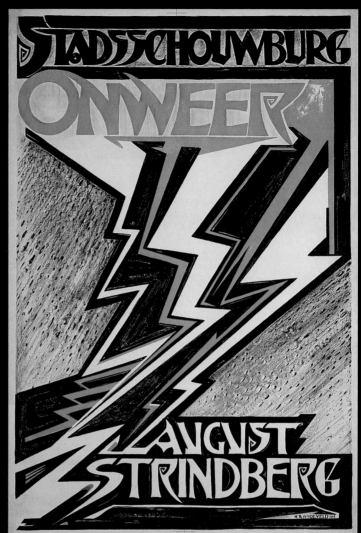

53 Minutes of the A et A directors and editorial board meeting on July 3, 1925.
54 H. P. L. Wiessing "Bewegend Portret" (Moving Portrait), page 352.
55 Minutes of the A et A board of directors meeting on June 19, 1922.
56 See minutes of the A et A board of directors meeting September 11, 1922.
57 Minutes of the A et A board of directors meeting on August 27, 1924.
58 *Architectura* XXVI-10, March 4, 1922 and *Architectura* XXVII-17, April 28, 1923.
59 The publisher's financial problems, however, were discussed at the A et A board of directors meeting on April 29, 1921. Roland Holst also designed a poster stamp in support of the *Nieuwe Amsterdammer* (reproduced in *De Reclame* February 1924, p. 101).
60 At the A et A board of directors meeting on December 11, 1923, Wiessing personally introduced Mees as his successor.
61 Wiessing had good contacts in Russia due to a son who had immigrated to the Soviet Union.
62 See the 1921/22 *Wendingen* annual report in *Architectura* XXVII-17, April 28, 1923.
63 Letters dated respectively July 26 and August 2, 1922, Mea Verwey Archive, University Library Amsterdam.
64 As evident from postage stamps on postcards sent from Germany, Mea Verwey Archive, University Library Amsterdam.
65 Minutes, December 11, 1923.
66 Only the Toorop 1-(11/)12 and woodcut numbers were for sale as deluxe editions. In the catalogue published by Mees in 1926, deluxe numbers were offered for sale, probably as a result of Wiessing's bankruptcy.
67 Letter from Kramer to publisher C. A. Mees dated August 11, 1926.
68 Wijdeveld sent an English copy to Eileen Gray.
69 See *Architectura* XXVII-18, May 5, 1923.
70 Numbers from the de Klerk collection are in the Museum van het Boek (Book Museum) at The Hague. The Staal collection was bought by the writer at a de Zon auction in 1991.
71 The series is in the NAI. Letter from Mees to Wijdeveld dated May 23, 1925.
72 Minutes of the A et A board of directors meeting on December 11, 1923.
73 Conno Mees and Mea Verwey were both praeses of the "Leidse litteraire dispuut Litteris Sacrum," according to their daughter, Mrs. Mol-Verwey, August 2000.
74 See the 1921/22 *Wendingen* annual report in *Architectura* XXVII-17, April 28, 1923 and minutes of the A et A board of directors meeting on December 28, 1923.
75 Minutes of the A et A board of directors meeting on August 27, 1924.
76 Letter from Mea Verwey to Wijdeveld dated Santpoort, September 9, 1968, Mea Verwey Archive, University Library Amsterdam.
77 Mea Verwey Archive, University Library Amsterdam.
78 Minutes of the A et A board of directors meeting on January 5, 1925.
79 Minutes of the A et A directors and editorial board meeting on July 3, 1925.
80 Letter dated August 2, 1925.
81 Letter from the publisher Mees to van Anrooij, February 4, 1926.
82 Minutes of the A et A board of directors meeting on September 11, 1925.
83 Minutes of the A et A directors and editorial board meeting on March 24, 1926.
84 For example, see letter from publisher Mees to A et A dated April 23, 1928.
85 Minutes of the A et A board of directors meeting on April 19, 1927.
86 *Bouwkundig Weekblad Architectura* (Architectural Weekly Architectura), July 5, 1930.
87 Minutes of the A et A board of directors meeting on July 28, 1931.
88 Minutes of the A et A board of directors meeting on June 27, 1928.
89 Minutes of the A et A board of directors meeting on November 22, 1931; A.M. Cassandre, French poster designer.
90 Minutes of the A et A board of directors meeting on July 28, 1931.
91 Minutes of the A et A board of directors meeting on October 19, 1931.
92 Public sale in the upstairs section of the restaurant La Reserve, Rembrandtplein 44, conducted by the firm Wed. J. C. van Kesteren en Zoon together with the international rare book dealer, Menno Herzberger, Broker, G. Theod. Bom.
93 Roebert bought remainders of numbers 2-2, 2-6, 2-11, 2-12, 3-11 and 5-11/12. The stamp is still in the family (information from Roebert Jr., July 2000).
94 For example, see the complaint list in *Architectura* XXVII-6, February 10, 1923.
95 Letter from publisher Mees to Wijdeveld dated February 18, 1925.
96 Conveyed verbally to the writer, July 2000.
97 Letter from Verkade to Wijdeveld dated September 29, 1920.
98 List in Mea Verwey Archive, University Library Amsterdam.
99 Letter from Mea Mees-Verwey to Wijdeveld dated February 11, 1925.
100 As Wijdeveld recollected in a radio broadcast on June 1, 1966, the text of which can be found in the Mea Verwey Archive, University Library Amsterdam. The letter to Le Corbusier is in the Wijdeveld Archive NAI.
101 Letter from Wijdeveld to Jan Wils dated August 20, 1924.
102 The Tiranti Archives were taken over by the London Art Bookshop, 8 Holland Street, London, which was discontinued around 1990. For the subscriptions in Spain see letter from publisher Mees to A et A dated 4 December 1926.
103 Letter from publisher Mees to Wijdeveld dated July 25, 1925.
104 Letters from and to Mrs. Coonley dated September 16 and 18 and November 30, 1953 (Mea Verwey Archive, University Library Amsterdam).
105 Letter to A. J. Hilgersom, Santpoort, June 6, 1962.
106 Exhibition from November 4 through December 9, 1966 arranged on the initiative of Emile de Vries, a Bührmann employee (1923, lives in Bussum).
107 *Bouwkundig Weekblad* (Architectural Weekly) 19, 83rd volume, September 24, 1965.
108 *Forum* XXV, no. 1.
109 Among others, see letter to Jan Wils (Christmas 1968) in the Wijdeveld Archive NAI.
110 Conveyed verbally by Earl M. Coleman to the writer in the summer of 1996. Coleman's *Wendingen* Archives were since acquired by the writer.
111 Palazzo Medici-Riccardi, April 3–June 5, 1982.
112 Publication of Franco Maria Ricci, Milano, isbn 88-216-0113-7.
113 Museum Künstlerkolonie, Darmstadt, October 10–November 9, 1992.
114 In cooperation with rare book dealer John Vloemans in the Museum Gallery Azië. Catalogue edited by Peter van der Toorn Vrijthoff.

Year or Series[1] + Subscription Price

 1 1918, advance subscription ƒ 12,–[2], afterwards ƒ 15,–[3] (beginning August 1918:
 ƒ 15,– + ƒ 5,– for the academy number + 50% war surcharge).[4]
 2 1919, January: ƒ 22.50 (ƒ 15,– + 50% war surcharge). Beginning September:
 ƒ 22,50. Between November 1917 and August 1919 printers wages increased by 55%.[5]
 3 1920: ƒ 30,–
 4 1921 (21/22), ƒ 35,–; £ 3 (beginning 4-11: £ 2.10); $ 10.—; RM 300,–[6]
 5 1923
 6 1924, ƒ 35,–
 7 1925 (25/26), ƒ 35,–
 8 1927 (27/28), d: ƒ 35,–; D: ƒ 45,–[7]
 9 1928 (28/29), d: ƒ 35,–[8]; D: ƒ 45,–
10 1929 (29/30), d: ƒ 35,–[9], D: ƒ 45,–
11 1930 (30/31)
12 1931 (1932)

Publication Versions

Cover details are coded as follows:

The original *Wendingen* numbering is retained whenever possible. The first number refers to the series or year and the second number to the month of the publication. As *Wendingen* often appeared late, the reference to the series and month usually does not coincide with the actual date of publication. Estimated dates are indicated by "ca." [10] The number code is followed by a letter to designate different versions of a single number. The letters d, e, f and g refer respectively to the Dutch, English, French, and German publications. As there were also deluxe editions printed on finer art paper beginning with 1-(11/)12, the lower case letter denotes the regular subscription and the upper case letter the deluxe edition. Starting with the third volume some of deluxe editions, and starting with the fourth volume all of deluxe editions, were published in hardcover. These editions differ from later hardbound numbers through the use of artist quality paper and through the fact that the covers are folded over the borders toward the center margins. In addition, deluxe numbers beginning with 4-4/5, unless otherwise noted, have special end papers designed by Wijdeveld. Exceptional numbers are indicated by X.

Separate enclosures are numbered beginning with 1 preceded by the code of the number in which the enclosure appears. When a given appears obvious, but cannot be proven by the writer, it is indicated by the addition of (?). The writer is unaware of information that is mentioned in some other issues, but is missing elsewere. Therefore, 4-7/8.*E* is the English publication of the double number for July/August of the fourth series or the 1921 volume in the hardbound deluxe edition.

Minimum estimates of editions from the beginning of each year: [11]

 1 650 (technical enclosure: 500), of which 500 are for members of A et A [12]
 2 1000 (technical enclosure: 550), of which ca. 550 (+ 100 extra) are for members of A et A [13]
 3 1100 (announcements: 600), of which ca. 600 (+ 100 extra) are for members of A et A
 4 2400 + (1200 Dutch + 600 English + 600 German) of which ca. 650 (+ 100 extra) are for members
 of A et A
 5 1700 (1200 Dutch + 500 English through 5-4), of which ca. 600 (+ 100 extra) are for members of
 A et A
 6 1200, of which 552 are for members of A et A
 7 1250, of which 540 are for members of A et A

8 1300, of which ca. 450 are for members of A et A
9 1100, of which 410 are for members of A et A
10 1050, of which 397 are for members of A et A
11 1000, of which 368 are for members of A et A
12 950 (through 12-4) afterwards 775 or less, of which 335 are for members of A et A [14]

Editing of Technical Enclosures / Announcements

1-1 through 1-5: W. J. M. van de Wijnperse
1-6 through 2-12: H. Th. Wijdeveld
3-1 through 3-10: J. F. Staal

Editorial Board

1-1: J. Gratama (chairman), H. van Anrooy, C. J. Blaauw, P. H. Endt, P. L. Kramer, E. J. Kuipers,
J. L. M. Lauweriks, R. N. Roland Holst, H. Th. Wijdeveld (editor-secretary)
1-2 through 1-12: J. Gratama (chairman), H. van Anrooy, C. J. Blaauw, P. H. Endt, P. L. Kramer, E. J.
Kuipers, J. L. M. Lauweriks, R. N. Roland Holst, M. J. Granpré Molière, H. Th. Wijdeveld (editor-secretary)
2-1: H. Th. Wijdeveld (chief editor), C. J. Blaauw, P. H. Endt, H. A. van den Eijnde, P. L. Kramer,
J. L. M. Lauweriks, R. N. Roland Holst, M. J. Granpré Molière, J. B. van Loghem
2-2. through 2-12: H. Th. Wijdeveld (chief editor), C. J. Blaauw, P. H. Endt, H. A. van den Eijnde,
P. L. Kramer, J. L. M. Lauweriks, R. N. Roland Holst, J. B. van Loghem
3-1. and 3-2: H. Th. Wijdeveld (chief editor), H. A. van den Eijnde, P. L. Kramer, J. L. M. Lauweriks,
R. N. Roland Holst, J. B. van Loghem, J. G. Boterenbrood, M. de Klerk
3-3/4 through 6-1: H. Th. Wijdeveld (chief editor), H. A. van den Eijnde, P. L. Kramer, J. L. M. Lauweriks,
R. N. Roland Holst, J. B. van Loghem, J. G. Boterenbrood, J. F. Staal
6-2 through 6-11/12: H. Th. Wijdeveld (chief editor), H. A. van den Eijnde, P. L. Kramer, J. L. M.
Lauweriks, R. N. Roland Holst, J. B. van Loghem, J. G. Boterenbrood, J. F. Staal, H. van Anrooy,
E. Kuipers [15]
7-1 through 7-11/12: H. A. van den Eijnde, P. L. Kramer, J. L. M. Lauweriks, R. N. Roland Holst, J. B. van
Loghem, J. G. Boterenbrood, J. F. Staal, H. van Anrooy, E. Kuipers, H. Th. Wijdeveld
8-1 through 12-11/12: C. J. Blaauw, W. M. Dudok, Hildo Krop, J. F. Staal, P. Vorkink, H. C. Verkruijsen

Publisher

1-1.d through 5-11/12.d: Uitgevers-maatschappij de Hooge Brug, Amsterdam (the last number was
actually already published by C. A. Mees)
4-1/2.*e* through 5-4.*e*: Cecil Palmer, Oakley House, 14, 16, and 18 Bloomsbury Street, London W.C.1. [16]
4-1/2.*g* through 4-6.*g*: Folkwang-Verlag G.m.b.H., Hagen i.W.
6-1.d through 12-11/12: C. A. Mees, Santpoort with distribution in Belgium via de Sikkel in Antwerp

Printer

1-1 through 3-11/12: N.V. Electrische Drukkerij Volharding, Amsterdam
4-1 through 4-12: A. Wohlfeld, Magdeburg, Germany
5-1 through 5-7: N.V. Electrische Drukkerij Volharding, Amsterdam
5-8/9 and 5-10: N.V. Drukkersbedrijf Volharding and de Nieuwe Tijd, Amsterdam
5-11/12 through 6-2: Gerhard Stalling Aktien-Gesellschaft, Oldenburg i.O., Germany
6-3 through 7-11/12: Firma Joh. Enschedé en Zonen, Haarlem
8-1 through 12-11/12: N.V. Ipenbuur en Van Seldam, Amsterdam

Published January 1918
Wendingen by H. Th. Wijdeveld.
*Work from the Buildings Depart-
ment of the Public Works Service,
Amsterdam* by A. R. Hulshoff
with eight illustrations.
C. A. Lion Cachet by J. F. Staal
with four illustrations *The New
Art of Painting* by H. C. Verkruy-
sen. Two woodcuts by Anne
Krizmany. Three illustrations
of J. M. van der Mey's project
Roei- en Zeilvereeniging
De Hoop (Rowing and Sailing
Society *The Hope*). P. 1–18 text,
p. 19–20 advertisements.

Cover Lithograph by J. L. M.
Lauweriks
Publication version *d*
Edition 650
Price *f* 1,75 [17]
Enclosure *d.* 1 (Technical Sec-
tion: January 1918, p. 1–4 +
four p. advertisements)
Special characteristics Reproduced
is the exceptionally rare cover
in green, pink, and brown. The
color brown is usually missing.
Because of a paper shortage
caused by the war situation in
Europe, the editors found it
necessary to have the illustra-
tions pasted in separately. [18]
Illustrated *d*

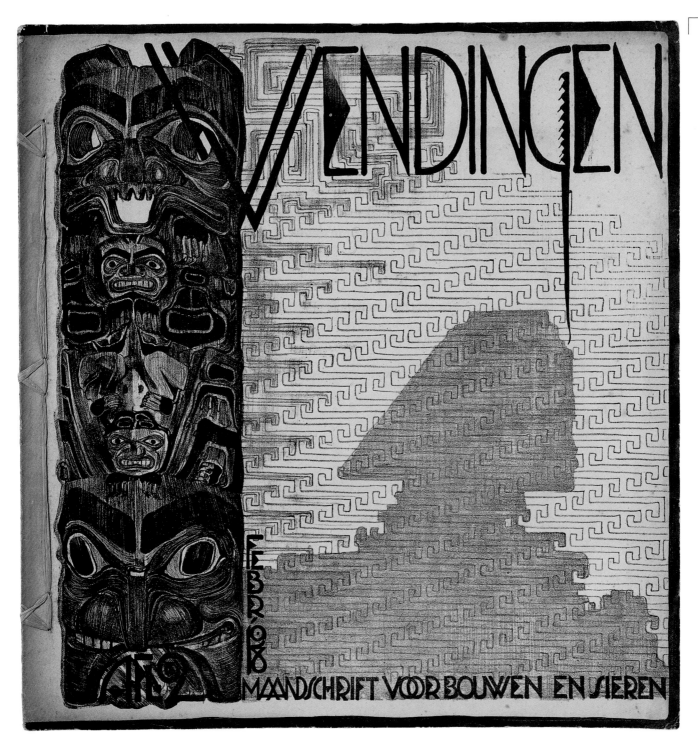

Published 20 February 1918
Competition for the National Academy of Fine Arts (Rijksacademie van Beeldende Kunsten) Building in Amsterdam. The Sculpture of H. A. van den Eynde by J. B. van Loghem with seven illustrations. *The Recent Mobility of Architecture* by C. J. Blaauw. *The New Art of Painting* by H. C. Verkruysen (continued). *Gustave Klimt* by H. Th. Wijdeveld with four illustrations. Eleven illustrations of non-executed plans for the Dutch Margarine factory office project by J. F. Staal. *Aphorisms* by Gustave le Bon. Illustration: clock by M. de Klerk. P. 1–16 text, p. 17–18 advertisements.

Cover Lithograph by M. de Klerk
Publication version *d*
Edition Ca. 650
Price *f* 1,75
Enclosure *d.* 1 (Technical Section: 20 February 1918, p. 5–8 + four p. advertisements)
Illustrated *d*

1-3 March 1918

Published 20 March 1918
Architecture and Society by
J. M. van der Mey. *Community
Art and Individualism* by
J. L. M. Lauweriks. *A New
Work by Mendes da Costa* by
Albert Verwey with four
illustrations. *Jessurun de
Mesquita* by J. Greshoff with
two drawing reproductions
and two woodcuts. Eleven
illustrations and floorplans
of country houses. *Concerning
Rationalism in Furniture Design*
by P. H. Endt. Embroidery in
stalk stitch with one illustra-
tion. P. 1–16 text, p. 17–20
advertisements

Cover Woodcut by Hildo Krop
Publication version *d*
Edition Ca. 650
Price *f* 1,75
Enclosure *d. 1* (Technical Sec-
tion: 20 March 1918, p. 9–14
+ four p. advertisements)
Illustrated *d*

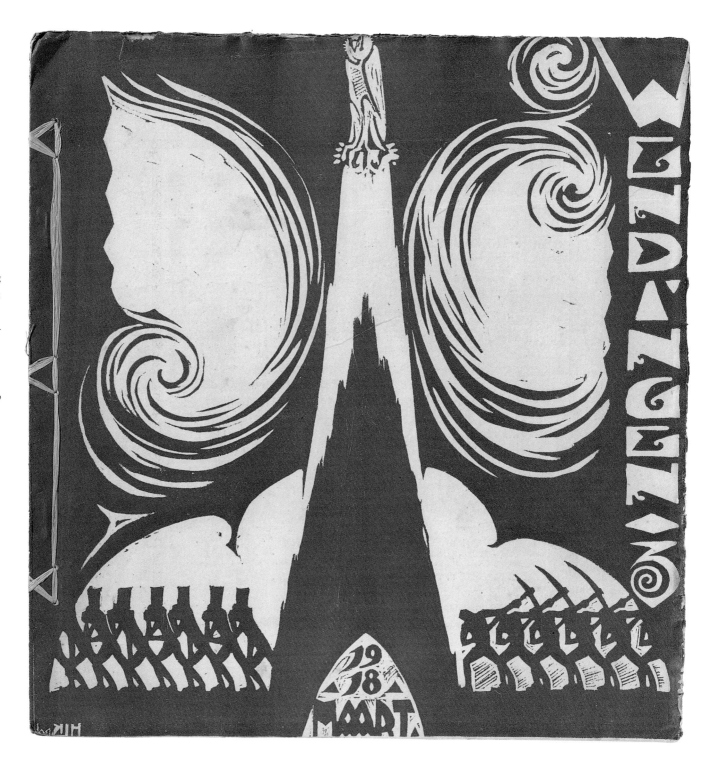

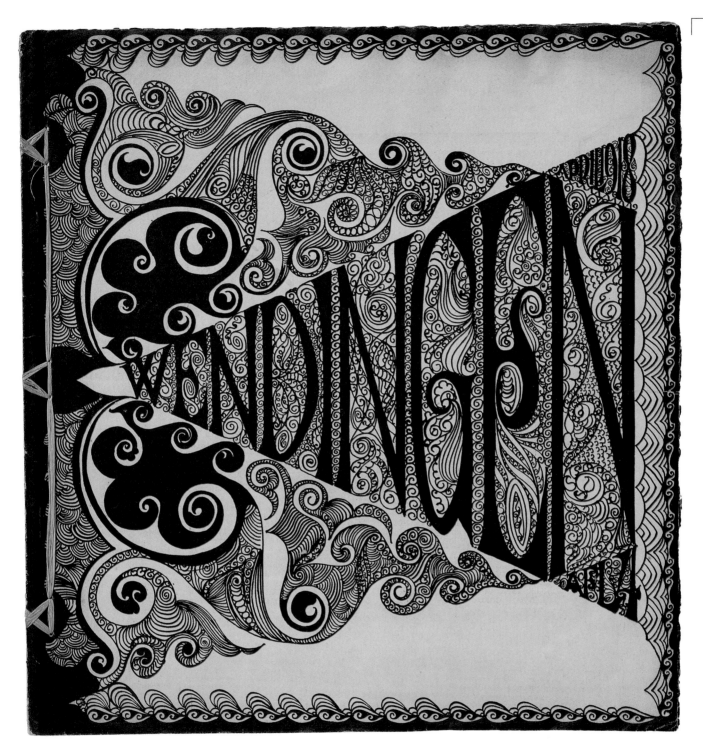

Published 20 April 1918
Contemplations on the Faust Performance by H. Th. Wijdeveld
with eight illustrations. *Dissension in Contemporary Art* by
M. J. Granpré Molière. *Kandinsky* by Jan Gratama with four
illustrations. *Indian Wickerwork* by A. J. Kropholler. Etching by Frank Brangwyn; four
illustrations of a Heemstede
country house designed by
H. Th. Wijdeveld. Double
manor house by the architect
G. F. Rutgers. P. 1–16 text,
p. 17–22 advertisements.

Cover Lithograph by
C. J. Blaauw
Publication version *d*
Edition Ca. 650
Enclosure *d.* 1 (Technical Section: 20 April 1918, p. 15–18
+ four p. advertisements)
Illustrated *d*

1-5 May 1918

Published 30 May 1918

The Construction of the Second Dutch Trade Fair by J. de Bie Leuveling Tjeenk with twelf illustrations. *Architecture and Society* II, by J. M. van der Mey. *The Murals of Frank Brangwyn* by R. N. Roland Holst. *Dr. Berlage's Office Building in London* by A. J. Kropholler with three illustrations. *Unity in Future Art* by J. B. van Loghem. *Ivar Arosenius* by Otto van Tussenbroek with two illustrations. *Occasionally Wendingen* by J. F. Staal. Poster for the Concertgebouw Sextet by Jan Sluyters. Exhibition for the 1914 *Werkbund-exhibition* at Cologne: hall for antique art by J. L. M. Lauweriks (Two illustrations); *Exhibition of Christian art at Dusseldorf:* exhibition space by Lauweriks (Two illustrations). P. 1–18 text, p. 19–24 advertisements.

Cover Lithograph by
R. N. Roland Holst
Publication version *d*
Edition Ca. 650
Enclosure *d.* 1 (Technical Section: 30 May 1918, p. 19–22 + four p. advertisements)
Special characteristics The cover produced a commentary from Wijdeveld.[19] Fanelli pointed out the evident Masonic symbolism in his cover design.[20]
Illustrated *d*

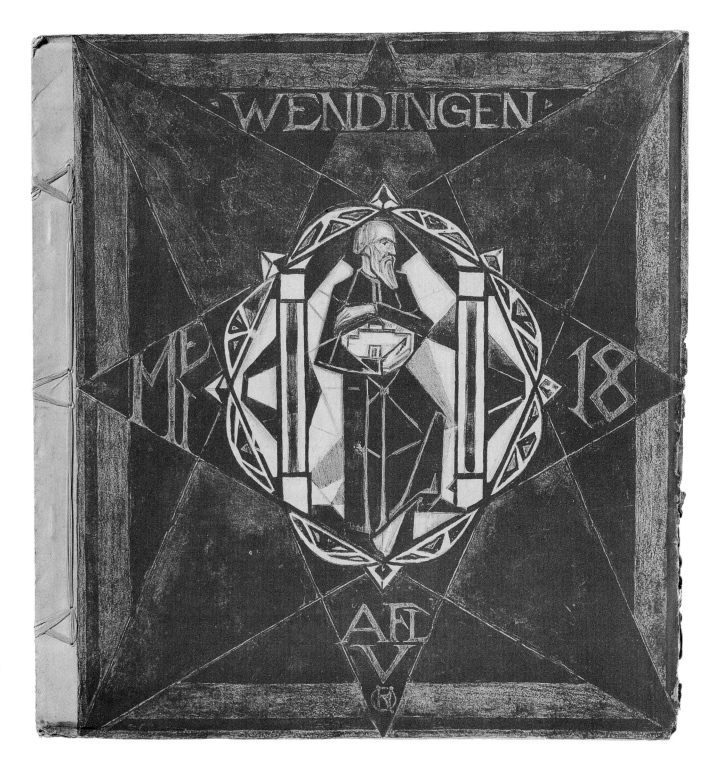

Published June 30 1918
Impressions of an Exhibition by
J. L. M. Lauweriks. *The mobility
of Architecture: Community Art
and Individualism* by C. J.
Blaauw. *The Art of Sculpture* by
Jan Wils with two illustra-
tions. *The Construction of the
Public Reading Hall* at Heerlen
by J. M. van Hardeveld (Four
illustrations). Fireplace piece
by Roland Holst, reliefs in
sandstone by Ms. H. Wille-
beek le Mair (Two illustra-
tions), three tapestries by
Jaap Gidding, embroidery
(Three illustrations) by Chr.
T. S. van Zeegen; etiquettes
(Five illustrations) by O. van
Tussenbroek; armchair, buf-
fet, and table by Hildo Krop.
P. 1–16 text, p. 17–22 adver-
tisements.

Cover Lithograph by Aart van
Dobbenburgh after a design
by H. A. van Anrooy
Publication version *d*
Edition Ca. 650
Price *f* 2,50
Enclosure *d*. 1 (Technical Sec-
tion: 30 June 1918, p. 23–26
+ four p. advertisements)
Illustrated *d*

WENDINGEN ___ MAANDBLAD
VOOR BOUWEN EN SIEREN _ VAN
ARCHITECTURA ET AMICITIA
REDACTIE: J. GRATAMA „VOORZ.
H.A.VAN ANROOY _ C.J. BLAAUW
J.L.M. LAUWERIKS _ E.J. KUIPERS
R.N. ROLAND HOLST _ P.J. KRAMER
M.J. GRANPRÉ MOLIÈRE _ P.H. ENDT
RED: SECR: H.TH. WIJDEVELD
VOSSIUSSTRAAT 50 A'DAM
JAARGANG 1 No 6 JUNI '18

v. A N R O O Y

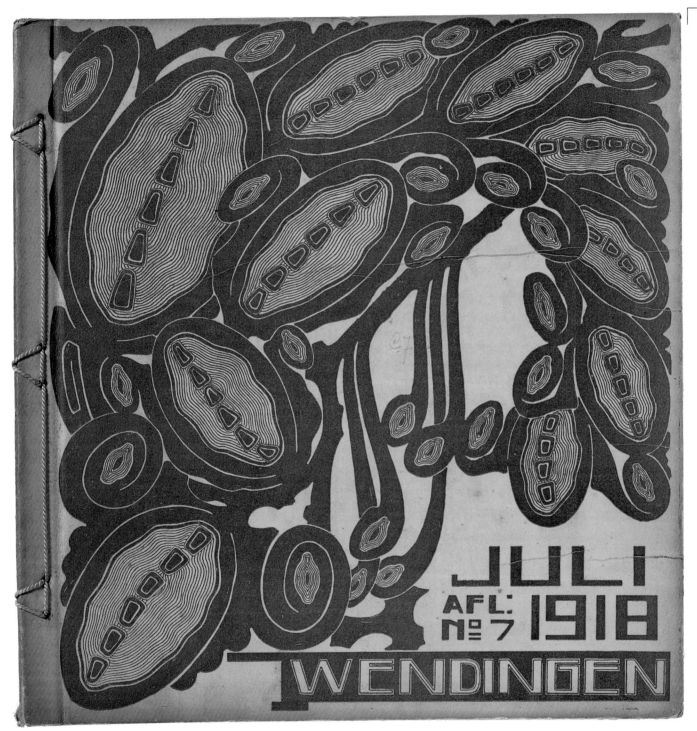

Published July 30 1918 *Amsterdam School* by P. H. Endt. *About Furniture Design* by H. F. E. Visser. *Artistic Flowers* by H. A. van Anrooy. *The Arts and Crafts School Quellinus, Exhibition of Student Work* by H. Th. Wijdeveld with seven illustrations. *Occasionally Wendingen* by M. J. Granpré Molière. Bridges designs for the *Amsterdam-South* expansion plans, Public Works, Bridge Section: engineer: W. A. de Graaf; architect: P. L. Kramer, with fifteen illustrations. P. 1–14 text, p. 17–20 advertisements.

Cover Lithograph by E. J. Kuipers
Publication version *d*
Edition Ca. 700
Price *f* 2,50
Enclosure *d.* 1 (Technical Section: 30 July 1918, p. 27–30 + four p. advertisements)
Illustrated *d* (in 1923 hard bound edition)

1-8 1918
**Meerwijk Park at
Bergen**

Published August 30 1918
*The Meerwijk Park at Bergen-
Binnen* by H. Th. Wijdeveld.
Plan of the park. Beukenhoek
House, architect, Ms. M.
Kropholler, (Two illustra-
tions). The Ark House (Three
illustrations). Three country
houses (Two illustrations),
the Bark House (Two illustra-
tions), architect J. F. Staal;
Meerhoek House (Three illus-
trations), Boschkant House
(Three illustrations), Beek
and Bosch House (Three illus-
trations), architect C. J.
Blaauw. Double residence
(Four illustrations), architect
G. F. la Croix. Tamalone
House, Mevena and Rogier
(Eight illustrations). The
Tyltyl Cottage (Two illustra-
tions), architect P. L. Kramer.
P. 1–20 text, p. 21–26 adver-
tisements.

Cover Lithograph by C. A.
Lion Cachet
Publication version *d*
Edition Ca. 700
Price *f* 2,50 + 50% war sur-
charge
Enclosures *d*. 1 (Technical Sec-
tion: 30 August 1918, p.
31–34 + four p. advertise-
ments)
d. 2 (exclusively in copies for
subscribers): letter from the
publisher dated August 1918
announcing the 50% war sur-
charge on the subscription
price for the second half of
1918.
Illustrated *d*

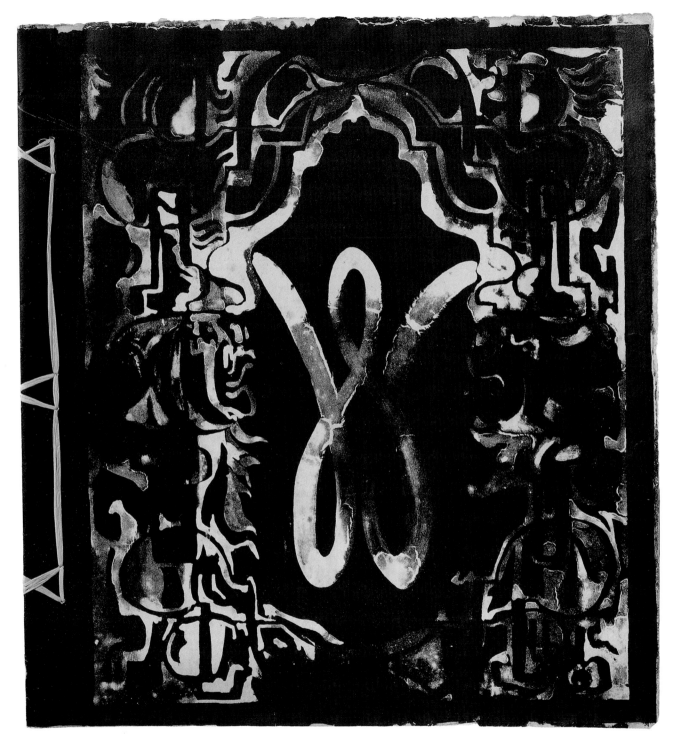

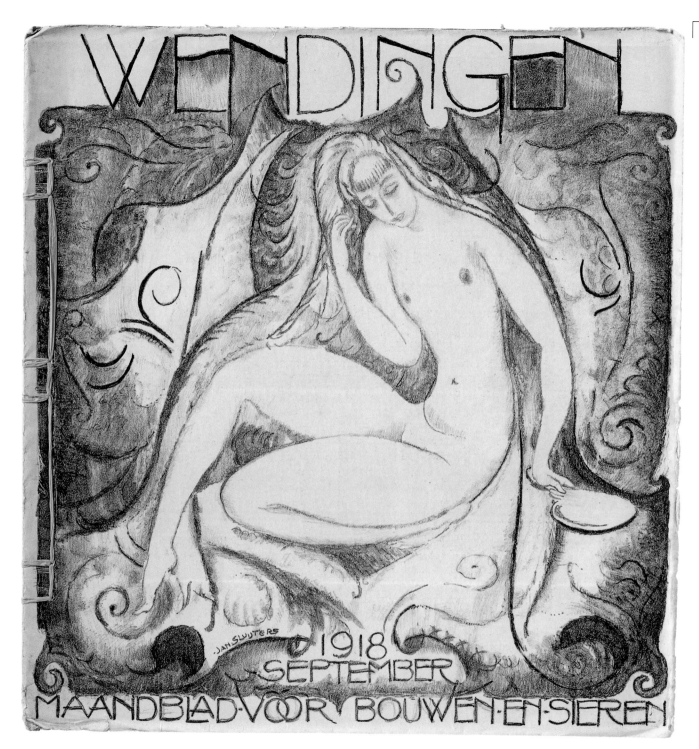

1-9 1918
Sculpture Art

Published September 30 1918
Ivan Mestrovitsj, by Jan
Borginon, with nine illustra-
tions. *Art and the Public* by
M. J. Granpré Molière. *Con-
cerning Public Gardens in Cities*
by B. C. van den Steenhoven.
Aphorisms by Oscar Wilde.
Occasionally Wendingen by
J. F. Staal. Twenty-one illus-
trations of sculpture and
carving by Jules Vermeire,
Hildo Krop and H. A. van den
Eijnde. P. 1–14 text, p. 15–20
advertisements.

Cover Lithograph by
Jan Sluyters
Publication version *d*
Edition Ca. 750
Price *f* 2,50 + 50% war
surcharge
Enclosure *d.* 1 (Technical Sec-
tion: 30 September 1918,
p. 35–38 + four p. advertise-
ments)
Illustrated *d*

1·10 1918
Country Houses

Published October 30 1918
Architecture and Society, by
J. J. van der Mey. *Two Leading
Trends* by J. L. M. Lauweriks.
*Housing Council and Architects
List* by X.IJ.Z. *Concerning
Postage Stamps* by E. J. Kuipers
with twenty-six illustrations.
Occasionally Wendingen by
J. F. Staal. *Amsterdam Shop
Buildings* by G. F. la Croix
(Two illustrations). Eleven
illustrations of country
houses by A. H. Wegerif Gz.,
J. Rodenburgh, H. F. Sijmons,
Heineke and Kuypers. P. 1–16
text, p. 17–22 advertisements.

Cover Lithograph by
S. Jessurun de Mesquita
Publication version *d*
Edition Ca. 750
Price *ƒ* 2,50 + 50% war sur-
charge
Enclosure *d.* 1 (Technical
section: 30 October 1918,
p. 39–42 + four p. advertise-
ments)
Illustrated *d*

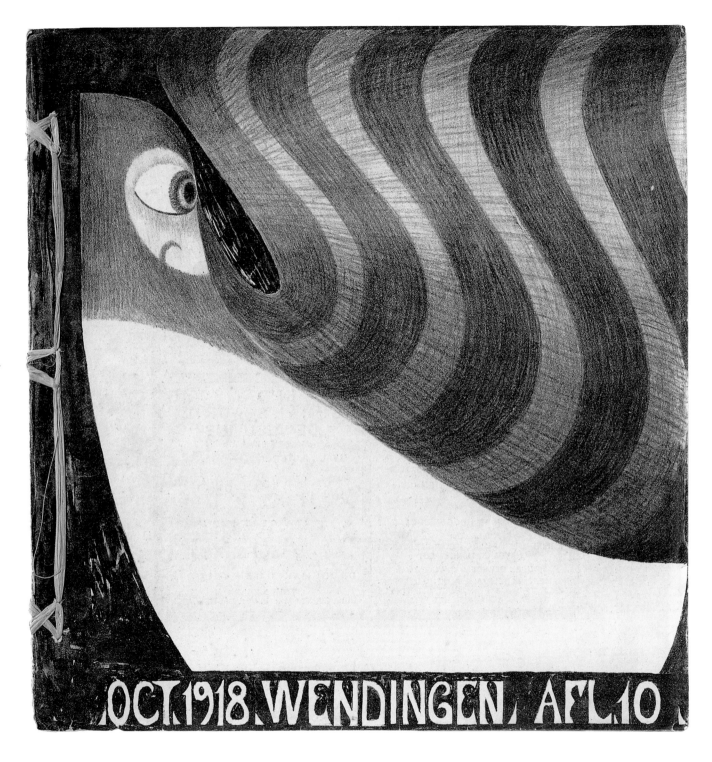

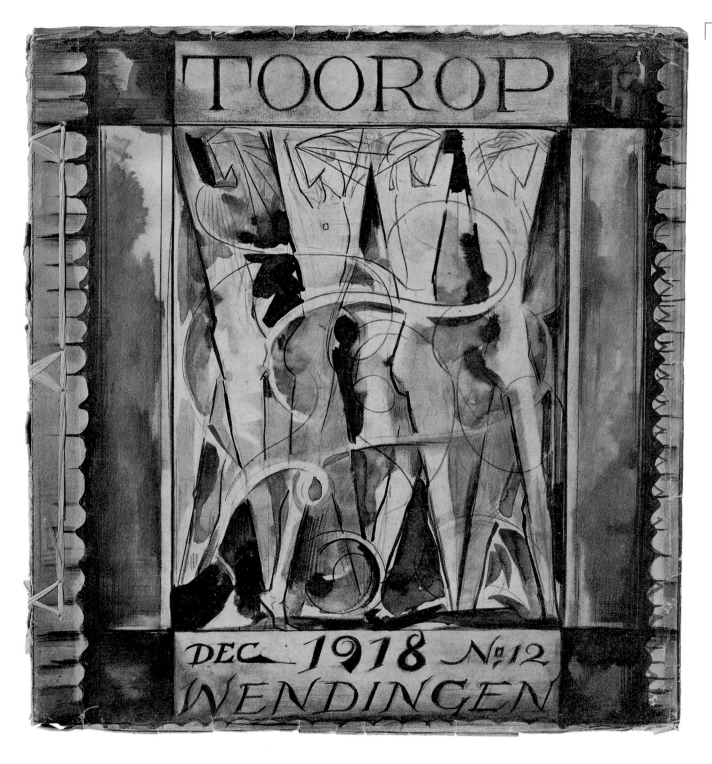

Toorop

Published Ca. December 1 1918
Toorop's Spiritualization by B. H.
Molkenboer O.P. *New Paths and
Old Acknowledgments* by Prof.
R. N. Roland Holst. *On Toorop* by
Albert Verwey. *Toorop's Monu-
mental Art* by Dr. H. P. Berlage.
From the Youth of Jan Toorop by
Dr. Jan Veth. *A Youth* by J. de
Meester. *Jan Toorop* by Prof. A. J.
Derkinderen. *Deposition from the
Cross* by Dr. P. C. Boutens. *Jan
Toorop, A Brief Characterization* by
Albert Plasschaert. *Toorop* by Dr
Gerard Brom. Sixty-five illustra-
tions after works of the painter
Toorop, including a youth por-
trait and a portrait of the mas-
ter by M. de Klerk. P. 1–42 text,
p. 43–48 advertisements.

Cover Lithograph by Willem
van Konijnenburg
Publication versions *d*; *D*
Edition Ca. 1510 (*d*: ca. 1000;
D: ca. 510)
Price *d*: ƒ 10,–; *D*: ƒ 15,–;
D. 1/2/3 or 4: ƒ 7,50 extra[21]
Enclosures *d*. 1 (Technical Sec-
tion: December 1918, p. 43–45
+ five p. advertisements) *D*. 1
(etching by Jan Toorop: *Woods
with Pond and Swans*, 1897)[22] *D*.
2 (etching by Jan Toorop: *Sick
child*, 1898)[23] *D*. 3 (etching by
Jan Toorop: *Net Menders*, 1899)
D. 4 (etching by Jan Toorop: *The
Shell Fisher*, ca. 1902)[24]
Special characteristics Published
on the occasion of Toorop's
Sixtieth birthday. *D* is num-
bered, signed by Jan Toorop
and not hardbound.[25]
Illustrated *d*

Published January 1919[26]
Tibetan Temple Paintings by
W. J. C. van Meurs with thir-
teen reproductions: *Concern-
ing Persian pottery* by C. A.
Lion Cachet with ten repro-
ductions. *The Art of the Ancient
East* by H. C. Verkruysen with
eight illustrations. P. 1–22
text, p. 23–28 advertisements.

Cover Lithograph after a
design by K. P. C. de Bazel
Publication versions *d*; *D*
Edition Ca. 1000 (*d*: ca. 950;
D: ca. 50)
Price *d*: ƒ 2,50 + 50% war sur-
charge
Enclosures *d*. 1 (Technical Sec-
tion: II–1 January 1919, p.
1–6 + four p. advertisements)
d. 2 A notice from the pub-
lisher printed in gray on
square yellow paper: "Order
today the 1918 annual cover
for Wendingen." The annual
cover offered at ƒ 4, was
probably never published due
to a lack of interest. Also, see
the announcement on p. 22.
Special characteristics A reprint
of the text by W. J. G. van
Meurs with matching illus-
trations from numbers 2-1
and 2-2 appeared as a cata-
logue titled: *Tibetan temple
paintings exhibited in the Ams-
terdam Rijksmuseum (below in
the Drucker annex).* There is
no evidence of 2-1. *D* having
been published in hardcover.
Illustrated *d*

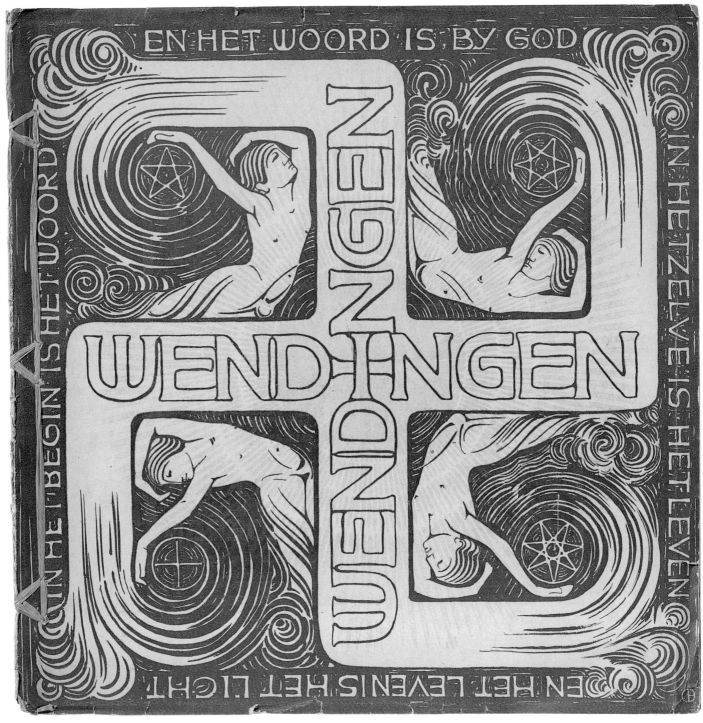

Published February 1919
*Our Times and the Work of
M. de Klerk* by K. P. C. de Bazel
with twenty-two illustrations
and eight floorplans of build-
ings by de Klerk. *Tibetan Tem-
ple Paintings* (conclusion) by
W. J. C. van Meurs. *Occasion-
ally Wendingen* by J. F. Staal.
P. 1–18 text, p. 19–24 adver-
tisements.

Cover Lithograph by Toon
Poggenbeek
Publication versions *d*; *D*
Edition Ca. 1000 (*d*: ca. 950;
D: ca. 50)
Price *d*: ƒ 3,75
Enclosures *d*. 1 (Technical
Section: II–2 February 1919,
p. 7–10 + four p. advertise-
ments)
Special characteristics see ad 2.1.
there is no evidence of *D* hav-
ing been published in hard-
cover.
Illustrated *D*

Published March 1919[28]
Modern Dance in the Lineup of the Arts by H. Th. Wijdeveld: *Dance and Theater of Java* by Soewardi Soeryaningrat. *The Javanese Art Evening in The Netherlands* by Soeryo Poetro. *Dances in Bali* by Dr. G. Krause. *The Productive Eye and the Grotesque Dance of Grit Hegesa* by Jaap Kool. *Some Dances of Gertrud Leistikow* by A. van Collem. Thirty illustrations of Javanese and European dance figures. P. 1–24 text, p. 25–30 advertisements.

Cover Lithograph by Jan Sluyters
Publication versions *d*; *D*
Edition Ca. 1000 (*d*: ca. 950; *D*: ca. 50)
Price *d*: ƒ 3,75
Enclosure *d*. 1 (Technical Section: II–3 March 1919, p. 11–14 + four p. advertisements)
Special characteristics There is no evidence of 2-3.*D* having been published in hardcover.
Illustrated *d*

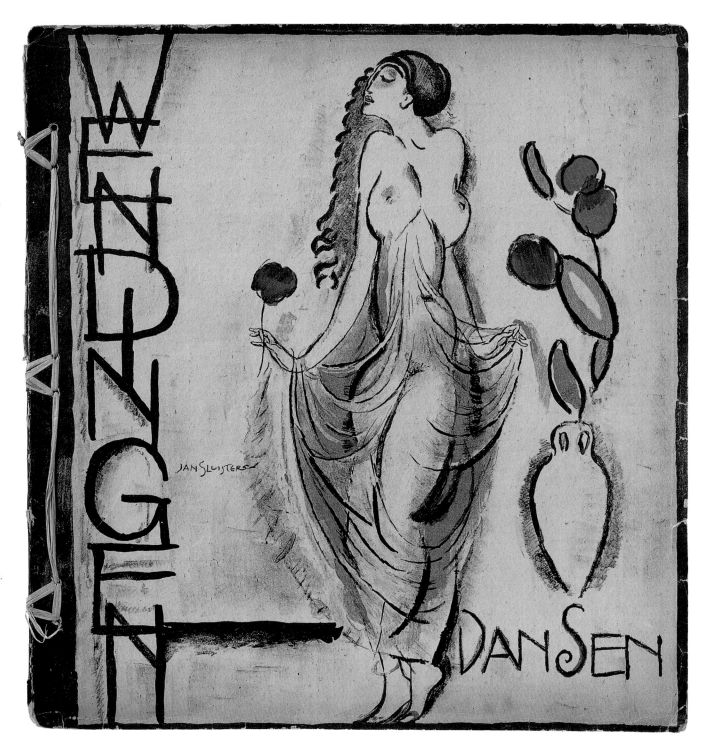

2·4 1919
Architecture

Published Ca. May 1919
The Titanic in Art by Lauw-
eriks. *What is Old Falls and
Turns Out to be Eternal* by J. B.
van Loghem. *The City Crown of
Bruno Taut* by J. F. Staal. Nine-
teen illustrations of build-
ings and designs by Lauw-
eriks, Luthmann, Wijdeveld,
de Groot and van Laren.
P. 1–16 text, p. 17–22 adver-
tisements.

Cover Lithograph by
Ms. Pauline Bolken
Publication versions *d*; *D*.
Edition Ca. 1000 (*d*: ca. 950;
D: ca. 50)
Price *d*: (*f* 5,–)
Enclosure *d*. 1 (Technical Sec-
tion: II–4 April 1919, p. 15–18
+ four p. advertisements)
Special characteristics *D* There is
no evidence of *D* having been
published in hardcover.
Illustrated *d*

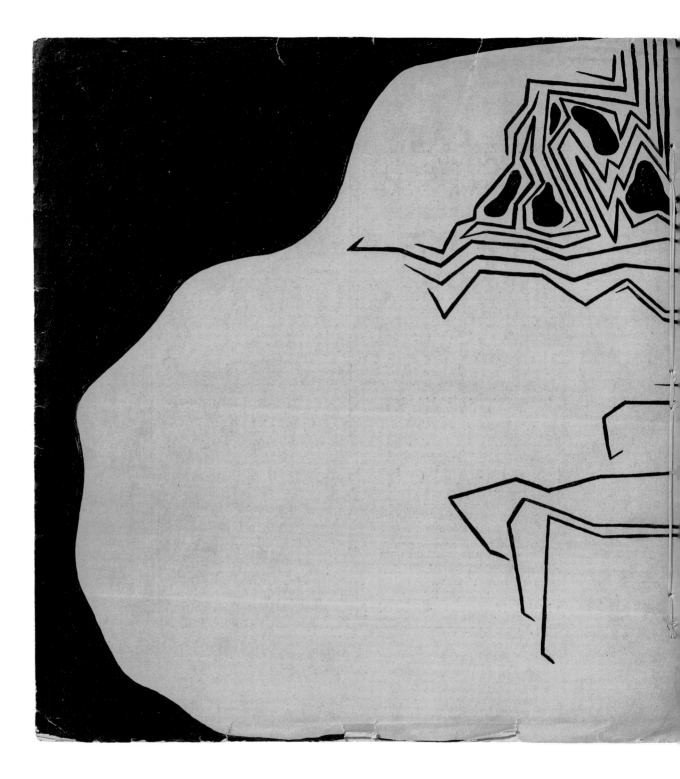

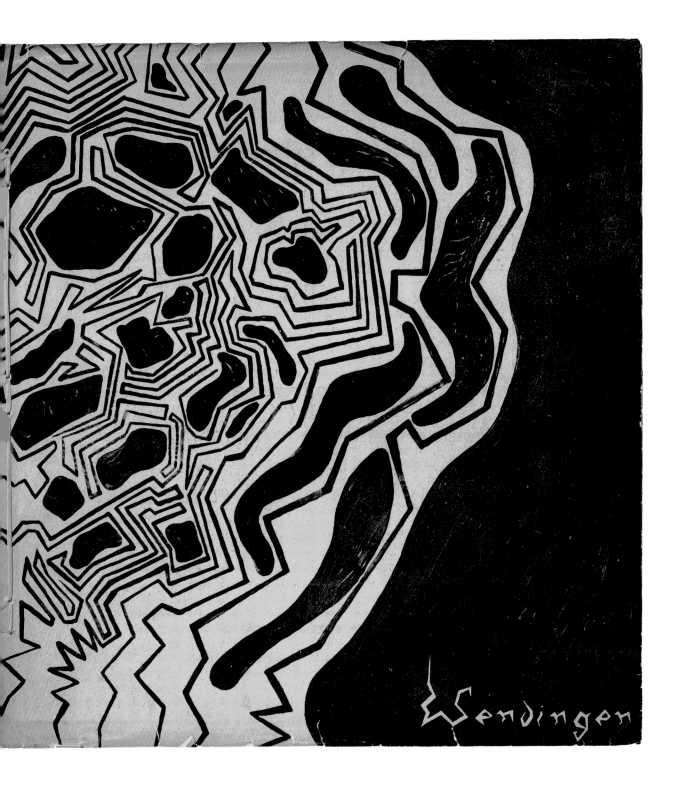

Wendingen

2-5 1919
Posters

Published July/August 1919[29]
*Modern Demands and Artistic
Objections* by R. N. Roland
Holst. *Old and New posters* by
P. H. Endt. *The Typographic
Poster* by L. Ronner. Thirty
poster reproductions by Jan
Toorop, R. N. Roland Holst,
Walter van Diedenhoven,
C. A. Lion Cachet, Chris
Lebeau, Jan Sluyters, M. de
Klerk, Leo Gestel, Willy
Sluiter, Albert Hahn, Matth.
Wiegman, H. Th. Wijdeveld,
G. F. la Croix and J. B.
Heukelom. P. 1–22 text,
p. 23–28 advertisements.

Cover Lithograph by J. B.
Heukelom
Publication versions *d*; *D*
Edition Ca. 1100 (*d*: ca. 1050;
D: ca. 50)
Price *d*: *f* 5,–
Enclosure *d*. 1 (Technical Sec-
tion: II–5 May 1919, p. 19–22
+ four p. advertisements)
Special characteristics There is
no evidence of *D* having been
published in hardcover.
Illustrated *d*

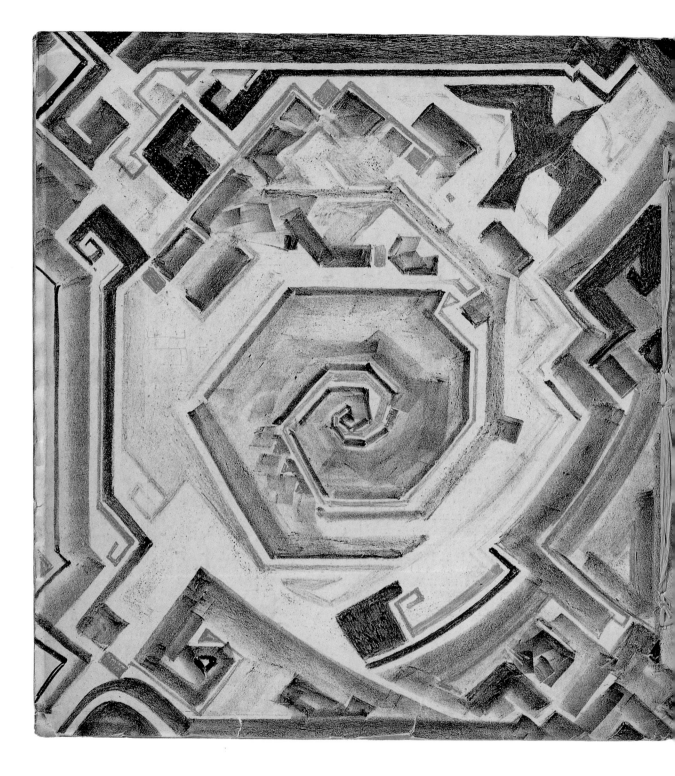

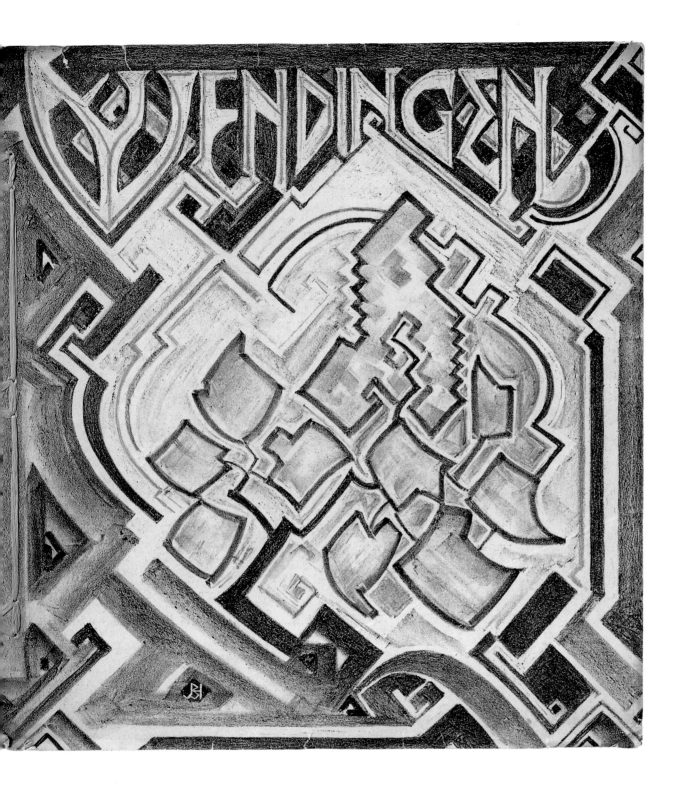

83

2-6 1919
Interiors and Furniture

Published September 1919 [30] *Koloman Moser* by J. L. M. Lauweriks. *The Voice of the New Time* by C. J. Blaauw. *Art of London* by Jan Poortenaar. *The New Time. Some thoughts on the Work of Frank Lloyd Wright* by Jan Wils. *Occasionally Wendingen* by H. A. van den Eynde. Twenty-nine illustrations of furniture by M. de Klerk, Hildo Krop, and P. Kramer; studies by H. Th. Wijdeveld; interiors of Frank Lloyd Wright, Eliel Saarinen, Sonck & Jung (Finland). P. 1–18 text, p. 19–24 advertisements.

Cover Lithograph by Johan Luger
Publication versions *d*; *D*
Edition Ca. 1000 (*d*: ca. 950; *D*: ca. 50)
Price *d*: ƒ 5,–
Enclosures *d*. 1 (Technical Section: II-6 June 1919 p. 23–26 + four p. advertisements) *d*. 2 A book mark (printed green on white) "with a message from the publisher" announcing the mailing of the woodcut number "within a few days."
Special characteristics There is no evidence of *D* having been published in hardcover.
Illustrated *d*

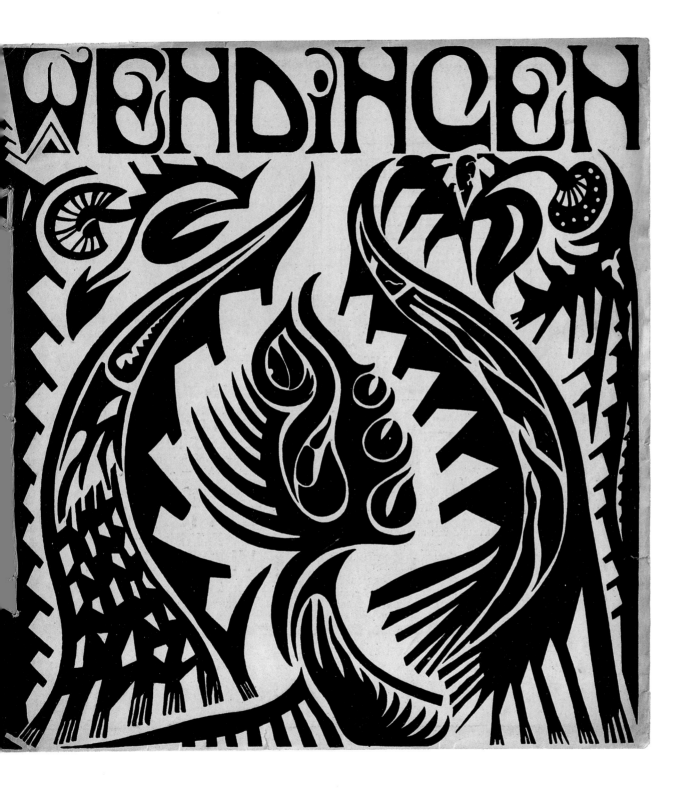

2-7/8 1919
Woodcuts

Published November 1919[31]
Introduction *On the Occasion of the Already 25 Year Old Woodcuts by De Bazel and Lauweriks* by R. N. Roland Holst.
A collection of roughly sixty original large woodcuts by the leading Dutch artists.
A complete overview of the Dutch woodcut including, among others, works by C. A. Lion Cachet, K. P. C. de Bazel, J. L. M. Lauweriks, B. Essers, J. Veldheer, N. Eekman, J. B. van Heukelom, Jac. Jongert, A. J. Grootens, W. O. J. Nieuwenkamp, Dirk Nijland, L. O. Wenkebach, Huib Luns, H. A. van der Stok, Hildo Krop, Joh. Polet, John Rädecker, Jan Mankes, S. Jessurun de Mesquita, Chris Lebeau, Joan Colette, L. Schwarz, J. Cantré, Elsa Berg, Gustav de Smet, Filarski, Erich Wichman, A. P. W. van Starrenburg, Kamp, G. P. L. Hilhorst, W. Wijnman, Daan de Vries.
P. 1–54 text and illustrations, p. 55–60 advertisements.

Cover Lithograph by R. N. Roland Holst
Publication versions *d*; *D*
Edition Ca. 2000 (*d*: ca. 1250; *D*: ca. 750)[32]
Price *d*: (*f* 10,–); *D*: *f* 17,50 by pre-subscription, *f* 20,– after publication.
Enclosures *d*. 1 (Technical Section: II–6 (sic) July–August 1919, p. 27–30 + four p. advertisements) *D*. 2: woodcut by

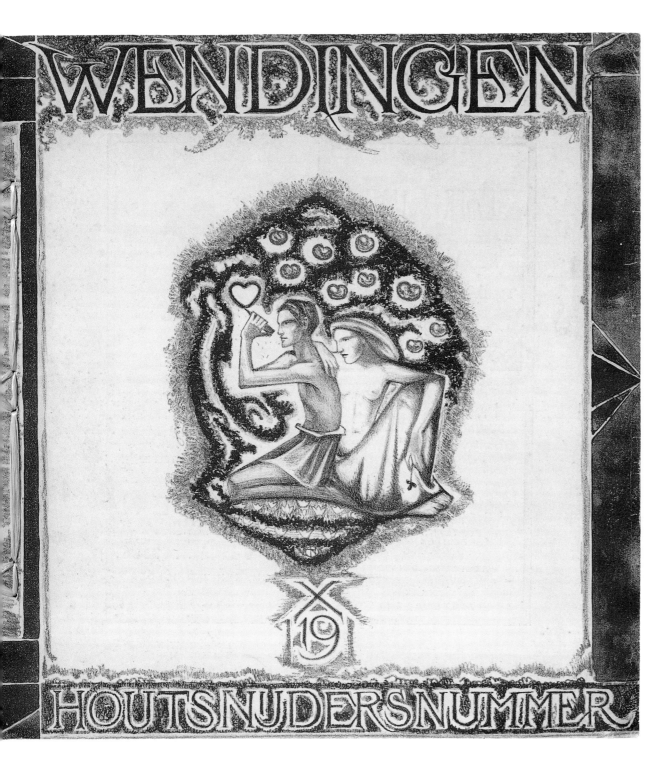

C. A. Lion Cachet folded in three sections: *Diploma for the International Exhibition for the Book Trade and Related Professions in Amsterdam, 1892,* format: 72 x 43.5 cm.

Special characteristics To strengthen the thin paper, these were folded around a stronger stock. There is no evidence of *D* having been published in hardcover. This is printed on Japanese silk paper[33] and differs in printing from *d* in that the ornaments on pages 5, 52, 53, and 54 of *D* are also printed on the back side (thus double). Further, with *D*, the lines on the side extend to the illustrations.

d; D. 2 is still printed on normal paper. According to a statement by Wijdeveld, many of the woodcuts were made especially for this number.[34] Also, there is mention of an English and German edition.[35]

Illustrated *d*

Published December 1919
Communism and the Theater by
Henriëtte Roland Holst-van
der Schalk. *The Great Popular
Theater* by H. Th. Wijdeveld.
Drama and the Dutch Theater by
Frans Coenen. *The Theater,
Some Thoughts* by Alb. Plass-
chaert. *The Magic of Movement*
by Herman Kloppers. *Theater
Memories from the United States*
by H. Laman Trip de Beau-
fort. Forty illustrations of
studies and scenery by E.
Gordon Craig, H. Th. Wijde-
veld, Frits Lensvelt, Sam.
Hume, Fr. Schumacher,
Alfred Roller, and R.
Teschner. P. 1–36 text,
p. 37–42 advertisements.

Cover Lithograph by Jan
Toorop[36]
Publication versions *d*; *D*
Edition Ca. 1150 (*d*: ca. 1100;
D: ca. 50)
Price *d*: ƒ 10,–
Enclosures *d*. 1 (Technical Sec-
tion: II–7 Sept.–Oct. 1919,
p. 31–32 + four p. advertise-
ments.
Special characteristics Between
pages nine and 10, Wijdeveld
uses for the first time an
illustration which is larger
than the page.[37] There is no
evidence of *D* having been
published in hardcover.
A copy exists with the cover
printed in black-and-white.[38]
Illustrated *d*

LITH.LANKHOUT DEN HAAG.

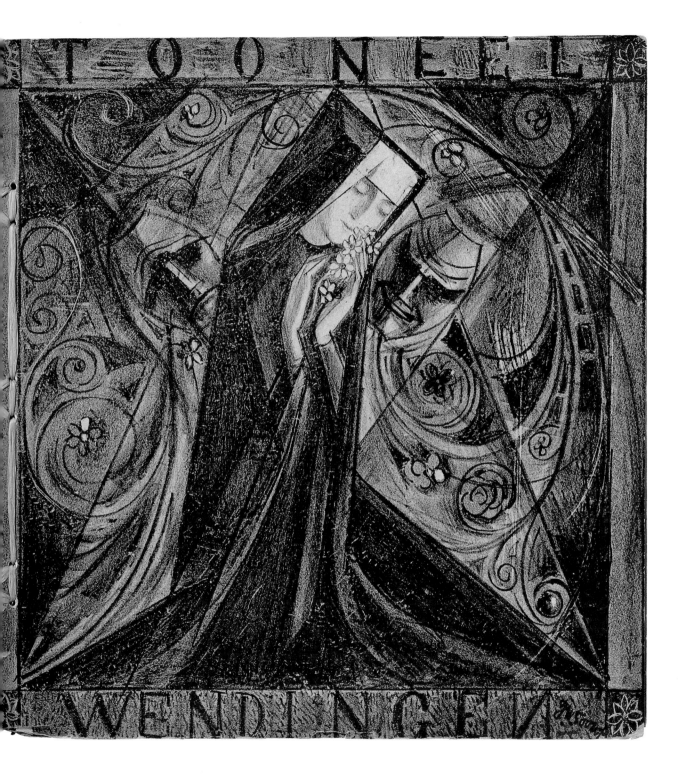

2-11 1919
Reinforced Concrete

Published January 1920
The Use of Reinforced Concrete
by A. Eibink. *Speech Delivered
on the Occasion of the Revival of
the "Werkbund"* by Hans
Poelzig. Twenty-seven illus-
trations of building designs
with floor-plans by Eibink &
Snellebrand and Hans
Poelzig (Dresden). P. 1–14
text, p. 15–20 advertise-
ments.

Cover Woodcut by Hildo Krop
Publication versions *d*; *D*
Edition Ca. 1000 (*d*: ca. 950;
D: ca. 50)
Price *d*: (*f* 5,–)
Enclosures *d*. 1 (Technical Sec-
tion: II–11 November 1919,
p. 33–36 + four p. advertise-
ments)
Special characteristics There is
no evidence of *D* having been
published in hardcover.
Illustrated *d*

Published January/February
1920
The Amsterdam Society for Secondary and Higher Architectural Education by J. de Meijer. Karl Scheffler: *The Gothic Spirit* (Insel Verlag 1917), *Book review* by P. H. Endt. Translation of Lord Dunsany's *Fifty-one Tales: A Misunderstood Identity, The City, The Workman.* Twenty-five illustrations after design studies by B. T. Boeijinga and J. Zietsma and interiors for English country houses by Baillie Scott. P. 1–12 text, p. 13–18 advertisements.

Cover Lithograph by G. F. la Croix
Publication versions *d*; *D*
Edition Ca. 1000 (*d*: ca. 950; *D*: ca. 50)
Price *d*: (*f* 5,–)
Enclosures *d.* 1 (Technical Section: II–12 December 1919, p. 37–40 + four p. advertisements). *d.* 2 (Technical Section: II–12A December 1919, p. 41–45 (membership list) *d.* 3 Notice printed in green "To the members and contributors of A et A."
Special characteristics There is no evidence of *D* having been published in hardcover.
Illustrated *d*

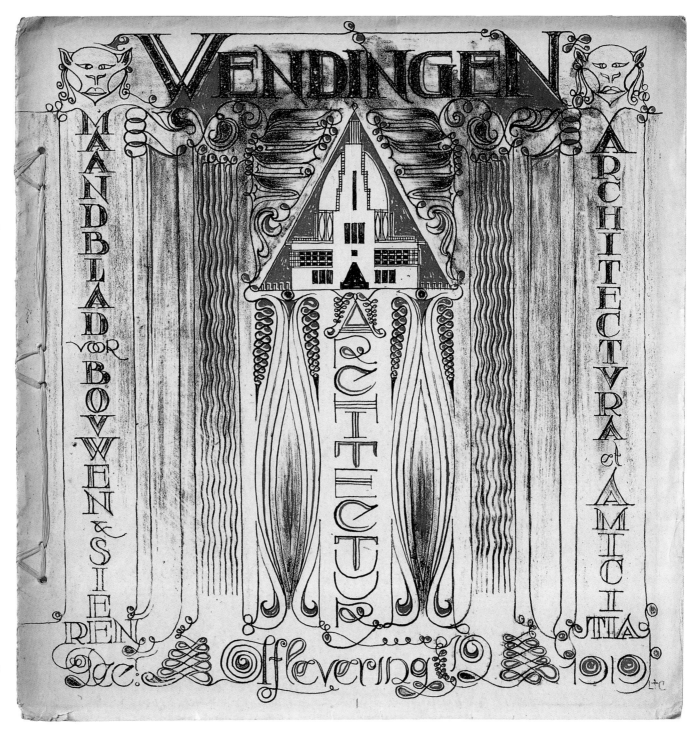

3-1 1920
Sculpture

Published March 1920

Contemporary Sculpture by H. A. van den Eynde. *An Art Program in Soviet Russia; Oskar Kokoschka* by Paul Westheim (book review by J. L. M. Lauweriks). *Over Modern Theories and Architectural Practice* by C. J. Blaauw. Thirty-one reproductions of sculpture by John Rädecker, Hildo Krop, Tjipke Visser, Josef Cantré, Joh. Polet, Anne Brandts Buys-Van Zijp, Ms. L. Beyerman, Theo van Reijn, G. J. van den Hof, Thérèse van Hall, Jules Vermeire, H. A. van den Eynde. P. 1–18 text, p. 19–22 advertisements.

Cover Lithograph by B. Essers
Publication versions *d*; *D*
Edition Ca. 1100 (*d*: ca. 1050; *D*: ca. 50)
Price *d*: ƒ 4,–; *D*: ƒ 5,–
Enclosures *d*. 1 (Announcements: 1920.1, p. 1–2 + 2 p. advertisements)
Special characteristics From left to right on the cover are images of J. H. de Groot, H. Th. Wijdeveld, and B. Essers.[39] *D* is the first number published in hardcover.
Illustrated *d*

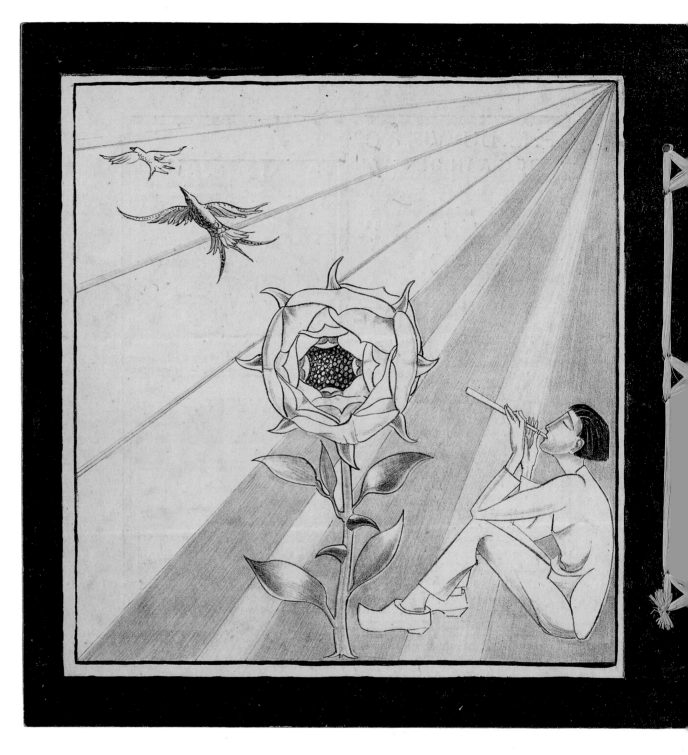

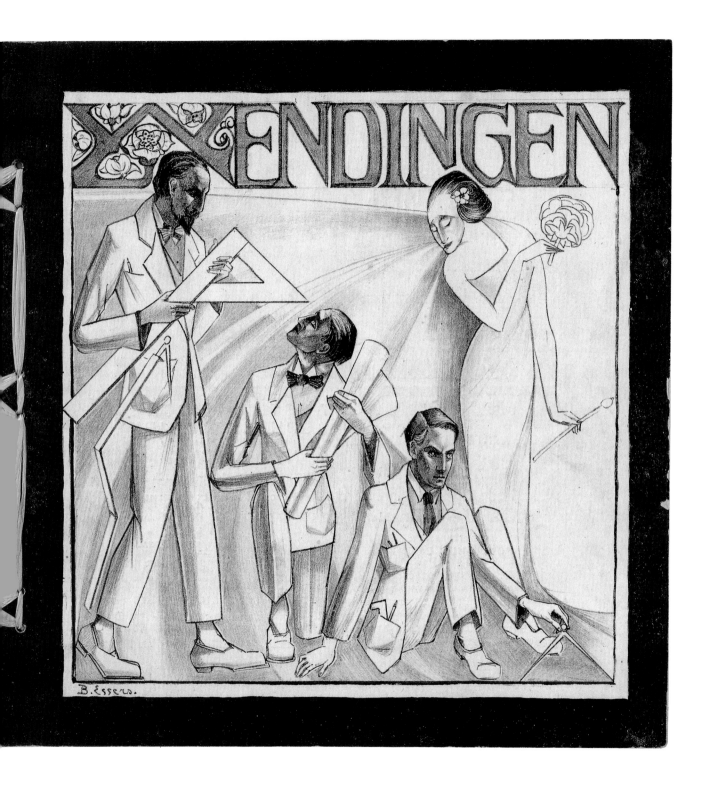

3-2 1920
Gustav Klimt

Published April 27, 1920
Introduction by Max Eisler.
Twenty-seven reproductions
of paintings and drawings by
the Austrian painter Gustav
Klimt. P. 1–20 text, p. 21–24
advertisements.

Cover Lithograph by Tjerk
Bottema
Publication versions *d*; *D*
Edition Ca. 1100 (*d*: ca. 1050;
D: ca. 50)
Price *d*: ƒ 4,–; *D*: ƒ 5,–
Enclosures *d*. 1 (Announce-
ments: 1920.2, p. 3–5 + three
p. advertisements)
Illustrated *d*

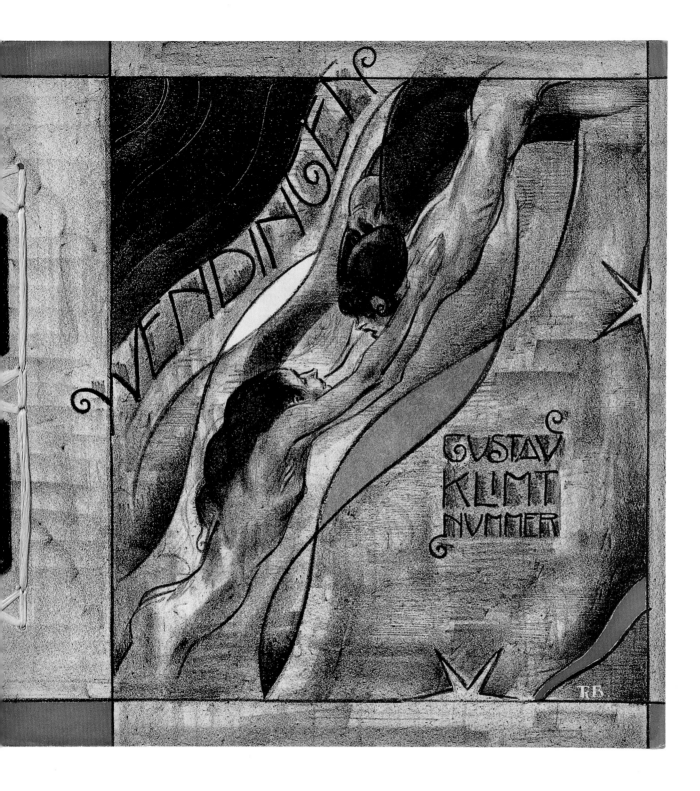

Published May 1920

Introduction by H. Th. Wijdeveld; additional texts: *Regarding the Significance of Artistic and Technical Problems* by Peter Behrens. *Development Plans for Public Housing* by B. van Calcar. Roughly eighty reproductions of designs and buildings by the architects J. F. Staal, Granpré Molière, Verhagen and Kok, H. G. van Eylen, Jan Pauw and W. van Hardeveld, D. A. van Zanten, G. F. la Croix, J. M. van der Mey, J. B. van Loghem, H. P. Berlage, Jan Gratama, G. Versteeg, Vorkink and Wormser, K. P. C. de Bazel, A. H. van Wamelen, J. H. Hellendoorn, J. Limburg, and J. Boterenbrood. P. 1–38 text, p. 39–44 advertisements.

Cover Lithograph by M. de Klerk

Publication versions *d; D*

Edition Ca. 1100 (*d*: ca. 1050; *D*: ca. 50)

Price *d*: ƒ 7,50; *D*: ƒ 10,–

Enclosures *d*. 1 (Announcements: 1920.3-4, p. 6–8 + one p. advertisements)

Illustrated *d*

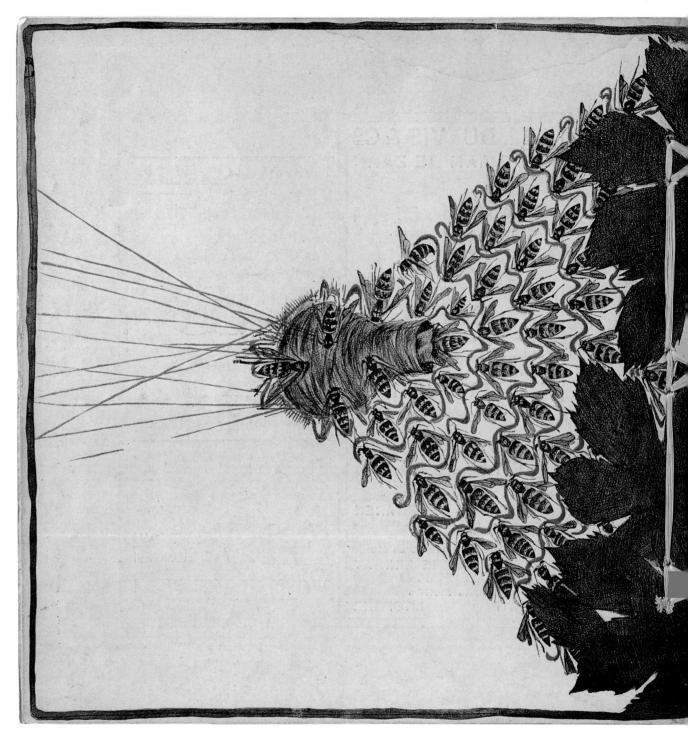

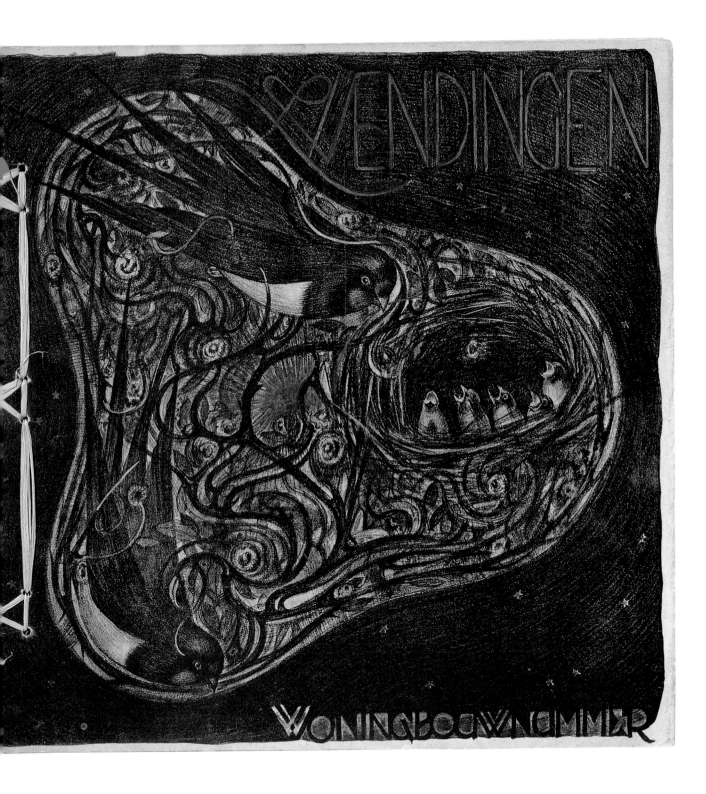

WENDINGEN

WONINGBOUWNUMMER

Published July 1920

Old Hungarian song in the original and in Dutch translation, illustrated with modern pen drawings; as a tribute to the Hungarian art magazine *Magyar-Iparmüvészet.* P. 1–12 text, p. 13–16 advertisements.

Cover Woodcut by Jozef Cantré

Publication versions *d; D*

Edition Ca. 1100 (*d*: ca. 1050; *D*: ca. 50)

Price *d*: ƒ 2,– / 3.5.*D*: ƒ 3,–

Enclosures *d.* 1 (announcements: 1920.5, p. 9–10 + 2 p. advertisements)

Special characteristics A soft cover copy of *D* is also known to exist.[40]

Illustrated *d*

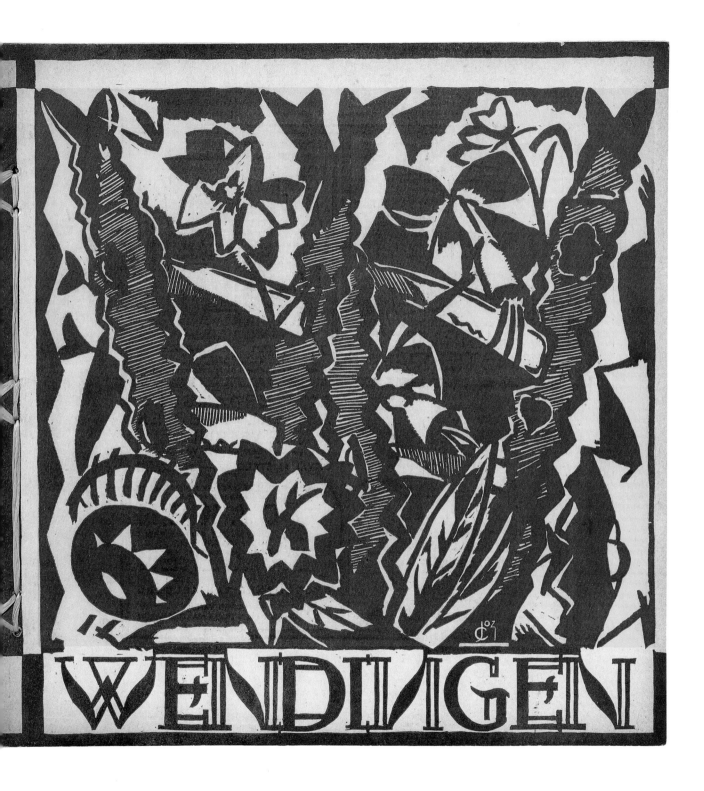

3·6/7 1920
Masks

Published September/October 1920

Introduction by H. Th. Wijdeveld; further articles: *The Theater Mask* by Herman Kloppers. *Notes on the Japanese Mask* by T. B. Roorda. *Concerning Various Masks* by R. N. Roland Holst. *Chinese and Tibetan Masks* by Herman Rosse. Roughly ninety illustrations of theater and dance masks: Greek-Roman, Japanese and Chinese, Javanese and Balinese, Tibetan, African, and Ceylonese, etc. P. 1–24 text, p. 25–30 advertisements.

Cover Lithograph by R. N. Roland Holst
Publication versions *d*; *D*
Edition Ca. 1350 (*d*: ca. 1100; *D*: ca. 250)
Price *d*: ƒ 7,50; *D*: ƒ 10,–
Enclosures *d*. 1 (Announcements: 1920.6/7, p. 11–13 + three p. advertisements)
Special characteristics *d* also exists with a cover printed on a smooth surface brown paper, probably on a handpress by Roland Holst himself. This was pasted over the existing cover and sometimes over the raffia binding as well.
Illustrated *D*

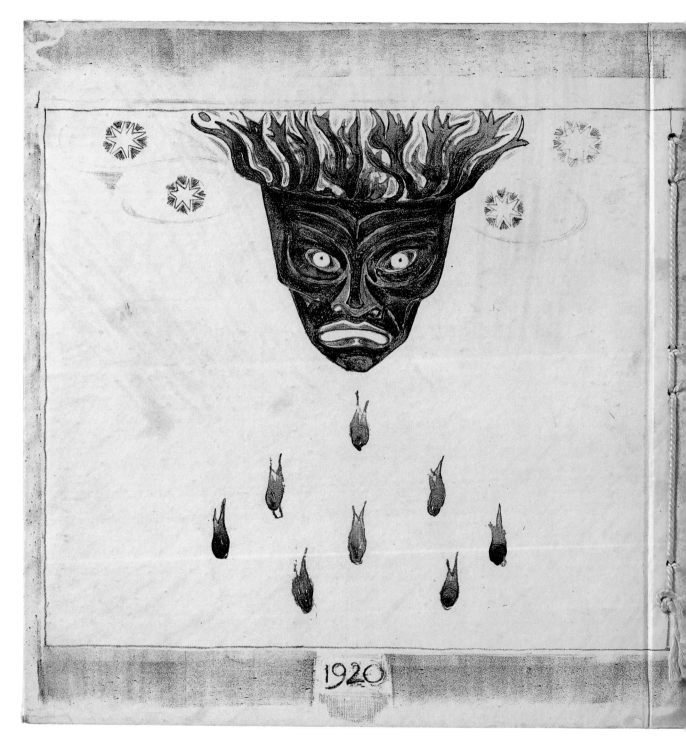

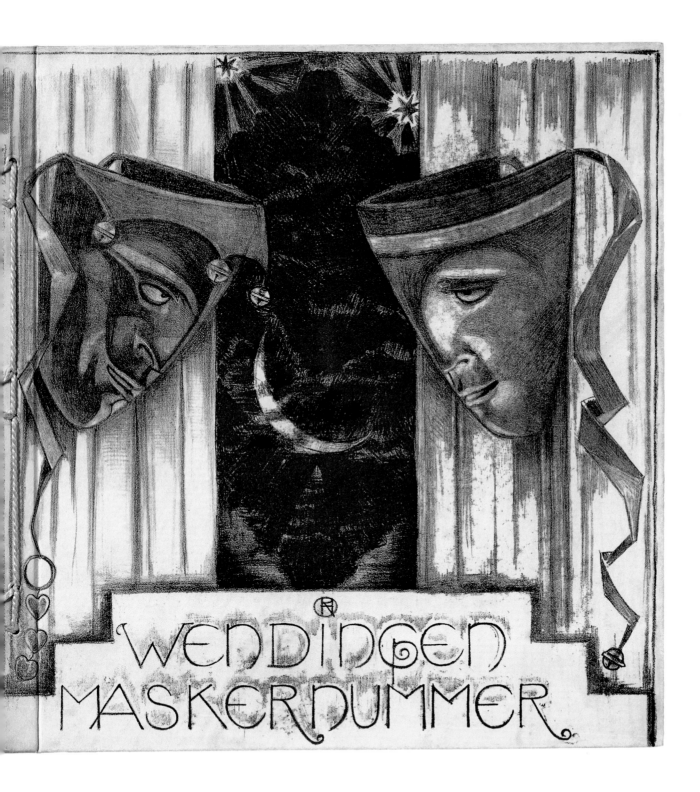

3-8/9 1920
Josef Hoffmann

Published November/December
1920

Introduction by J. Boteren-
brood. *Josef Hoffmann* by Max
Eisler. *About the Future of
Vienna* by Josef Hoffmann.
Regarding Josef Hoffmann by
some of his friends. Forty-
eight illustrations of works
by Josef Hoffmann, including
the Stocklet House in Brus-
sels, the Leipzig Exhibition,
the Poldihütte in Vienna, the
Buffet Villa Skiwa, embossed
silver coffee services with
ivory knobs and grips,
embossed golden ornaments,
and a leather book binding.
P. 1–28 text, p. 29–34 adver-
tisements.

Cover Woodcut by H. A. van
den Eijnde
Publication versions *d; D*
Edition Ca. 1150 (*d*: ca. 1100;
D: ca. 50)
Price *d*: *f* 6,–; *D*: *f* 7,50
Enclosures *d*. 1 (Announce-
ments: 1920.8-9, p. 14–18
+ three p. advertisements)
Special characteristics In the
middle of the African – or
perhaps more correctly
Melanesian – appearing
cover, Architecture and the
Decorative Arts are opposite
one another as a totem
group with explanatory
attributes. Architecture bears
a tower-like structure in
which a monumental stair-
case leads to "the Higher."
Decorative Arts holds a small
sculpture representing a

horned beast in its hands. Around them are arranged smaller figures in boats such as Music (with a lyre), Dance (in a characteristic posture), Theater (with a mask), the Poet (hand under the head), the Worker (rowing), the Scout (who puts out to sea), the Critic (with an arrow) and the Visionary (outstretched hand above the eyes). On the reverse side the ones left behind are portrayed, "the rigid elements", who have moored their ships.[41]

Illustrated D

3-10 1920
Erich Mendelsohn

Published January 1921
Introduction *With Reference to the Mendelsohn's Designs* by J. F. Staal; *Architecture in Iron and Concrete* by Oscar Beyer. Thirty illustrations including color reproductions of drawings and buildings by Erich Mendelsohn. P.1–14 text, p. 15–20 advertisements.

Cover Produced typographically after a design by H. Th. Wijdeveld
Edition Ca. 1150 (*d*: ca. 1100; *D*: ca. 50)
Publication versions *d*; *D*
Price *d*: ƒ 5,–; *D*: ƒ 6,50
Enclosures *d*. 1 (Announcements: 1920.10, p. 19–21 + three p. advertisements)
Illustrated *d*

3-11/12 1920
H. P. Berlage

Published January/February
1921
Introduction: *The design for
the Municipal (Gemeente)
Museum at The Hague* by H. P.
Berlage. Twenty-one illustra-
tions of maquette and floor-
plans of the design for the
Municipal Museum at The
Hague by H. P. Berlage.
P. 1–16 text, p. 17–26 adver-
tisements.

Cover Lithograph by Jac.
Jongert
Publication versions *d; D*
(with the advertisements)
Edition Ca. 1200 (*d*: ca. 1100;
D: ca. 100)
Price *d*: ƒ 6,–; *D*: ƒ 7,50
Enclosures *d; D.* 1: Editors'
announcement black on
green: "the editorial board of
Wendingen has the plan ..."
Special characteristics *d* is also
published with a printing on
thin or normal cover-paper
(probably printed on a hand-
press by Jongert himself)
without the advertisements
on the inside of the cover.
Berlage also made a design
for the cover himself, which
was to have been printed by
Lankhout at The Hague.[42]
Illustrated *D*

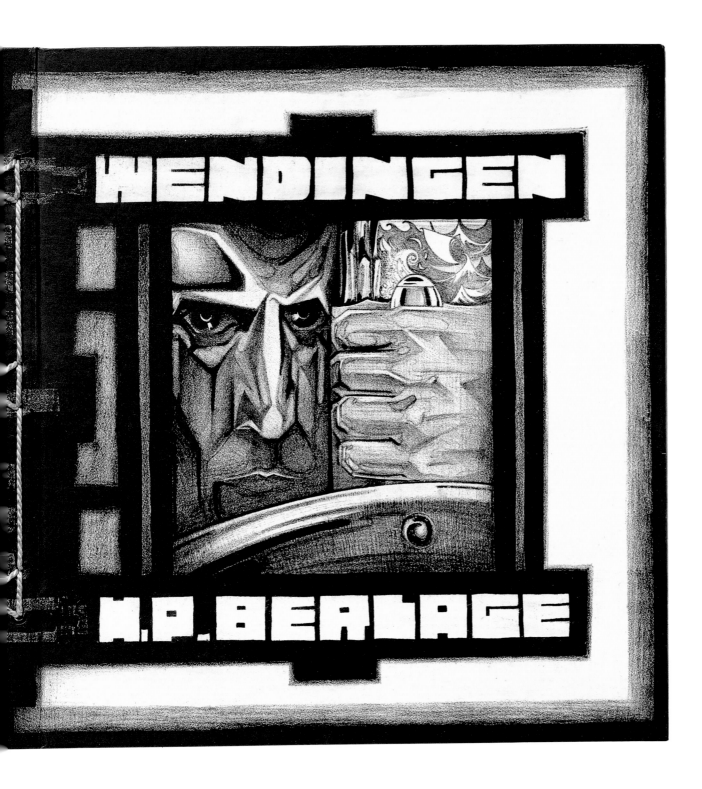

4-1/2 1921
Willem van Konijnenburg

Published ca. May 1921
Introductory poem *The
Prophet* (De Ziener) by P. C.
Boutens, accompanying text
Biography with Some Digressions by Albert Plasschaert;
Twenty-six large reproductions of works by the painter.
P. 1–32 text, p. 33–42 advertisements.

Cover Lithograph by Willem
van Konijnenburg
Publication versions *d*; *D*; *e*; *E*;
g; *G*
Edition Ca. 2400 (*d*: ca. 1100;
D: ca. 100; *e*: ca. 550; *E*: ca. 50;
g: ca. 550; *G*: ca. 50)
Price *D*: ƒ 15,–; *e*: ƒ 6,–;
g: RM 45,–
Enclosures *d*. 1: Announcement to the subscribers
printed in green: "The great
concern being expressed
regarding the content of
Wendingen ..."
Special characteristics The English and German editions do
not contain the entire text.
A notable omission in these
publications is the poem
written especially for this
number by P. C. Boutens.[43]
D (and probably *E* and *G*)
appeared without endpapers.
Illustrated *D*

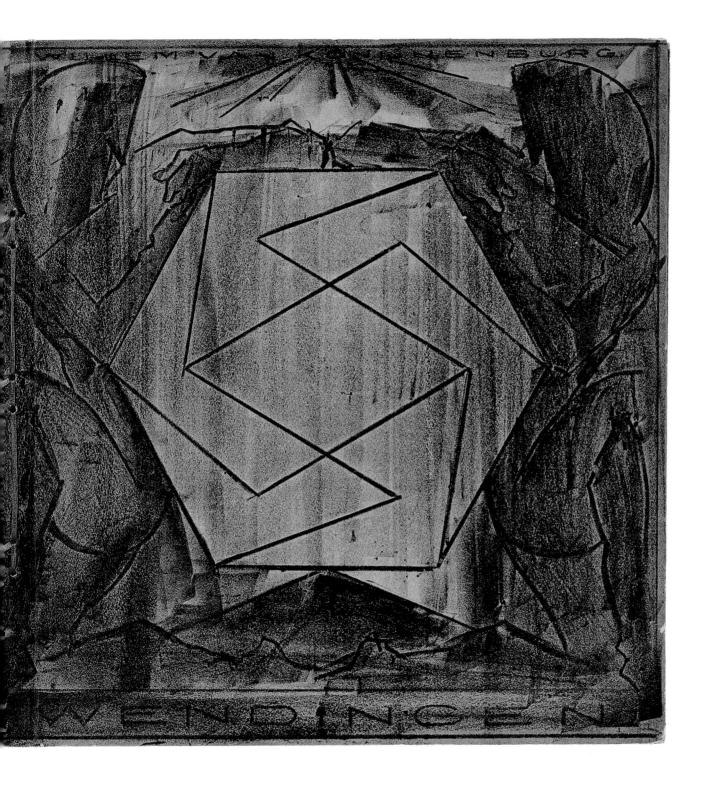

4·3 1921
East-Asian Art (The Petrucci Collection)

Published Ca. September 1921[44]
Accompanying texts by Henri
Borel: *Raphael Petrucci.* Karl
With: *East-Asian Painting and
the Plastic Arts.* Hermann Key-
serling: *The Meaning of Chinese
Art:* A. Vecht: *A Few Thoughts
on the Life and Work of R.
Petrucci.* Twenty-six large
illustrations of East-Asian art
works: Buddha images, tem-
ple figures, kakemonos, etc.
P. 1–24 text, p. 25–36 adver-
tisements.

Cover Lithograph by M. de
Klerk
Publication versions *d*; *D*; *e*; *E*;
g; *G*
Edition Ca. 2400 (*d*: ca. 1050;
D: ca. 150; *e*: ca. 550; *E*: ca. 50;
g: ca. 550; *G*: ca. 50)
Price *d*: ƒ 6,–; *D*: ƒ 7,50;
g: RM 30,–; *G*: RM 45,–
Special characteristics *D*; *E*; *G*
appeared without end-
papers.
Illustrated *D*

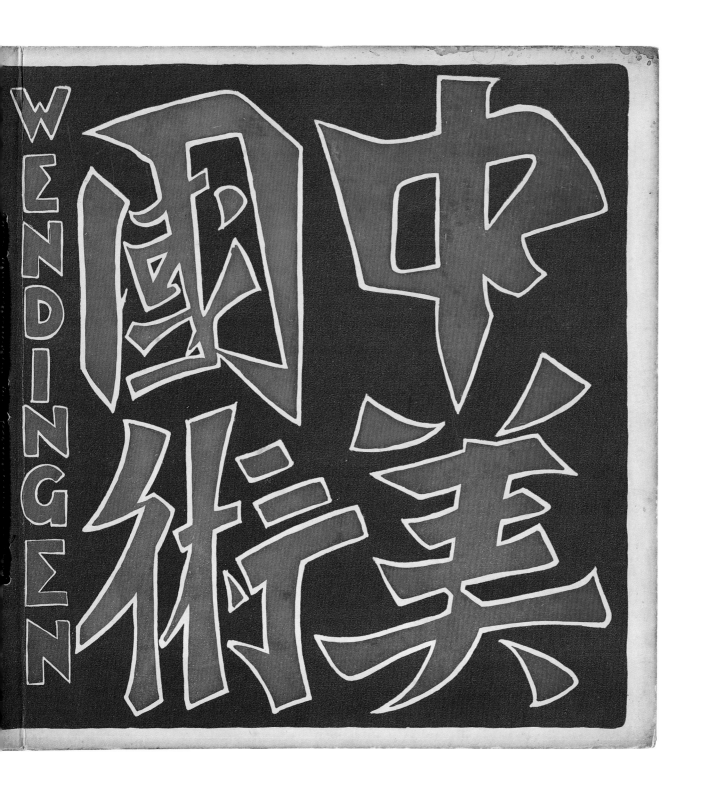

4-4/5 1921
Work by Representative Members of A et A

Published December 1921
Brief explanation regarding
the selection of Representa-
tive Members by the adminis-
tration of A & A.; Sixty-two
illustrations of buildings,
design, floorplans, sculpture,
glass-in-lead, etc. by Repre-
sentative Members of the
society: de Bazel, Berlage,
Cuypers, Kromhout, Klijnen,
Luthmann, Crouwel, van
Laren, Kropholler, Kramer,
Eybink and Snellebrand, la
Croix, Boeyinga, de Meyer,
Zietsma, Limburg, van de
Kloot Meyburg, Dahlen, Mar-
nette, Westerman. Lansdorp,
Blaauw, Boterenbrood,
Kuypers, de Klerk, Gratama,
Wijdeveld, Vorkink, Mendes
da Costa, Krop, Luyken, van
den Eynde, de Koo, Zwollo,
Roland Holst, Jessurun de
Mesquita, Tjerk Bottema.
C. Rol. P. 1–28 text, p. 29–40
advertisements.

Cover Lithograph by R. N.
Roland Holst
Publication versions d; D; e; E (?);
g (?); G (?)
Edition ca. 1650 (d: 1000;
D: 250; e: 400
Price d: ƒ 6,–; D: ƒ 7,50
Special characteristics D is the
first number with the Wijde-
veld endpapers, which, with
the title pages, are designed
as a single unit. Previously,
the endpapers were blank.
The cover for e is printed on
better paper than the cover

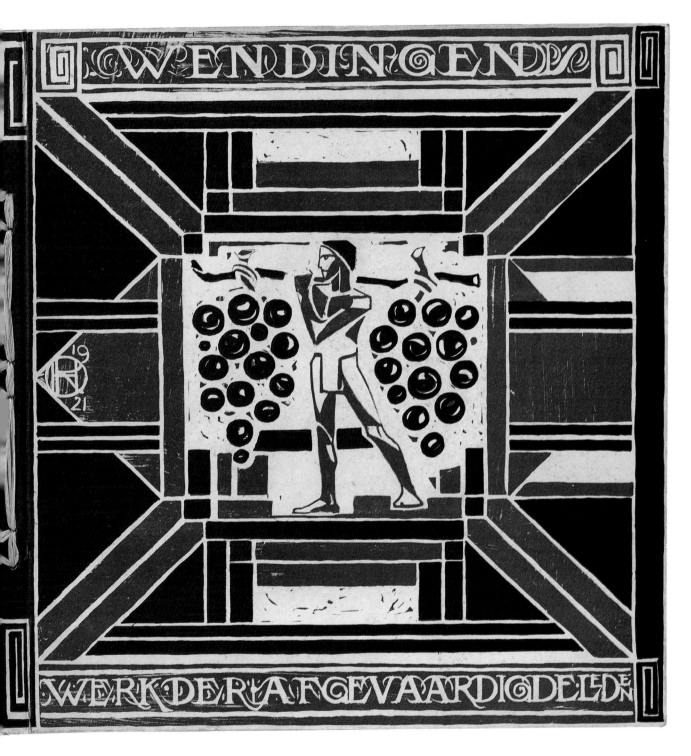

WENDINGEN

WERK DER AFGEVAARDIGDELDN

for *d*. A copy of *d* with the better paper is identified by the stamp: "Not available in the trade" (niet in den handel).[45] According to criticism by J. Luthmann the "Representative Members" selected themselves, and he referred to this publication of *Wendingen* as a "sloppy hotch potch."[46]

Illustrated *D*

4·6 1921

Vorkink and Wormser, Country House at Oostvoorne

Published February 1922
Introduction by J. F. Staal.
Fifteen images of the Country House of Mr. Hudig at
Oostvoorne with gardener's
cottage, cupola, etc. P. 1–14
text, p. 15–26 advertisements.

Cover *d*; *D*: Lithograph by
Jaap Gidding
Cover *e*; *E*; *g*; *G*: woodcut by
H. A. van den Eijnde
Publication versions *d*; *D*; *e*; *E* (?);
g; *G* (?)
Edition Ca. 2000 (*d*: ca. 1100;
D: ca. 150; *e*: ca. 450; *g*: ca. 300
Price *d*: ƒ 3,50; *D*: ƒ 5,–
Special characteristics For the
covers of the English and
German editions, the blocks
on the cover for 3-8/9 were
reprinted in another color
combination.[47]
Illustrated *D*

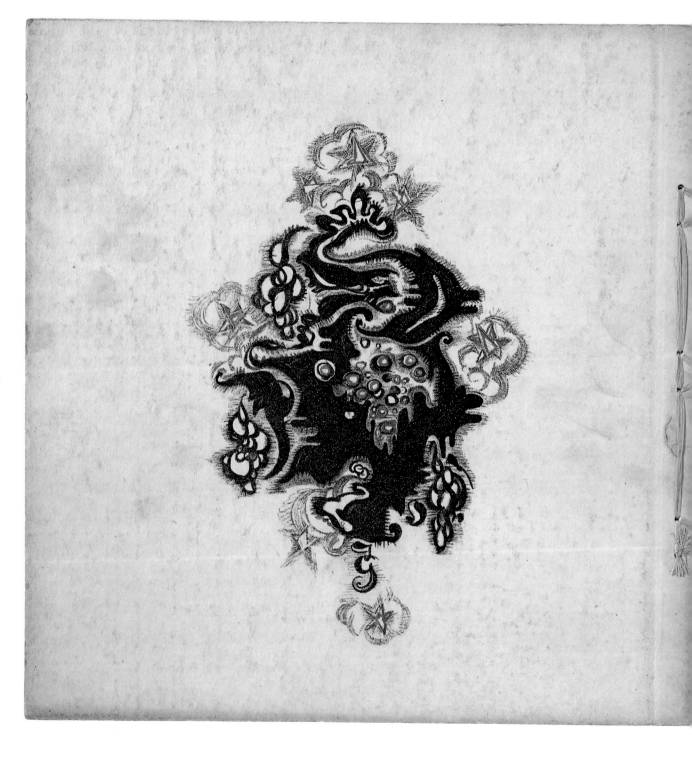

114

WENDINGEN

4-7/8 1921
Marionettes

Published May/June 1922
Introduction by H. Th. Wijde-veld and Gordon Craig. Other articles by Weremeus Bun-ing, P. Clavel, H. van Kleist and P. Kahle. Sixty-five illus-trations of marionettes from China, Japan, Java, and North-Africa in addition to modern marionettes by Sophie Taeu-ber, Otto Morach, and Teschner. P. 1–32 text,
p. 33–50 advertisements.

Cover Woodcut by C. A. Lion Cachet
Publication versions d; D; e; E
Edition Ca. 2150 (d: ca. 1200; D: ca. 250; e: ca. 600; E: ca. 100
Price d: ƒ 7,50; D: ƒ 10,–
Special characteristics Jan Voskuil complained about over the fact that no Dutch marionettes were repro-duced. The editorial board responded that there were no Dutch marionettes of high enough quality to be considered.[48]
Illustrated D

119

Published July 1922
Introduction by H. Th. Wijde-
veld, further articles by Gor-
don Craig, Adolphe Appia,
Gaston Bary, F. Gémier,
Leopold Jessner, Oskar Fischel,
Ri Macgowan and George
Nathan. Forty-six illustrations
of the design for the Interna-
tional Theater Exhibition
(Amsterdam Jan./Febr. 1922)
and of scenery designs and
costume drawings. P. 1–36
text, p. 37–56 advertisements.

Cover Typographically pro-
duced after a drawing by
Frits Lensvelt
Publication versions *d*; *D*; *e*; *E*
Edition Ca. 2200 (*d*: ca. 1200;
D: ca. 200; *e*: ca. 600; *E*: ca. 200
Price *d*: *f* 7,50; *D*: *f* 10,–
Special characteristics The num-
ber appeared too late, an
attempt was made to have it
ready for the opening of the
exhibition at the Victoria and
Albert Museum in London on
June 2, 1922.[49] That proved to
be unsuccessful as well,
although the text copy had
been given to the publisher
by March 20, 1922.[50] It was
intended to have the cover
printed on another kind of
paper, but the publisher did
not have it in stock.[51] *D* has a
simplified title page with the
opening words: "*Theater*
deluxe edition." *E* has a sim-
plified title page with the
opening words: "*Theater* spe-
cial number."
Illustrated *D*

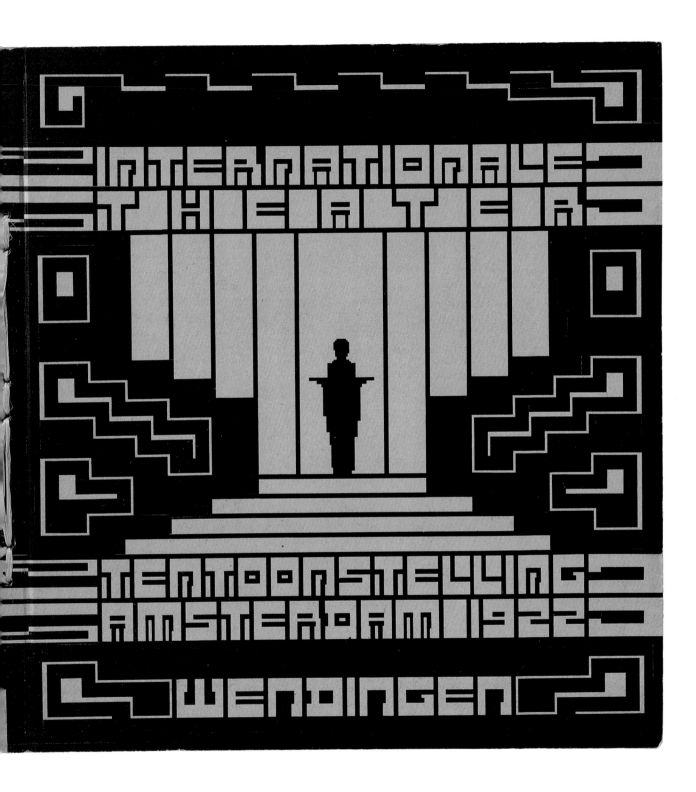

Frank Lloyd Wright

Published November 1922
Introduction by Dr. H. P. Berlage. Twenty-two illustrations of the following buildings by Lloyd Wright: summer garden in America, country house, shops, residences, cinema, theater in Los Angeles, Imperial Hotel in Tokyo. P. 1–18 text, p. 19–38 advertisements.

Cover Lithograph after a drawing by El Lissitzky
Publication versions d; D; e; E
Edition Ca. 1400 (d: ca. 1000; D: ca. 125; e: ca. 200; E: ca. 75
Price d: ƒ 6,–; D: ƒ 7,50

Special characteristics This number with the Lissitzky cover had already been announced in June 1922,[52] and the text copy was delivered to the publisher on April 24, 1922.[53] Thus, the date "1923" provided by Sophie Lissitzky-Küppers is incorrect.[54] Lissitzky came to Germany from Russia at the end of 1921, and there is no indication that he came to The Netherlands before the end of 1922. It is plausible that the Berliner, Dr. Adolf Behne, who was in close contact with Lissitzky, asked Wijdeveld to give his friend Lissitzky an assignment during this difficult time of hyper-inflation in Germany.[55] Wijdeveld had met Behne (and Lissitzky?) during his travels through Europe around 1920,[56] and Behne was published in Architectura and

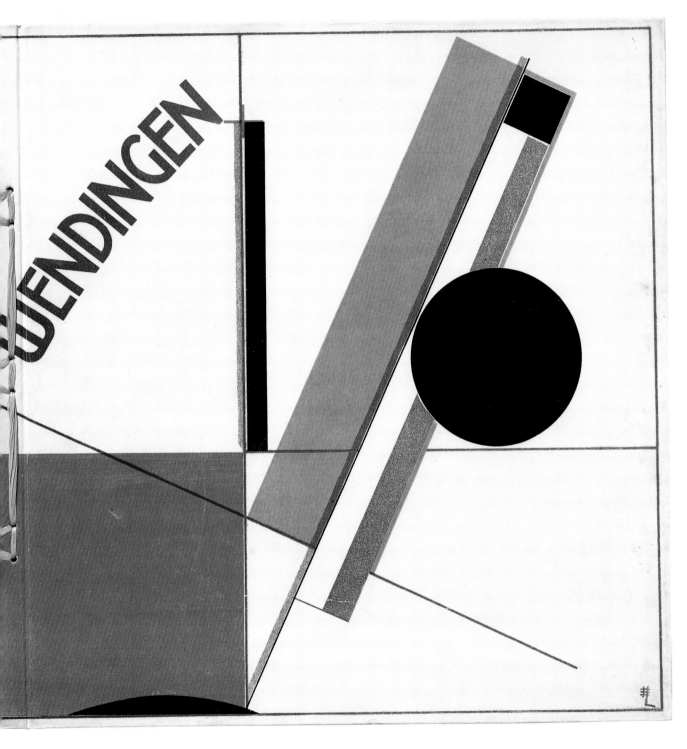

Wendingen. Later, in a 1925 paper, Lissitzky referred to Frank Lloyd Wright as "the father of contemporary architecture."[57] *D* has a simplified title page with the opening words: '*Lloyd Wright* deluxe-publication.' In the Netherlands, Jan Wils, who had become acquainted with Frank Lloyd Wright's [58] work through Berlage,[59] had published about Wright somewhat earlier. Frank Lloyd Wright had not taken the publication seriously, and as a result of his frequent stays in Japan he had left Wijdeveld's requests unanswered. "Had I been aware of the seriousness of this purpose however I might have responded with more characteristic views of my later work to be included in this publication." A copy of the cover reproduced on p. 53 in Purvis' "Dutch Graphic Design,[60] 1918–1945" has a round drop of printing ink on the lower right. This does not indicate a variation.

Illustrated *D*

4-12 1921
The new Rijks Academy building in Amsterdam

Published Ca. December 1922
Introductory texts by A. J.
Derkinderen and H. Th.
Wijdeveld. Eighteen repro-
ductions based on elaborate
drawings by the architects
Bijvoet and Duiker for the
new Rijks Academy building
in Amsterdam. The design
won the first prize in the
1917 competition; although
it was intended to be built,
the plans, after having been
completely finished, became
the victim of economizing.
P. 1–18 text, p. 19–38 adver-
tisements.

Cover Lithograph after a
drawing by B. Bijvoet and
J. Duiker [61]
Publication versions d; D; e; E
Edition Ca. 1350 (d: ca. 1000;
D: ca. 100; e: ca. 200; E: ca. 50
Price d: f 4,50; D: f 6,–
Special characteristics D has a
simplified title page with the
opening words: "Academy
deluxe publication."
Illustrated D

125

5·1 1923
Stained Glass
after Designs by
R. N. Roland Holst

Published January 1923
Introduction by J. F. van
Royen. Twenty-eight illustra-
tions of the stained glass
windows by Roland Holst,
designed and painted for the
auditorium of the Amster-
dam Lyceum and for the
staircase of the Haarlem Post
Office. P. 1–18 text, p. 19–38
advertisements.

Cover Photoplate print after a
drawing by Jac. Jongert
Publication versions *d; D; e; E*
Edition Ca. 1700 (*d*: ca. 1000;
D: ca. 200; *e*: ca. 450; *E*: ca. 50)
Price *d: ƒ* 4,–; *D: ƒ* 5,–
Special characteristics Roland
Holst was pleased with the
cover design.[62] Wijdeveld
introduced a new title page
design, similar to the one
that had already been used
in a tighter version for
4-9/10-*D; E*. The actual text
got a distinctive heading,
and beginning with this
number, the designs of the
endpapers in the deluxe
editions are printed on the
inside of the cover in the
single Dutch numbers, while
the advertisements are
integrated into the design.
Illustrated *D*

5-2 1923
Posters by Dutch Artists

Published March 1923
Introduction by Jac. Jongert,
twenty-seven illustrations
after designs by Roland
Holst, Tjerk Bottema, Adr.
van der Horst Jr. Ernst Ley-
den, Tine Baanders, Jac.
Jongert, Willem Klijn, Bie-
ling, Jan Sluyters, Alex
Asperslagh, W. Arondeus,
H. Th. Wijdeveld, Schwarz,
N. J. van de Vecht, C. de
Haas. P. 1–18 text, p. 19–38
advertisements.

Cover Lithograph after a
drawing by Jan Sluyters.
Publication versions d; D; e; E
Edition Ca. 1650 (d: ca. 1200;
D: ca. 100; e: ca. 300; E: ca.
50)
Price d: ƒ 4,–; D: ƒ 5,–
Illustrated D

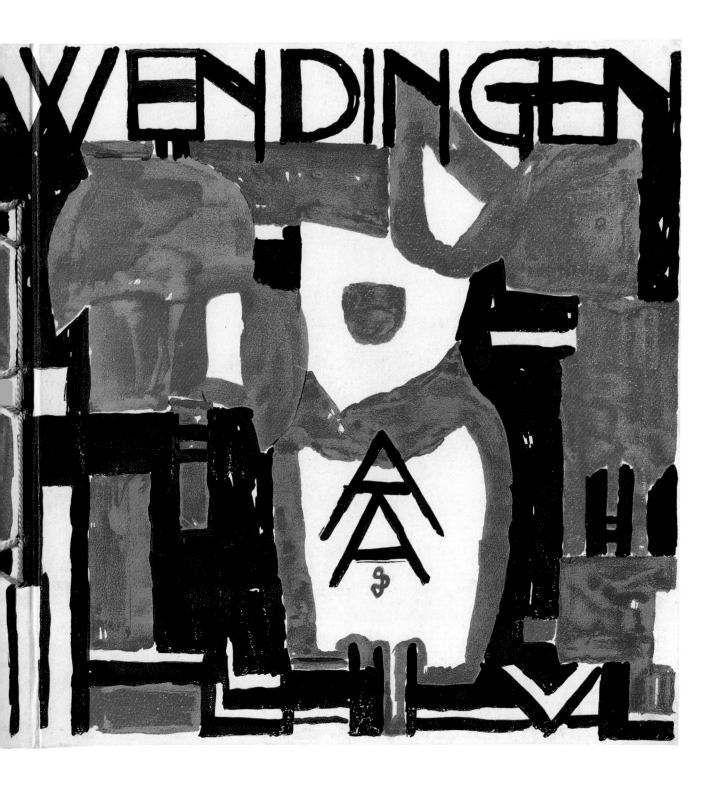

High-rises

Published Ca. April 1923
Introduction by H. Th. Wijde-
veld with accompanying text
by Dr. A. Behne. Twenty-four
images and twenty-four exe-
cuted and non-executed
floorplans of high-rises by
European and American
architects. P. 1–20 text,
p. 21–38 advertisements.

Cover Lithograph by Johan
Polet
Publication versions d; D; e; E
Edition Ca. 1800 (d: ca. 1200;
D: ca. 100; e: ca. 450; E: ca. 50)
Price d: ƒ 6,–; D: ƒ 7,50
Illustrated D

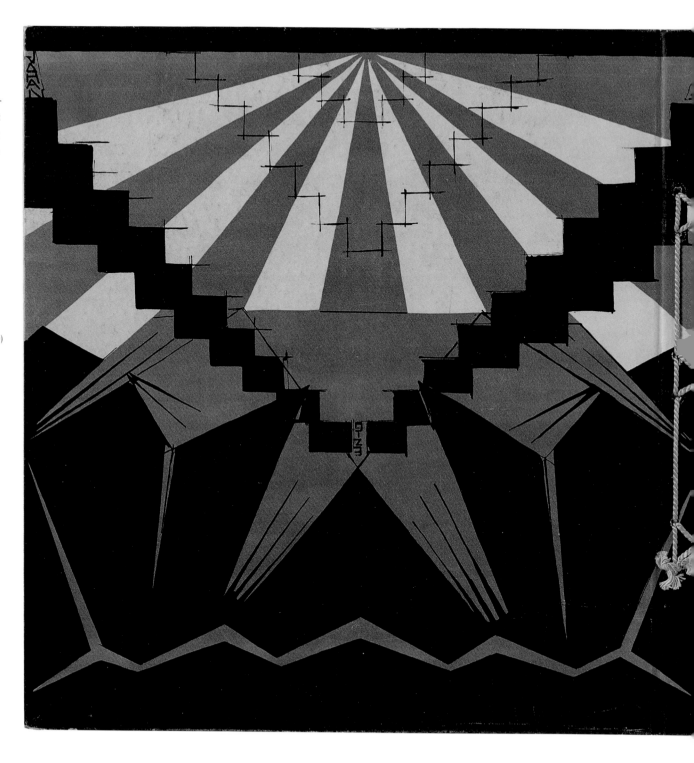

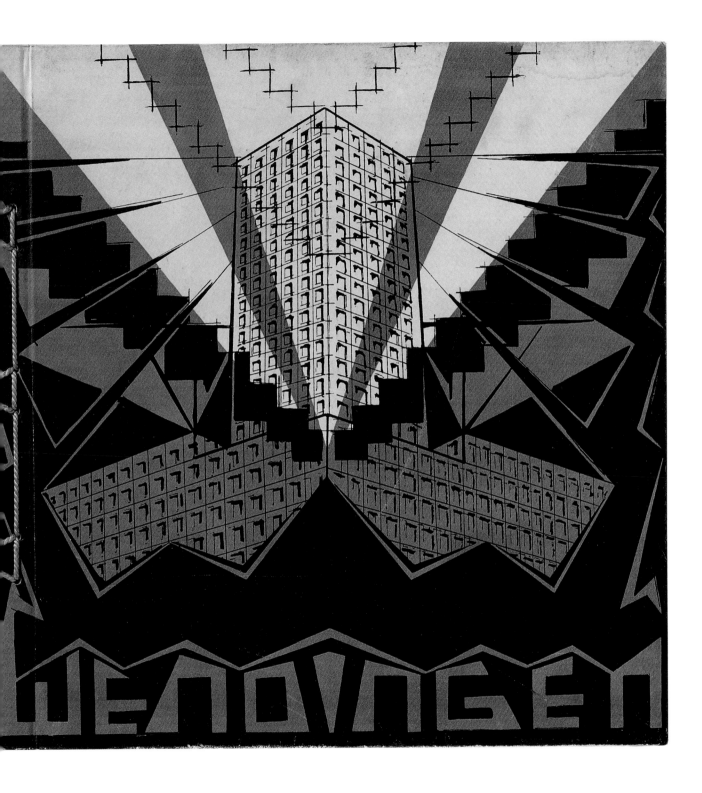

Published May 1923
Introduction by J. P. Mieras.
Twenty-five large images of
middle-class housing in the
Amsterdam "South" expan-
sion plan. P. 1–18 text, p.
19–36 advertisements.

Cover Lithograph by Albert
Klijn

Publication versions *d*; *D*; *e*; *E*

Edition Ca. 1650 (*d*: ca. 1100;
D: ca. 50; *e*: ca. 450; *E*: ca. 50)

Price *d*: ƒ 6,–; *D*: ƒ 7,50

Special characteristics There
were complaints about the
poor production quality of
this number.[63]

Illustrated *D*

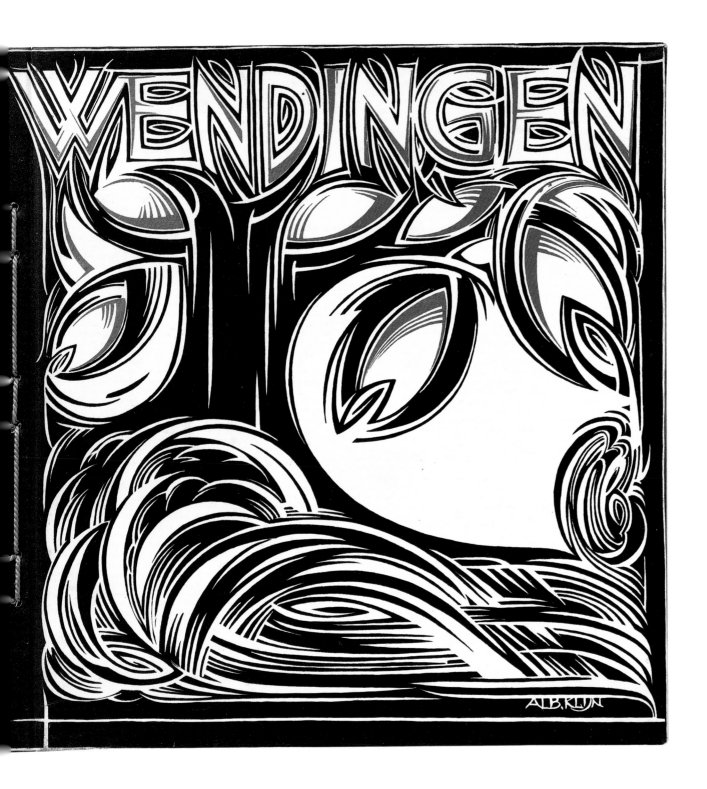

5-5/6 1923
**Mendes da Costa,
Dutch Sculptor**

Published Ca. July 1923
Introduction by M. W. van
der Valk and accompanying
text by H. C. Verkruysen.
Fifty-four illustrations of
sculpture by the Dutch artist,
Dr. J. Mendes da Costa.
P. 1–36 text, p. 37–52 adver-
tisements.

Cover Photoplate print after a
drawing by Dr. J. Mendes da
Costa
Publication versions d; D
Edition Ca. 1300 (d: ca. 1200;
D: ca. 100)
Price d: f 6,–; D: f 7,50
Illustrated D

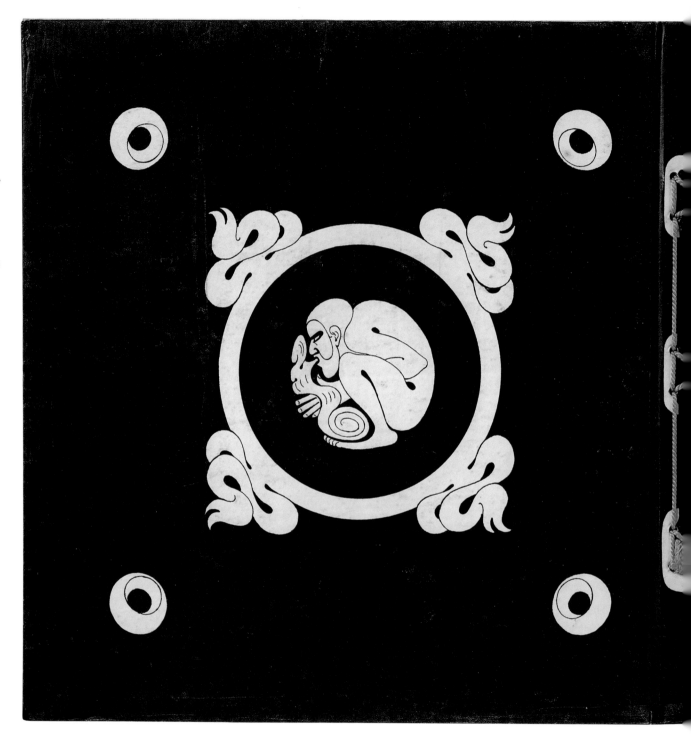

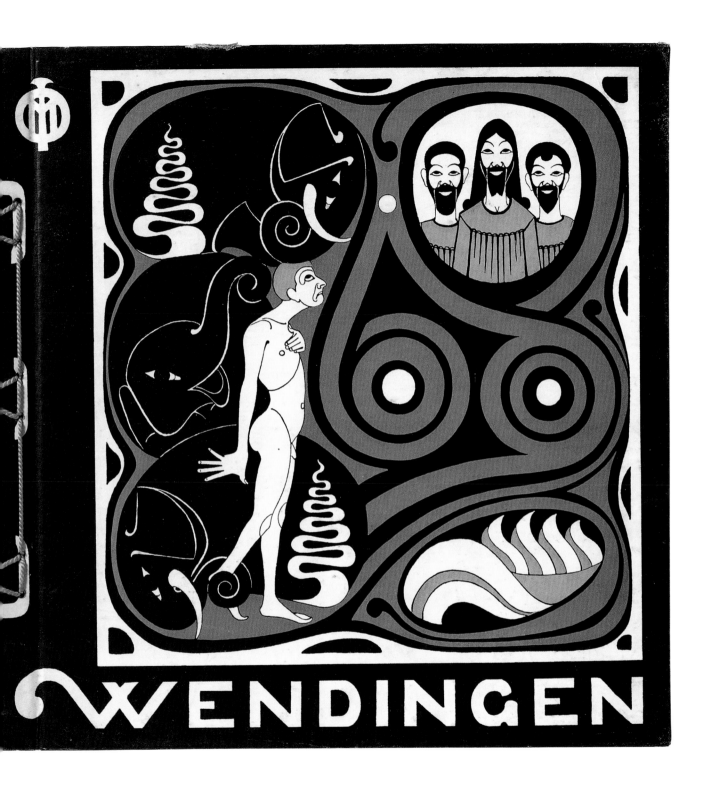

WENDINGEN

5-7 1923

Constructions from the Amsterdam Public Works Building Department

Published September 1923
Introduction by Jan Gratama, engineer. Sixteen large illustrations and sixteen floorplans of buildings from the Amsterdam Public Works Service. P. 1–18 text, p. 19–34 advertisements.

Cover Lithograph by Anton Kurvers
Publication versions *d*; *D*
Edition Ca. 1050 (*d*: ca. 1000; *D*: ca. 50)
Price 5-7d: ca. *f* 6,–; *D*: ca. *f* 7,50
Special characteristics In *Architectura, Wendingen's* editorial board was reproached by the governing body of A et A for breaking the honor code mandating that the creators of architectural works must be clearly credited. "The society A et A cannot as such acknowledge anonymous architectural works, and the publication of such works is not in line with its ethical standards. Also, when eight contributors are listed as sharing this work..." *Wendingen's* editorial board then requested clear guidelines as to how Public Works and similar bureaus should be dealt with in the future.[64]
Illustrated *D*

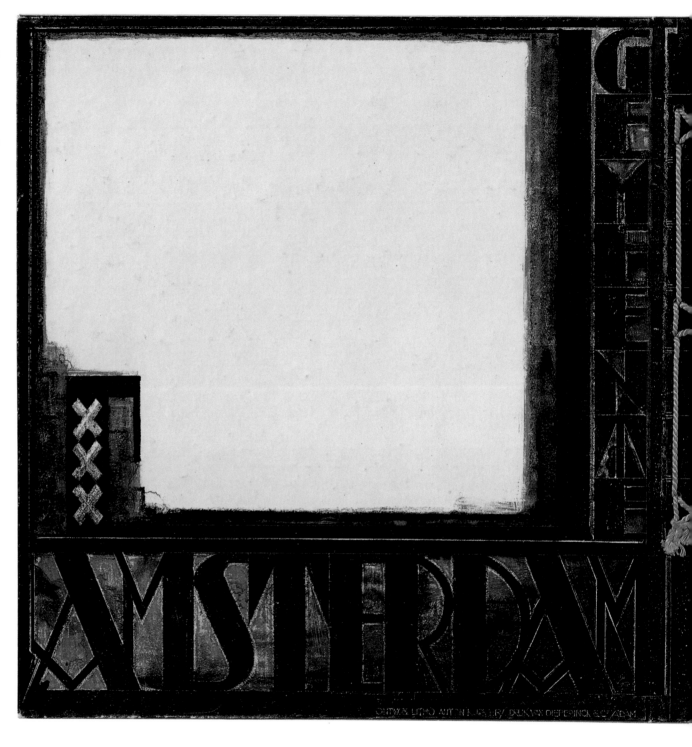

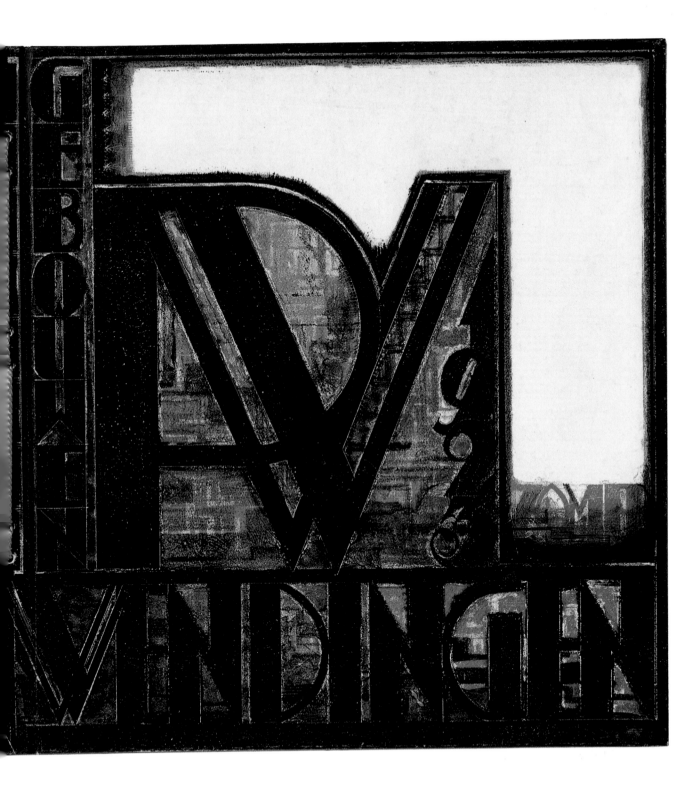

137

5-8/9 1923
Shells, the Wonder
Forms of the Sea

Published November 1923
Strange Resemblance's by R. N.
Roland Holst; *Nature, Architecture and Technology* by H. Th.
Wijdeveld. Sixty-seven regular and X-ray photographs of
the most spectacular shells.
X-ray photographs by Doctor
J. B. Polak. P. 1–36 text,
p. 37–50 advertisements.

Cover Lithograph by R. N.
Roland Holst
Publication versions *d*; *D*
Edition Ca. 1200 (*d*: ca. 1125;
D: ca. 75)
Price *d*: ca. *f* 7,50; *D*: ca. *f* 10,–
Special characteristics Wijdeveld
was the first to have X-ray
photographs made of shells.[65]
El Lissitzky reproduced the
photograph on page 17 in a
1925 paper giving credit for
the image to "Dr. J. B.
Polax."[66]
Illustrated *D*

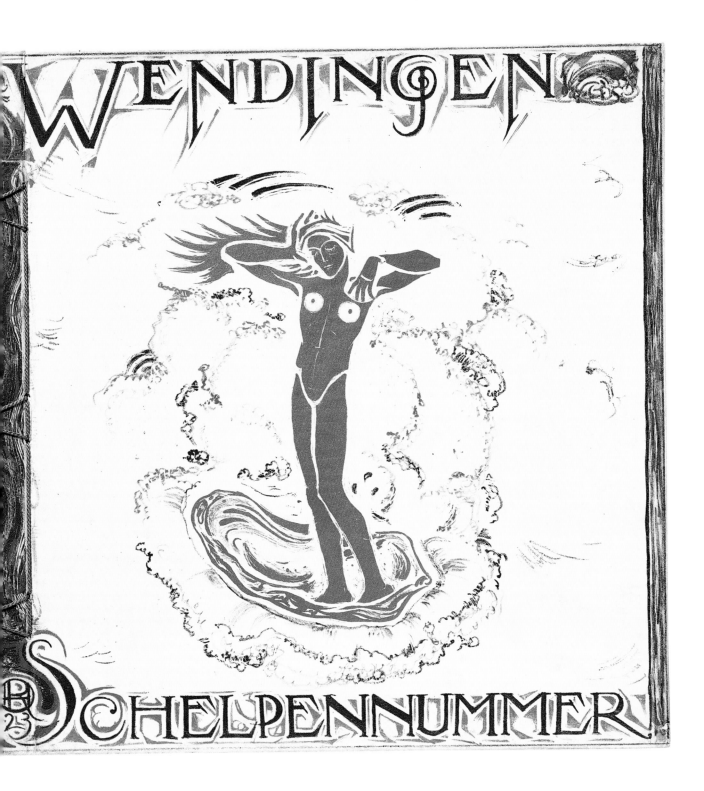

WENDINGEN

SCHELPENNUMMER

**Ex Libris by Dutch
Artists**

Published February 1924
Introduction by J. van
Krimpen. Seventy-six Ex Libris
by Dutch artists: R. M. Wich-
ers Wierdsma, Lodewijk
Schelfhout, W. Nieuwen-
kamp, Lion Cachet, B. Essers,
Joan Colette, R. N. Roland
Holst, G. L. Hilhorst,
G. Rueter, Alb. Hahn,
L. O. Wenckebach, Theo van
Hoytema, M. de Klerk, and
many others. P. 1–18 text,
p. 19–32 advertisements.

Cover Woodcut in pear wood,
quatersawn by B. Essers
Publication versions *d*; *D*
Edition Ca. 1200 (*d*: ca. 1125;
D: ca. 75)
Price *d*: ƒ 6,–; *D*: ƒ 7,50
Illustrated *D*

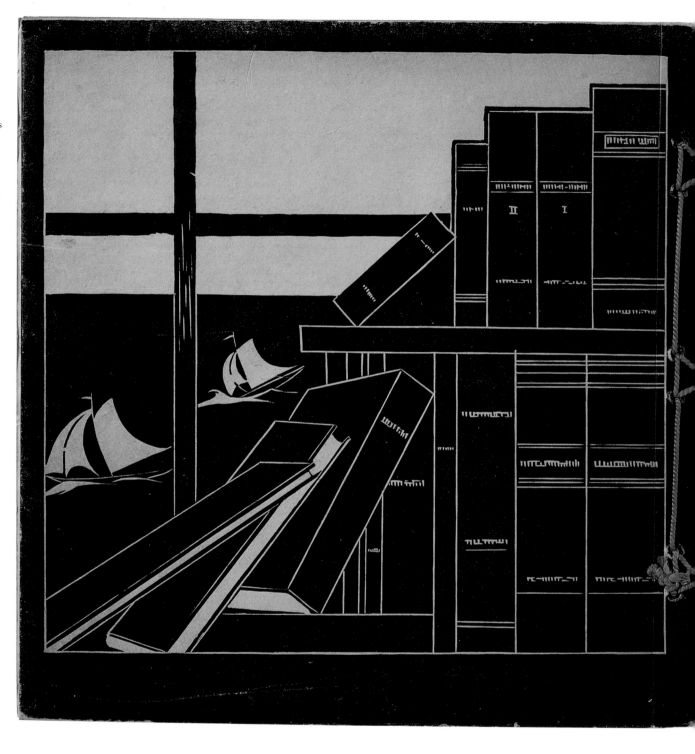

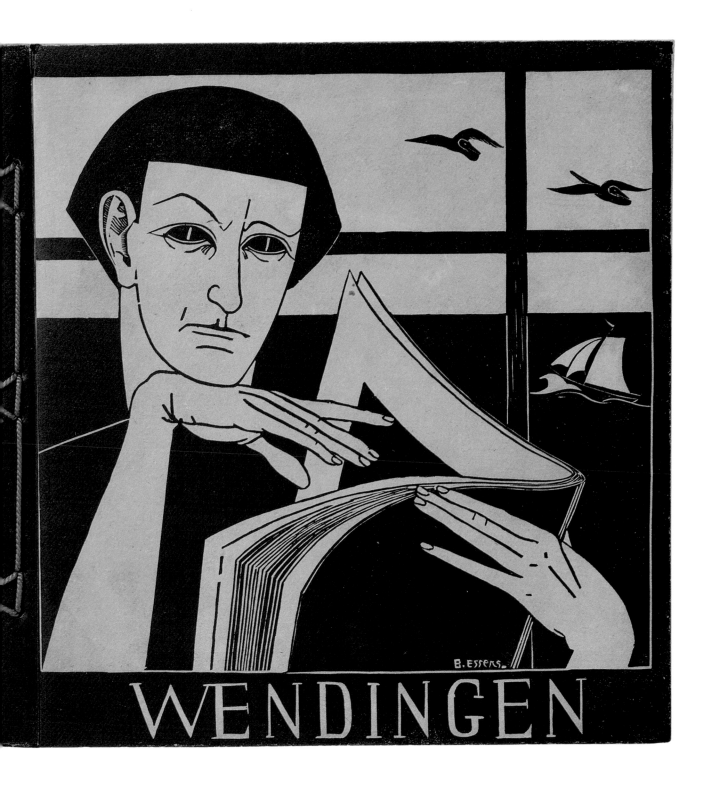

WENDINGEN

5·11/12 1923
Government Buildings: C. J. Blaauw, J. Crouwel, J. M. Luthmann

Published March 1924
Introduction by J. F. Staal.
Thirty illustrations of buildings and perspective drawings, together with fifteen floorplans of buildings designed and executed by the architects in government service, Blaauw, Crouwel, and Luthmann. P. 1–28 text, p. 29–40 advertisements.

Cover Woodcut by S. Jessurun de Mesquita
Publication versions d; D
Edition Ca. 1200 (d: ca. 1100; D: ca. 100)
Price d: ƒ 7,50; D: ƒ 10,–
Special characteristics Copies are known to exist with the following stamp on the title page: "Now a publication of A. J. Roebert, The Hague."[67]
D: appeared without endpapers
Illustrated D

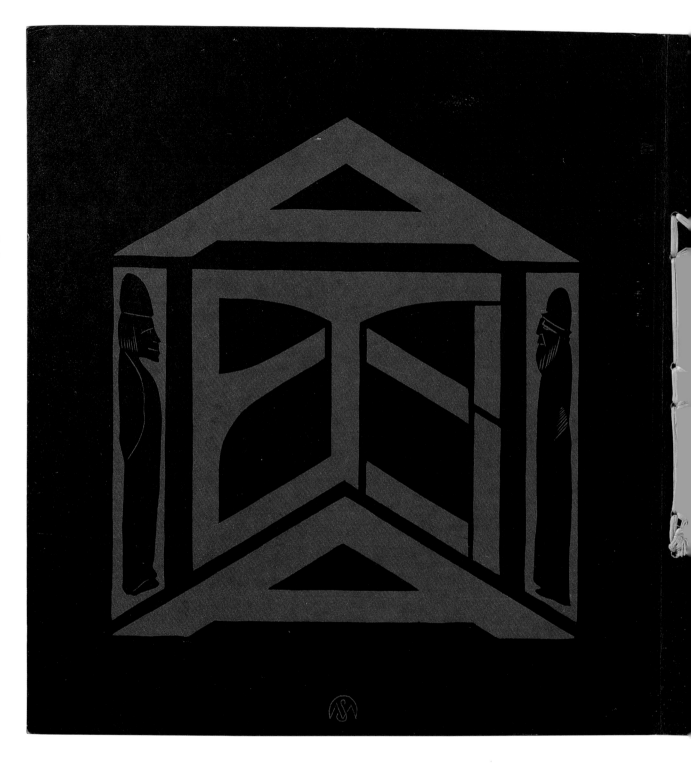

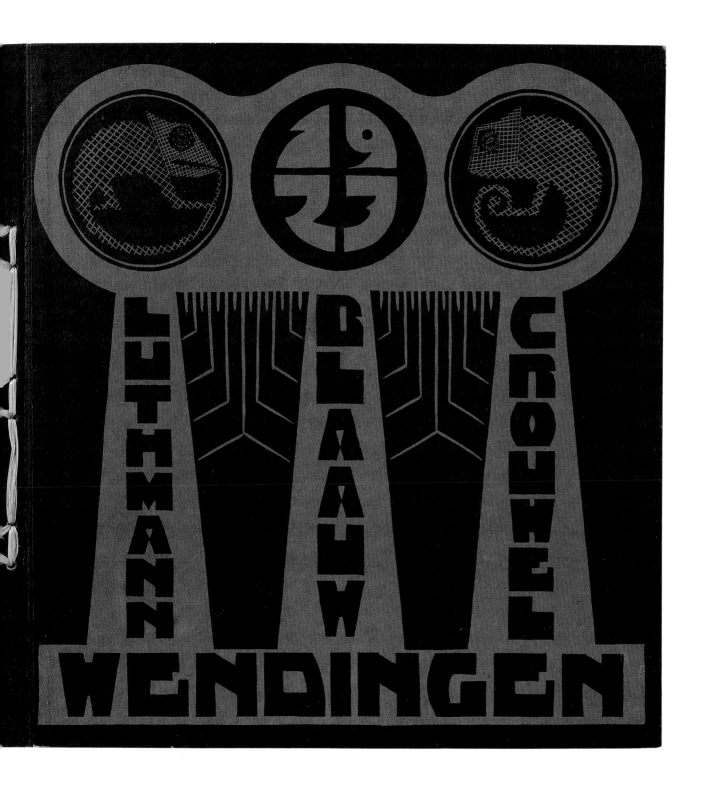

LUTHMANN BLAAUW CROUWEL

WENDINGEN

6·1 1924
Architecture Related Sculpture

Published April 1924[68]
Introduction by H. C. Verkruysen. Forty-one reproductions of sculpture by H. A. van den Eynde, John Rädecker, Th. A. Vos, Theo van Reyn, Joh. Polet, Hildo Krop, and J. van Lunteren. P. 1–18 text, p. 19–30 advertisements.

Cover Woodcut by Jan Havermans
Publication versions d; D
Edition Ca. 1200 (d: ca. 1150; D: ca. 50)
Price d: ƒ 6,–; D: ƒ 7,50
Special characteristics Part of the introductory text not included due to lack of space was printed in *Architectura*.[69]
Illustrated D

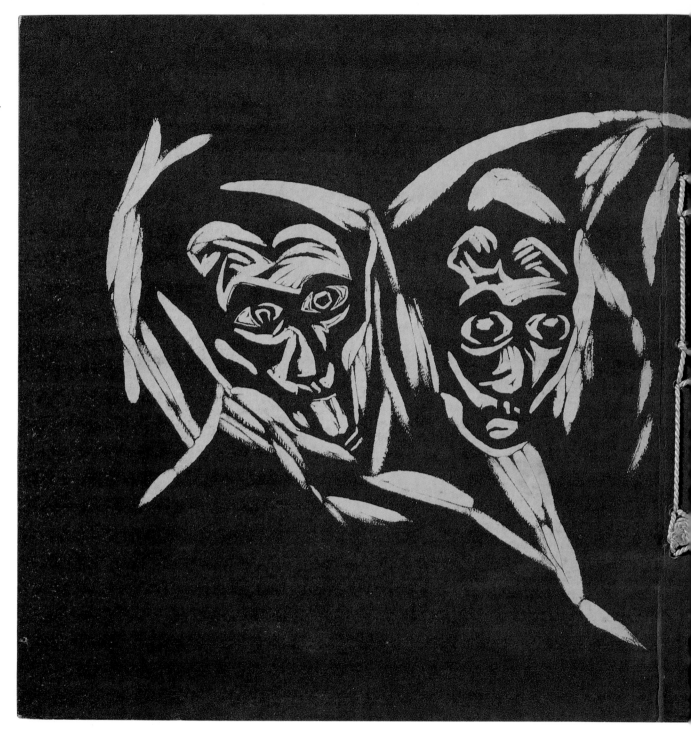

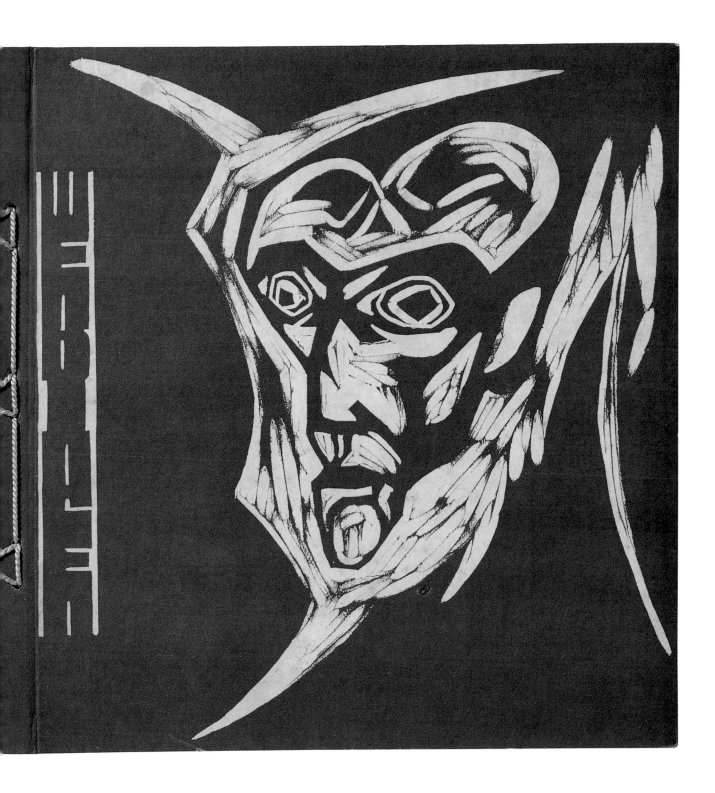

145

6-2 1924
Travel Sketches by the Architect M. de Klerk

Published May 1924
Introduction by J. P. Mieras. Forty-five reproductions of drawings by the early deceased architect M. de Klerk. P. 1–24 text, p. 25–36 advertisements.

Cover Lithograph by
L. E. Beyerman
Publication versions *d*; *D*
Edition Ca. 1400 (*d*: ca. 1300; *D*: ca. 100)
Price *d*: ƒ 6,–; *D*: ƒ 7,50
Special characteristics A special number of *Architectura* was published on the occasion of the unexpectedly deceased architect M. de Klerk on November 24, 1923. In this publication, it was announced that on December 29, 1923 a decision was made to publish as complete a selection as possible in *Wendingen*.[70] After publication, it all appeared as a book, for which purpose probably 200 copies were printed. See also 7-10. Ultimately the numbers: 6-2; 6-4/5; 6-7; 6-9/10 and 7-10 were part of this commemorative series. Number 10-4 was not part of the series.[71]
Illustrated *D*

147

6-3 1924
Finsterlin, the Play of Forms in Architecture

Published July 1924 [72]
Fantasy architecture by the Bavarian architect Hermann Finsterlin with an introduction by C. J. Blaauw. Forty-seven reproductions after the original drawings. P. 1–24 text, p. 25–36 advertisements.

Cover Photo lithography from a brush drawing by Hermann Finsterlin
Publication versions d; D
Edition 1155 (d: 1100; D: 50 + 5) [73]
Price d: ƒ 6,–; D: ƒ 7,50
Special characteristics The original design for the cover *Architektonische Liebe* was not used. [74] It was, though, reproduced on page 11.
Illustrated D

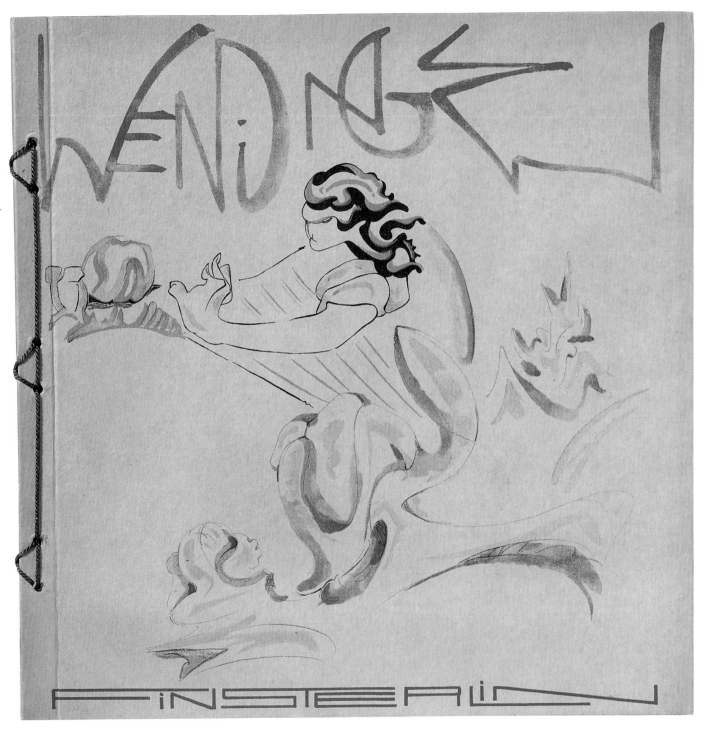

6-4/5 1924
M. de Klerk, Non-executed Projects

Published August 1924 [75]
Introduction by J. F. Staal.
Fifty-four reproductions after
drawings, floorplans, and
cross-sections of non-exe-
cuted architectural projects.
P. 1–34 text, p. 35–48 adver-
tisements.

Cover Produced typographi-
cally after a design by
Margaret Kropholler
Publication versions d; D
Edition Ca. 1400 (d: ca. 1300;
D: ca. 100)
Price d: ƒ 7,50; D: ƒ 10,–
Special characteristics See 6-2
and 7-10.
Illustrated D

ARCHITECTURA ET AMICITIA

1924

WENDINGEN

MAANDBLAD VOOR BOUWEN EN SIERKUNST

151

6-6 1924
Eileen Gray, Furniture and Interiors

Published September/October
1924 [76]
Introduction by Jan Wils
with accompanying text by
Jean Badovici. Thirty illustra-
tions of interior and furni-
ture design by the Irish-
Parisian artist Eileen Gray.
P. 1–18 text, p. 19–32 adver-
tisements.

Cover Produced typographi-
cally after a design by H. Th.
Wijdeveld [77]
Publication versions *d*; *D*
Edition Ca. 1200 (*d*: ca. 1150;
D: ca. 50)
Price *d*: ƒ 6,–; *D*: ƒ 7,50
Special characteristics Jan Wils
provided the initiative for
this issue in the spring of
1923. Work by Eileen Gray
was seen earlier in Amster-
dam at the Exhibition Fran-
cais d'Intérieur. [78]
Illustrated *D*

6-7 1924
Portraits by the Architect M. de Klerk

Published October 1924
Introductory text by Prof.
R. N. Roland Holst. Twenty-
nine reproductions of por-
traits of well-known people.
P. 1–16 text, p. 17–30 adver-
tisements.

Cover Phototype after a
design by Tine Baanders
Publication versions d; D
Edition Ca. 1400 (d: ca. 1300;
D: ca. 100)
Price d: ƒ 6,–; D: ƒ 7,50
Special characteristics See 6-2
and 7-10.
Illustrated D

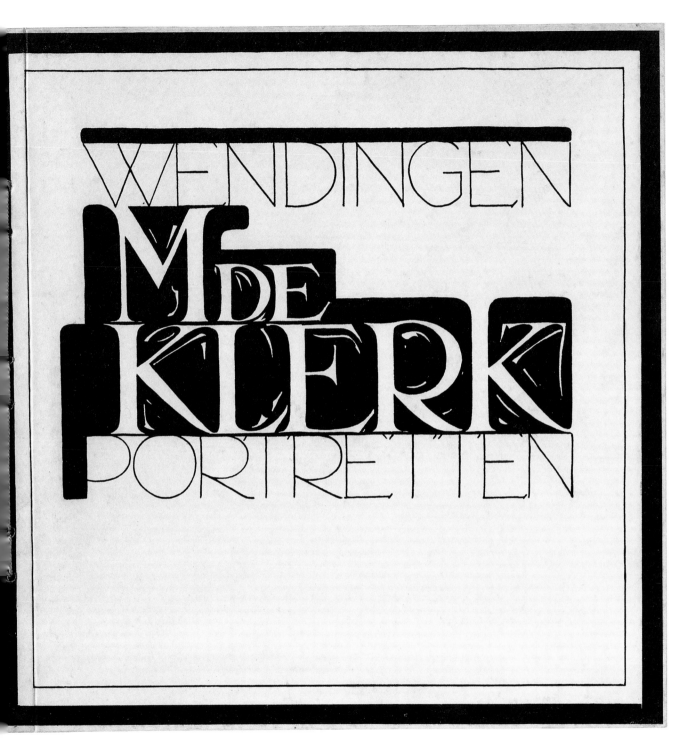

WENDINGEN
M DE
KLERK
PORTRETTEN

6-8 1924
W. M. Dudok, City Hall Design and Executed Work

Published January 1925 Introduction by H. Th. Wijdeveld with accompanying text by J. M. Luthmann. Twenty-two design drawings for the Hilversum City Hall and twenty-six reproductions of executed works.

Cover Lithograph after a drawing by W. M. Dudok
Publication versions *d*; *D*
Edition 1210 (*d*: 1150; *D*: 60)
Price *d*: ƒ 6,–; *D*: ƒ 7,50
Special characteristics It was intended to produce the cover typographically, but the printer Enschedé seemed to be unable to do this. There were probably several hundred copies of this number reprinted. [79] See also 11-11/12. The inside was printed just in time to be distributed at the Hilversum City Council meeting where a decision would be made over the design of the city hall. [80]
Illustrated *D*

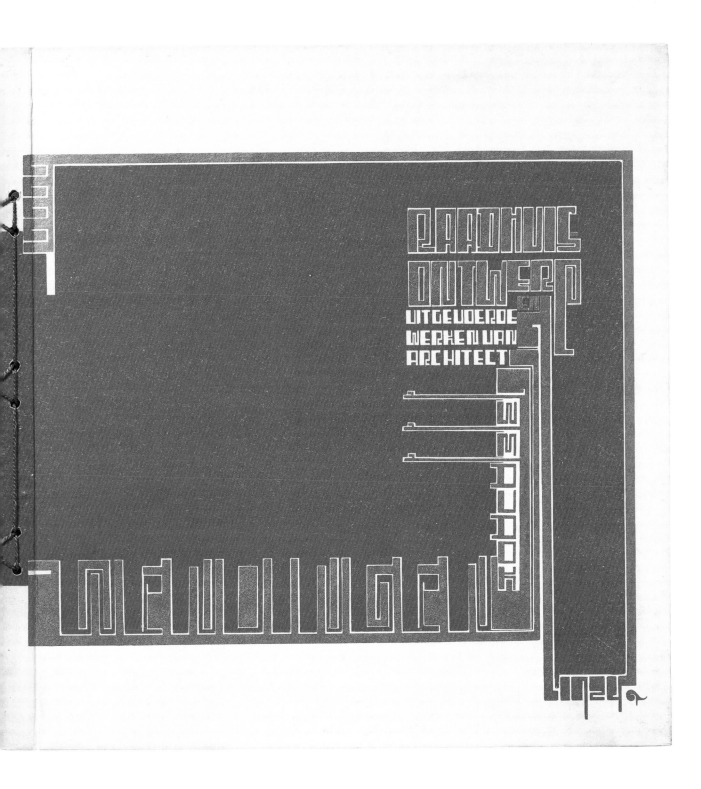

RAADHUIS ONTWERP EN UITGEVOERDE WERKEN VAN ARCHITECT MENALDA 1892 [Stadhuis] NIEUWINGEN

6-9/10 1924
M. de Klerk, Completed Buildings

Published February 1925
Introduction by P. L. Kramer.
Fifty-two reproductions of
buildings and floorplans by
de Klerk in Amsterdam and
other locations. P. 1–30 text,
p. 31-46 advertisements.

Cover Lithograph by Tine
Baanders
Publication versions d; D
Edition 1400 (d: ca. 1300; D:
ca. 100)[81]
Price d: ƒ7,50; D: ƒ 10,–
Special characteristics See 6-2
and 7-10. A partial reprint
complete with photographs
of the location in 1983 was
designed as a *Wendingen*
number and was published
on the occasion of the reno-
vation of the P. L. Takbuurt
in Amsterdam. This was pre-
sented to the residents by
the restoration architect
J. van Stigt.
Illustrated D

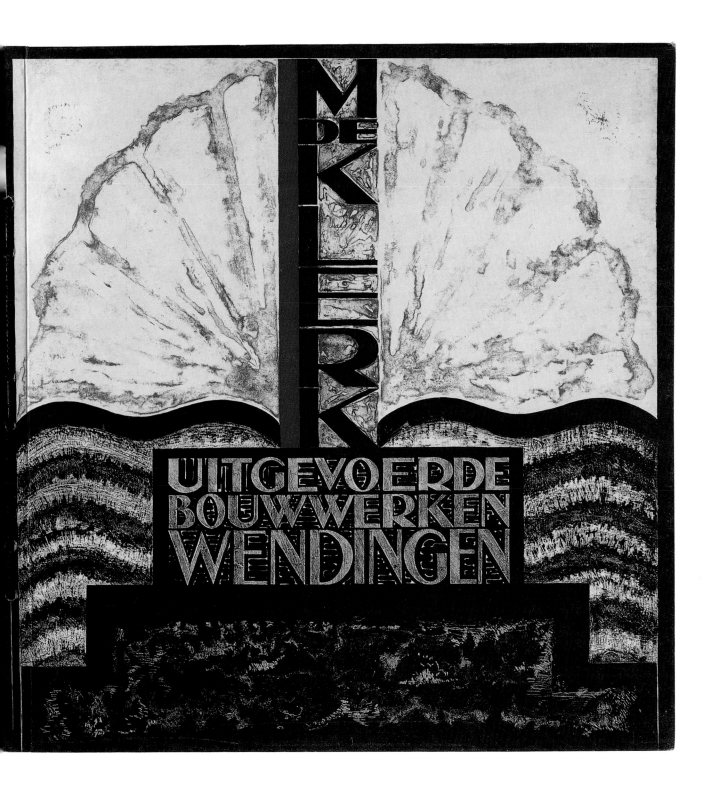

M DE KLERK

UITGEVOERDE
BOUWWERKEN
WENDINGEN

159

6-11/12 1924
Crystals, the Wonder Forms of Nature

Published April 1925 [82]

Introduction *Architectural Fantasies in the World of Crystals* by H. Th. Wijdeveld. Accompanying text, *Crystal Formation, Form and Grouping* by Prof. B. G. Escher and *Crystals* by W. Steenhoff. Poems by M. Nijhoff, A. Roland Holst and J. W. F. Werumeus Buning. Thirty-nine illustrations of crystal formations. P. 1–36 text and illustrations, p. 37–52 advertisements.

Cover Electrotype after a woodcut by B. Essers [83]

Publication versions *d; D*

Edition Ca. 1250 (*d*: ca. 1100; *D*: ca. 150)

Price *d: ƒ* 7,50; *D: ƒ* 10,–

Special characteristics The poems were written especially for this number. [84] According to an advertisement on p. 24 in 6-6, this number was to appear in the fall of 1924. Wijdeveld referred to the shell number 5-8/9 [85] for the layout.

Illustrated *D*

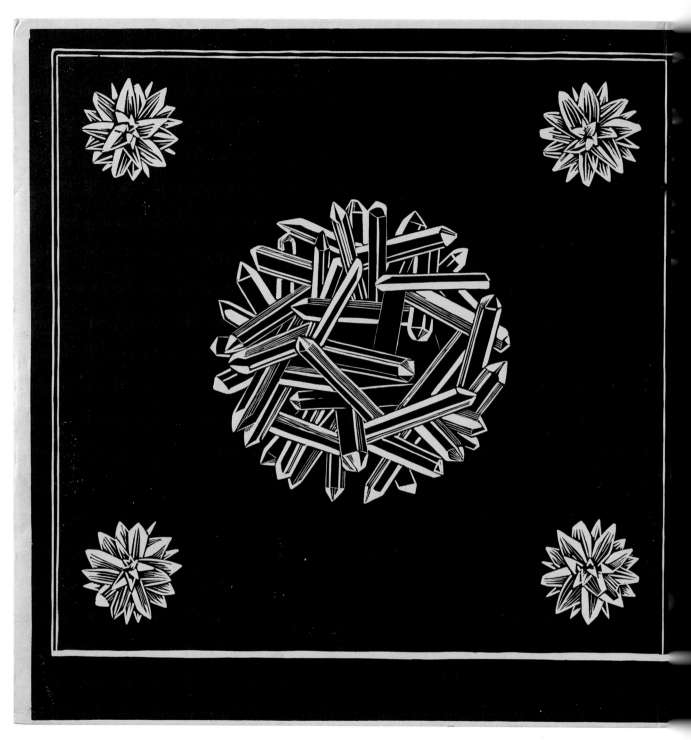

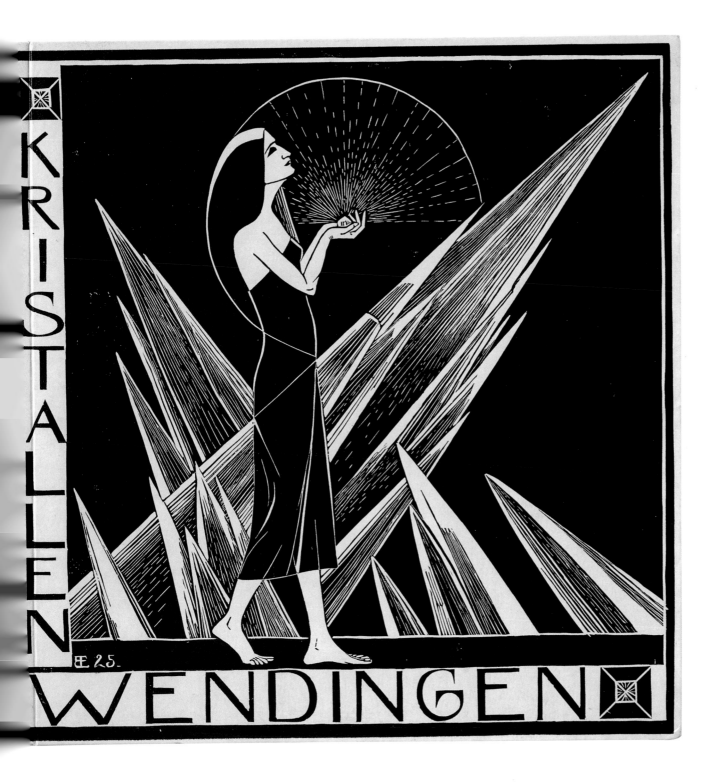

KRISTALLEN

WENDINGEN

EE 25.

7-1 1925
De Mesquita, Draw-
ings and Etchings

Published May 1925.[86]
Introduction by H. C. Verkruy-
sen. Fifty-five reproductions
after drawings and etchings
by Jessurun de Mesquita.
P. 1–24 Text, p. 25–36 adver-
tisements.

Cover Phototype in black on
gold after a woodcut by
S. Jessurun de Mesquita
Publication versions *d*; *D*
Edition Ca. 1250 (*d*: ca. 1200;
D: ca. 50)
Price *d*: *f* 6,–; *D*: *f* 7,50
Special characteristics This is
the first number edited by
H. C. Verkruysen and no
longer by Wijdeveld.[87]
Illustrated *D*

DE MES QUI TA

ASA. WENDINGEN 1925

7-2 1925

Hildo Krop, Overview of His Sculpture

Published July 1925[88]
Introduction by C. J. Blaauw.
Forty-one reproductions of
sculpture by the Amsterdam
municipal sculptor Hildo
Krop. P. 1–24 text, p. 25–36
advertisements.

Cover Woodcut by Hildo Krop
dated summer 1925
Publication versions d; D
Edition 1250 (d: 1200; D: 50)
Price d: ƒ 6,–; D: ƒ 7,50
Special characteristics The deci-
sion to publish was made at
the A et A board of directors
meeting on April 9, 1925.
Wijdeveld made all the mate-
rial available, and the editing
was left to Verkruysen and
Blaauw.
Illustrated D

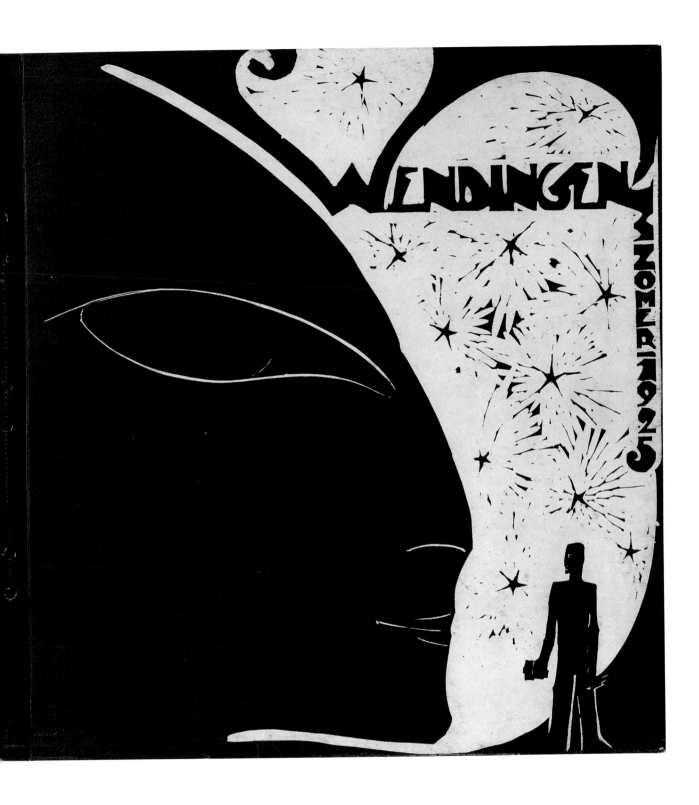

165

7-3 1925
The Lifework of Frank Lloyd Wright, part I

Published October 1925
Introduction by H. Th. Wijdeveld. *In the Cause of Architecture* by Frank Lloyd Wright (first paper, March 1908) P. 1–24 text, p. 25–36 advertisements. Title page after a design by Frank Lloyd Wright.

7-4 1925
The Lifework of Frank Lloyd Wright, part II

Published November 1925
In the Cause of Architecture by Frank Lloyd Wright (second paper, May 1914).
P. 25–52 text, p. 25–36 advertisements.

7-5 1925
The Lifework of Frank Lloyd Wright, part III

Published January 1926
Continuation of *In the cause of architecture* by Frank Lloyd Wright (second paper).
P. 53–76 text, p. I–XII advertisements.
Illustrated *E*
(7-3, 4, 6, 7, 8, and 9 are nearly identical)

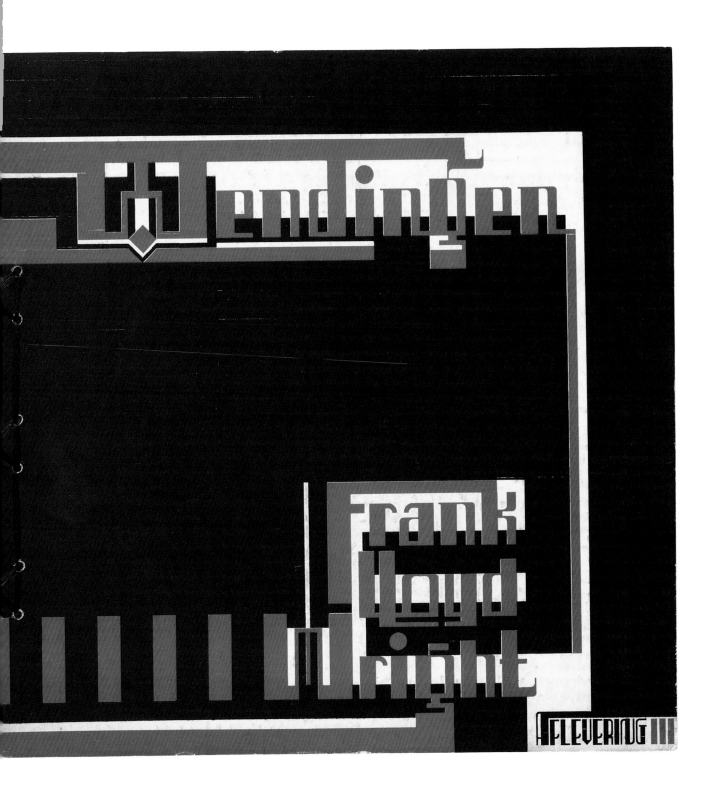

7-6 1926
The Lifework of Frank Lloyd Wright, part IV

Published February 1926

Continuation of *In the Cause of Architecture* by Frank Lloyd Wright (second paper). *Frank Lloyd Wright* by Dr. H. P. Berlage. *The Influence of Frank Lloyd Wright on the Architecture of Europe* by J. J. P. Oud. *Frank Lloyd Wright et l'architecture nouvelle* by Rob. Mallet-Stevens, 1925. P. 77–94 text, p. I–X advertisements.

7-7 1926
The Lifework of Frank Lloyd Wright, part V

Published March 1926

Frank Lloyd Wright by Erich Mendelsohn. *Concerning the Imperial Hotel Tokyo, Japan* by Louis H. Sullivan, 1923. P. 95–118 text, p. I–X advertisements.

7-8 1926
The Lifework of Frank Lloyd Wright, part VI

Published March 1926

Continuation of *Concerning the Imperial Hotel Tokyo, Japan* by Louis H. Sullivan, 1923. *Reflections on the Tokyo Disaster* by Louis H. Sullivan, 1924. P. 119–140 text, p. I–VIII advertisements.

7-9 1926
The Lifework of Frank Lloyd Wright, part VII

Published April 1926

To my European Co-workers by Frank Lloyd Wright. P. 141–164 text, p. I–VIII advertisements. The seven numbers consist of more than 200 illustrations, floorplans and drawings by Frank Lloyd Wright.
The cover for the single numbers was produced typographically after a design by H. Th. Wijdeveld.[89] The title page in the first of the series and the book was designed by Frank Lloyd Wright.

Publication versions Single issues 7-3. *e* through 7-9. *e*; 7-3. *E* through 7-9. *E* [90] In book form: 7-3/9. *e* (linen binding with a line motif and back vignette after a design by Frank Lloyd Wright. The binding was available separately for ƒ 3,50); 7-3/9. *E*, (white leather or linen cover with back vignette after a design by Frank Lloyd Wright); 7-3/9. *X*, (white half-leather or vellum binding with line motif and back vignette after a design by Frank Lloyd Wright). Edition of single numbers 1110 (7-3. *e* through 7-9. *e*: 1100; 7-3. *E* through 7-9. *E*: 10). Price of single numbers: 7-3. *e* through 7-9. *e*: ƒ 6,–; 7-3. *E* through 7-10. *E*: ƒ 7,–. Price of the book: 7-3/9. *e*: ƒ 30,– (presubscription: ƒ 20,–),[91] 7-3/9. *E*: ƒ 35,–, 7-3/9. *X*: ƒ 45,–.
It was also possible to obtain the book in normal, deluxe linen, or deluxe vellum through trading in a single number with an extra payment of 5, 10, or 20 guilders.[92] Edition of the book: 7-3/9. *e*: ca. 650,[93] 7-3/9. *E*: ca. 3000 (including at least 140 unbound copies for William Helburn Inc. in New York City and ca. 500 unbound copies for the American publisher A. Kroch & Son in Chicago), and 7-3/9. *X*: ca. 10 + 240 unbound.[94]

Special characteristics The idea for the Wright series was proposed by Wijdeveld during the A et A board of directors meeting on February 13, 1925.[95] At the board of directors meeting on January 21, 1926 it was confirmed that the printing of number three (7-5. *e*) was better than the previous one, suggesting that the cover for 7-3. *e* was not made by the regular printer.[96] In some copies of 7-3. *e* there is a statement by

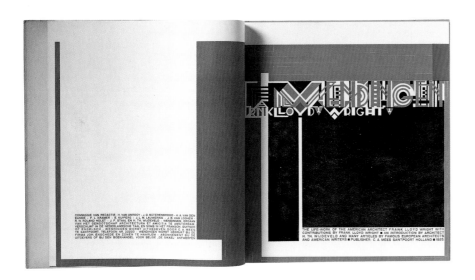

the publisher and printer pasted on the inside of the cover. The black of Wright's title page, actually intended to be a cover, on his instructions had to be printed as on the cover for 4-12.[97] Wright preferred that the book's binding method not be visible.[98] For the deluxe editions paper was used that was almost 33 percent heavier than that used for the single publications. Because of the paper difference, 7-3/9. *E* is much thicker (17 mm) than 7-3/9. *e* (12 mm). 7-3/9. *E* is the version intended for export to America. According to a notice in 7-4. *e* and following numbers, 7-3/9. *X* would be a numbered publication, but Wijdeveld could remember only ten copies being produced.[99] 7-3/9. *e* has the Wijdeveld endpapers printed on normal paper. 7-3/9. *E* had special endpapers using the name Frank Lloyd Wright. In 7-3/9. *e* as well as 7-3/9. *E* the

endpapers are so far as is known bound inside out. Frank Lloyd Wright was very pleased: "First seventh with bouquet received with admiration for both, he cabled to Wijdeveld after receiving the first part."[100] Wright went on to suggest that the publisher A. Kroch & Son in Chicago would purchase 2000 copies of the book (*E*). He ordered 100[101] himself. As a result of these anticipated orders the first two already published numbers were reprinted.[102] The order from Kroch did not come through, whereupon the new edition remained unbound. In 1947, Kroch did take the remaining stock of around 500 copies and had them bound himself (E-Kroch).[103] In 1946, William Helburn Inc. in New York City also took 140 unbound copies.[104] The text appeared in Dutch in various numbers of *Architectura*.[105] Previously in *Architectura*, there

had also been an account of Erich Mendelsohn's visit with Frank Lloyd Wright in America.[106] Mendelsohn was introduced to Wright by H. P. Berlage.[107] Wijdeveld, on the occasion of the 1931 Wright exhibition, which he organized at the Stedelijk Museum in Amsterdam, suggested to Wright that the works which had not previously appeared in *Wendingen* be published in a second *Wendingen* book which in turn could become a series.[108] The plan, though, was never carried out. The poster designed by Wijdeveld for the 1931 exhibition was signed by prominent Dutch architects and sent to Wright, who kept a photograph of it in the front of his copy of the *Wendingen* book.[109] Reprints: In 1965, the Horizon Press in New York published an accurate reprint with extra illustrations, more information, and a foreword by Wright's widow.[110]

Wijdeveld was enraged over the fact that he was not consulted about this reprint.[111] Dover Publications in New York published in ca. 1992 an inexpensive reprint with a foreword by Donald Hoffmann.[112] Gramercy Books in New York also published an inexpensive reprint in 1994.[113]

7-3/9 e

7-3/9 E

7-3 E

7-9 E-Kroch

7-10 1925
M. de Klerk, Furniture and Interiors

Published May/June 1926
Introduction by H. Th. Wijdeveld. Forty-one illustrations of designs and completed furniture by the architect M. de Klerk. P. 1–20 text, p. 21-26 advertisements.

Cover Lithograph by Fokko Mees
Publication versions *d; D*
Edition Ca. 1400 (*d*: ca. 1300; *D*: ca. 100)
Price *d*: ƒ 6,–; *D*: ƒ 7,50
Special characteristics This was the fifth, and with numbers 6-2, 6-4/5, 6-7 and 6-9/10, the last number of the de Klerk series as is also evident at the end of p. 20.[114] This number was still completely edited by Wijdeveld.[115] The poor printing led to a conflict with the publisher and resulted in a new printer being selected for the next volume.[116] The executive board of A et A and the *Wendingen* editorial board were also dissatisfied with the cover design.[117] The de Klerk book appeared around June 1927 in a brown linen cover with title printed in gold.[118] There had been some talk of an introduction by Blaauw and a photograph of de Klerk, but a copy in which they appear has not been found.[119] At the auction on 28 December 1934, Forty-six copies were offered for sale.
Illustrated *D*

7-11/12 1925
P. L. Kramer, the Bijenkorf in The Hague

Published September/October 1926
Introduction by J. M. Luthmann. Ninety-one illustrations of interiors and exteriors with sculpture, stained glass, etc. and floorplans for the Bijenkorf building at The Hague by the architect P. L. Kramer.

Cover Lithograph after a drawing by J. M. Luthmann
Publication versions d; D
Edition 1350 (d: 1250; D: 100)
Price d: ƒ 7,50–; D: ƒ 10,–
Special characteristics Because they were waiting on the copy for a Paris Art Deco number, it was decided at the A et A board of directors meeting on April 20, 1926 to publish the Bijenkorf number edited by Wijdeveld. Actually, Wijdeveld had already been commissioned by the Bijenkorf[120] management to produce a book on the subject, which appeared soon after the *Wendingen* number.[121] Although already announced by the publisher, the issue on the Paris exhibition was never produced. Architect Kramer wrote to the publisher: "May I offer my compliments for the careful manner in which this number was produced?"[122]
Illustrated D

Published March 1 1927 [123]
Introduction by Johan Polet.
Thirty-eight illustrations of
sculpture by the Dutch
artists Hildo Krop, Johan
Polet, and John Rädecker.
P. 1–24 text, p. 25–28 adver-
tisements.

Cover Lithograph after a
woodcut by Johan Polet
Publication versions *d*; *D*
Edition Ca. 1300 (*d*: ca. 1250;
D: ca. 50)
Price *d*: ƒ 6,–; *D*: ƒ 7,50
Special characteristics Beginning
with this number, the dis-
tinctive heading introduced
in 5-1 is replaced by *Wendin-
gen* which is repeated on the
title page. *D* appeared with-
out the Wijdeveld endpapers
and with advertisements on
pp. 25–28
Illustrated *D*

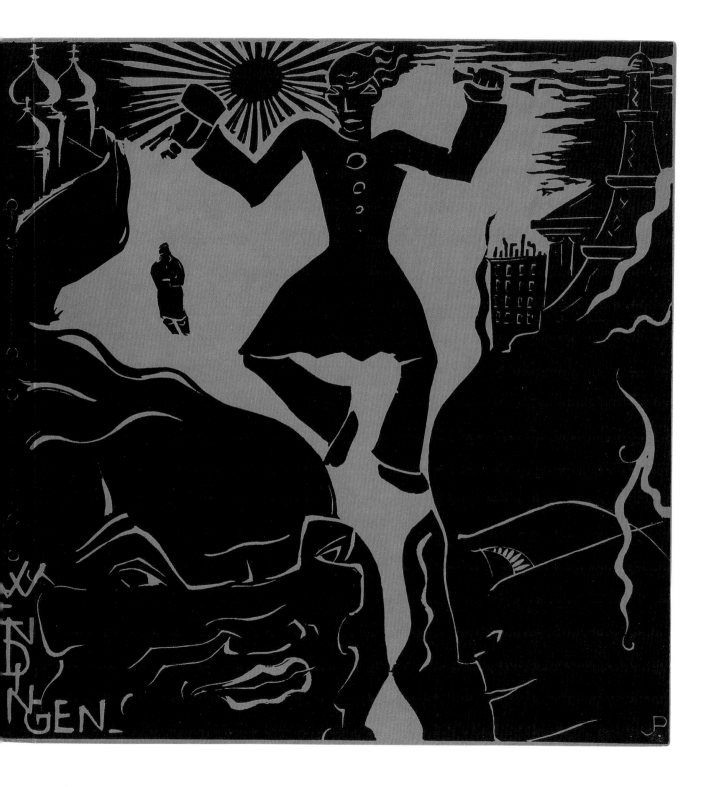

8-2 1927
Interiors

Published 15 July 1927 [124]
Introduction by W. M. Dudok.
Thirty-two Photographs of
interiors and furniture and
two floorplans of rooms by
the Dutch architects C. J.
Blaauw, W. M. Dudok, Piet
Kramer, S. van Ravesteyn,
Schröof and G. Rietveld,
A. F. van der Wey and H.
Wouda. P. 1–18 text, p. 19–22
advertisements.

Cover Lithograph by
Otto B. de Kat
Publication versions d; D
Edition Ca. 1300 (d: ca. 1250;
D: ca. 50)
Price d: ƒ 6,–; D: ƒ 7,50
Special characteristics D appeared
with advertisements on pages
19-22.
Illustrated D

The Flemish Popular Theater, Joh. de Meester Junior

Published September 1927 [125]
Accompanying texts by Joh. de Meester and M. de Ghelderode (the French issue includes a text by Jacques Copeau). Thirty-two illustrations of decors, floorplans, scenery, etc. for the performance of Anton van de Velde's *Tijl, and Where the Star Stands Still, (Tijl, En waar de Ster bleef stille staan),* Reinaert de Vos, Marieken van Nijmegen, *Vondel's Lucifer,* Little Images from the Life of St. Francis, *Marlborough Goes to War, A-Z play,* by the Flemish Popular Theater. P. 1–18 text, p. 19–22 advertisements.

Cover Lithograph after a drawing by Anton Kurvers
Publication versions *d; D; f; F(?)*
Edition Ca. 1450 (*d:* ca. 1250; *D:* ca. 50; *f:* ca. 250)
Price *d: ƒ* 6,–; *D: ƒ* 7,50
Special characteristics The Flemish Popular Theater held a performance of Anton van de Velde's *Tijl* at the Stadsschouwburg in Amsterdam on May 8, 1926 under the direction of Johan de Meester Jr. A et A members received a 25 percent reduction.[126]
D appeared with advertisements on pages 19–22; *f* has an introduction by Jacques Copeau and appeared without advertising pages.
Illustrated *D*

8-4 1927
Danish Architecture

Published October 1927
Introduction by Prof. Dr. F. S. Slothouwer. Nineteen illustrations and five floorplans of buildings by the Danish architects Skovgaard, H. H. Kampmann, Rafn, Jacobsen, H. J. Kampmann, Fisker, Jensen Klint, C. Petersen, Baumann, Hjejle, and Rosenkjaer and Helsöe. P. 1–18 text, p. 19–20 advertisements.

Cover Lithograph after a drawing by S. Jessurun de Mesquita
Publication versions *d*; *D*
Edition Ca. 1500 (*d*: ca. 1450; *D*: ca. 50)
Price *d*: ƒ 6,–; *D*: ƒ 7,50
Special characteristics *D* appeared with advertisements on pages 19–20, the endpapers are bound inside out. This number was also available with an inserted English text.[127] It was intended to publish numbers 8-4, 8-5, 8-7, and a Norwegian number as a single book in English. This is also probably the reason that the covers are identical as with the Frank Lloyd Wright series. The book never materialized due to the fact that the Norwegian number was never published.[129]
Illustrated *D*

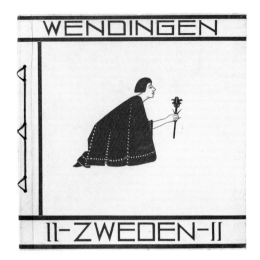

8-5 1927
Swedish Architecture

Published Ca. November/
December 1927
Introduction and cover as
with 8-4. Thirty-four illustra-
tions and four floorplans of
the Stockholm City Hall and
other monumental buildings
by the Swedish architects Ost-
berg, Asplund, Ericson, Teng-
bom, Ahlberg, Bergsten, and
Milles. P. 1–24 text, p. 25–26
advertisements.

Cover Lithograph after a draw-
ing by S. Jessurun de Mesquita
(reprint of cover 8-4)
Publication versions d ; D
Edition Ca. 1500 (d: ca. 1450;
D: ca. 50)
Price d: f 6,–; D: f 7,50
Special characteristics D
appeared with advertisement
on pages 25–26, the endpa-
pers are bound inside out.
This number was also
available with an inserted

English text. Also see 8-4.

Illustrated D

8-8 1927
Swedish Arts and Crafts

Published Ca. February 1928
Introduction by Prof. D. F.
Slothouwer, engineer. Thirty-
two illustrations of furniture,
weaving, wrought iron, chas-
ing, etc. by the Swedish
artists Milles, Gate, Hald,
Björk, Gahn, Osterberg,
Anderson, Munthe, Percy,
Angman, Aageson, Maskelins,
Malmsten, Ryberg, Grage,
Bergsten, Asplund, Gullberg
and others. P. 1–24 text,
p. 25–26 advertisements.

Cover Lithograph after a draw-
ing by S. Jessurun de Mesquita
(reprint of cover 8-4)
Publication versions d ; D
Edition Ca. 1500 (d: ca. 1450;
D: ca. 50)

Price d: f 6,–; D: f 7,50
Special characteristics D appeared
with advertisements on pages
25–26. This number was also
available with an inserted
English text. Also see 8-4.

Illustrated D

8-6/7 1927
Architecture in the Amsterdam Plan West

Published January 1928
Introduction by J. Boteren-
brood. Thirty-two Page-size
illustrations of gable archi-
tecture in Amsterdam West
by the Dutch architects:
Blaauw, Berlage, Franswa,
Heineken and Kuipers,
Kropholler, van der Mey,
Noorlander, Peters, Rooden-
burg, Rutgers, Staal, Wester-
man, and Wijdeveld.
P. 1–36 text, p. 37–38 adver-
tisements.

Cover Lithograph after a
drawing by J. A. Snellebrand
Publication versions *d*; *D*
Edition Ca. 1300 (*d*: ca. 1250;
D: ca. 50)
Price *d*: ƒ 7,50; *D*: ƒ 9,–
Special characteristics *D*
appeared with advertise-
ments on pages 37–38.
According to the publisher,
this number was also avail-
able with an inserted English
text.
Illustrated *D*

WENDINGEN.

AMSTERDAM.WEST

8-9/10 1927
Austrian Art

Published Ca. March 1928
Introduction by Dr. G. Knut-
tel Wzn. Forty illustrations
after paintings and drawings
by Oskar Kokoschka, Gustav
Klimt, Egon Schiele, Hans
Boehler, Anton Faistauer,
L. H. Jungnickel, Max Oppen-
heimer, Ferdinand Kitt,
Anton Kohlig, Robin C.
Andersen, Paris van Guter-
sloh, Maria Strauhs-Litarsk.
Ceramic figures by Vally
Wieselthier, Susi Singer-
Schinnerl, Herta Bucher,
M. Powolny, Mathilde Floegl,
Franz van Zülow; glass work,
chasing, etc. by Josef Hoff-
mann, Michael Powolny, and
Christa Ehrlich. P. 1–30 text,
p. 31–32 advertisements.

Cover Lithograph after a
drawing by Christa Ehrlich
Publication versions *d*; *D*
Edition Ca. 1300 (*d*: ca. 1250;
D: ca. 50)
Price *d*: ƒ 7,50; *D*: ƒ 9,–
Special characteristics This num-
ber was published with a
cover in the Austrian
national colors on the occa-
sion of the Austrian exhibi-
tion in the Netherlands.[130]
D appeared with advertise-
ments on pages 31–32. This
number was also available
with an inserted English text.
Illustrated *D*

OOSTENRIJK

WENDINGEN

8-11 1927

The Buildings Department of the Amsterdam Public Works Service

Published April 1928 [131]
Introduction by A. J. van der Steur, engineer. Nineteen illustrations and fourteen floorplans of buildings built by the Public Works Service in Amsterdam. P. 1–18 text, p. 19–20 advertisements.

Cover Lithograph after a drawing by P. L. Marnette
Publication versions *d*; *D*
Edition Ca. 1300 (*d*: ca. 1250; *D*: ca. 50)
Price *d*: ƒ 6,–; *D*: ƒ 7,50
Special characteristics *D* appeared with advertisements on pages 19–20. According to the publisher, this number was also available with an inserted English text.
Illustrated *D*

WENDINGEN

AFDEELING GEBOUWEN

Published May 31 1928 [132]
Introduction by Dr. H. E. van
Gelder. Thirty-nine illustra-
tions of plastic art and utili-
tarian objects in pottery,
terra-cotta, porcelain by
Dutch, Danish, French,
Finnish, German, and
Belgian artists including
Lanooy, Colenbrander, Senf,
Gauguin, Barlach, Wackerle,
and Lenoble. P. 1–18 text,
p. 19–20 advertisements.

Cover Lithograph after a
drawing by Tine Baanders
Publication versions *d*; *D*
Edition Ca. 1300 (*d*: ca. 1250;
D: ca. 50)
Price *d*: ƒ 6,–; *D*: ƒ 7,50
Special characteristics *D*
appeared with advertise-
ments on pages 19–20. This
number was also available
with an inserted English text.
Illustrated *D*

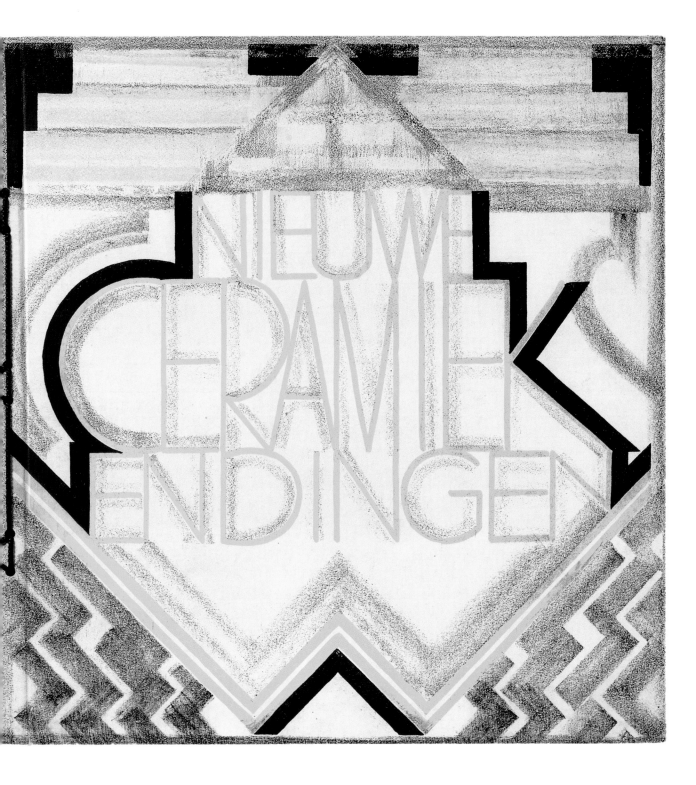

NIEUWE CERAMIEK ENDINGEN

9-1 1928
Architecture of
Dudok

Published July 1928
Introduction by architect
J. Boterenbrood. Eleven
design drawings for the
Dutch Student House in Paris
and nineteen reproductions
and eight floorplans of build-
ings, including the colombar-
ium at Westerveld, schools at
Hilversum, a residence, etc.
P. 1–24 text, p. 25–26 adver-
tisements.

Cover Lithograph after a
drawing by Hendrik Wouda
Publication versions d; D
Edition Ca. 1100 (d: ca. 1050;
D: ca. 50)
Price d: f 5,–; D: f 6,–
Special characteristics D
appeared with advertise-
ments on pages 25–26.
Also see 11-11/12.
Illustrated D

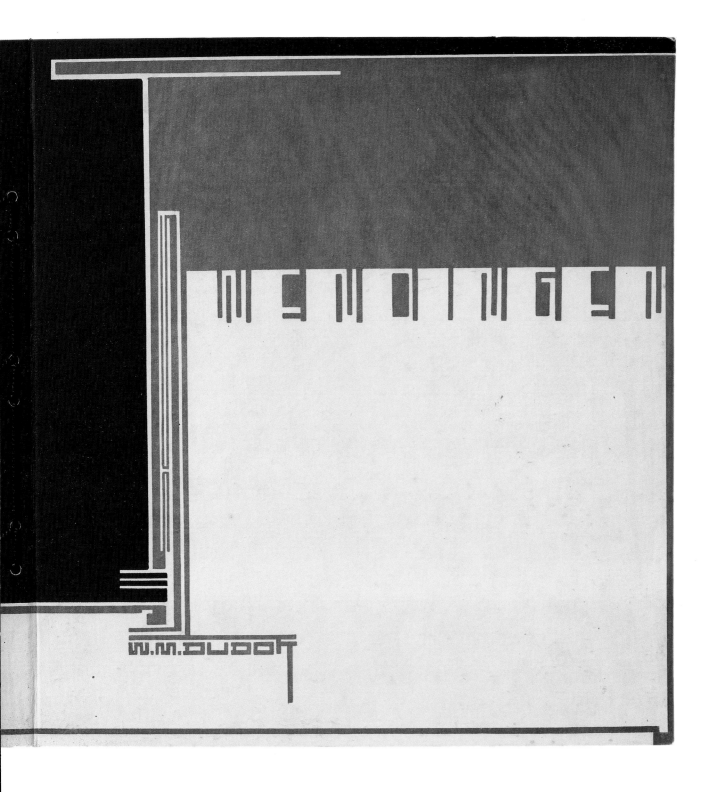

W.M.DUDOK

189

Technology and Art

Published August 1928
Introduction by W. H. Gis-
pen. Twenty-seven illustra-
tions of applied arts consist-
ing of wrought iron, pottery,
enameling, glass, and leather.
P. 1–18 text.

Cover Lithograph after a
drawing by W. H. Gispen
Publication versions *d*; *D*
Edition Ca. 1100 (*d*: ca. 1050;
D: ca. 50)
Price *d*: ƒ 5,–; *D*: ƒ 6,–
Illustrated *D*

TECHNIEK EN KUNST

WENDINGEN

1928

9-3/4 1928
Work by Jan Toorop in Private Collections

Published September 1928
Introduction by H. C.
Verkruysen. Seven illustrations from *The Offer* in pencil
and chalk, eight reproductions of portraits and other
works from private collections. P. 1–30 text.

Cover Lithograph by Prof.
R. N. Roland Holst
Publication versions d; D
Edition Ca. 1100 (d: ca. 1050;
D: ca. 50) seizure
Price d: ƒ 7,50; D: ƒ 8,50
Special characteristics Toorop,
who died in March 1928, had
agreed to the publication
while still alive, and, as
noted on page 3, reproduction rights were secured.
However, the publisher
F. P. Abrahamson, who had
acquired the rights to some
of the images, had the
remaining copies of this
issue withheld on October
16, 1928. Publisher C. A.
Mees had to pay a fine, which
A et A helped to cover because
of moral obligations.[133] Pages
5, 8, 11, and 13 were removed
from the withheld copies.
Illustrated D

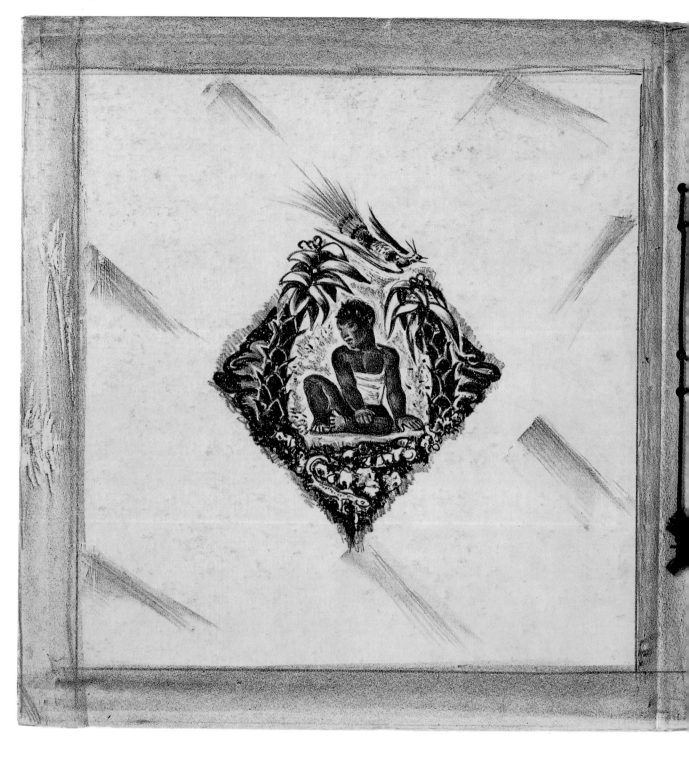

192

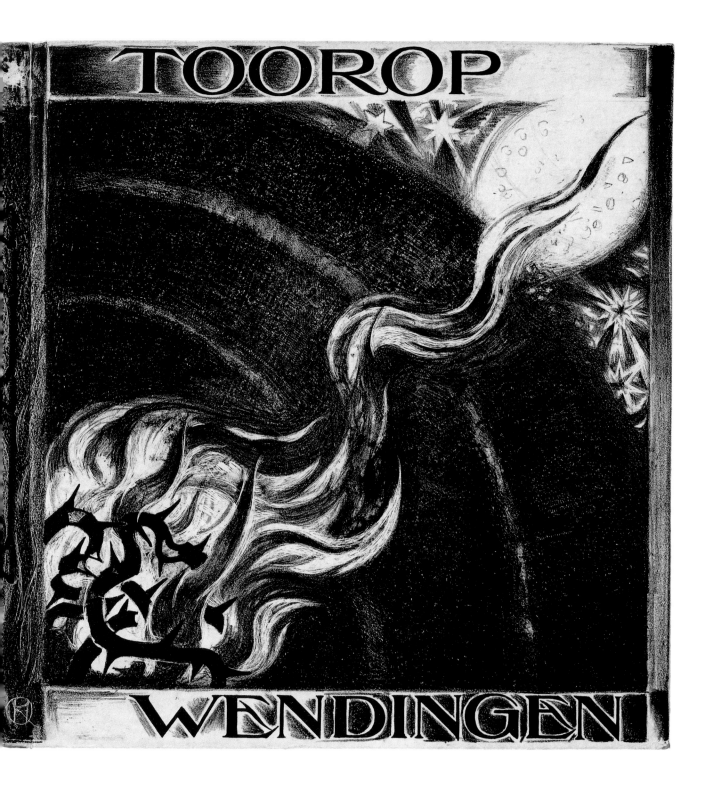

9·5 1928
Hindu-Javanese Sculpture

Published October 1928
Introduction by T. B. Roorda.
Twenty-eight illustrations of
temple and other sculpture
in Java. P. 1–18 text.[134]

Cover Lithograph after a
drawing by J. ten Klooster
Publication versions *d; D*
Edition Ca. 1100 (*d*: ca. 1050;
D: ca. 50)
Price *d*: ƒ 5,–; *D*: ƒ 6,–
Special characteristics This num-
ber was also available with
an inserted English text.
Illustrated *D*

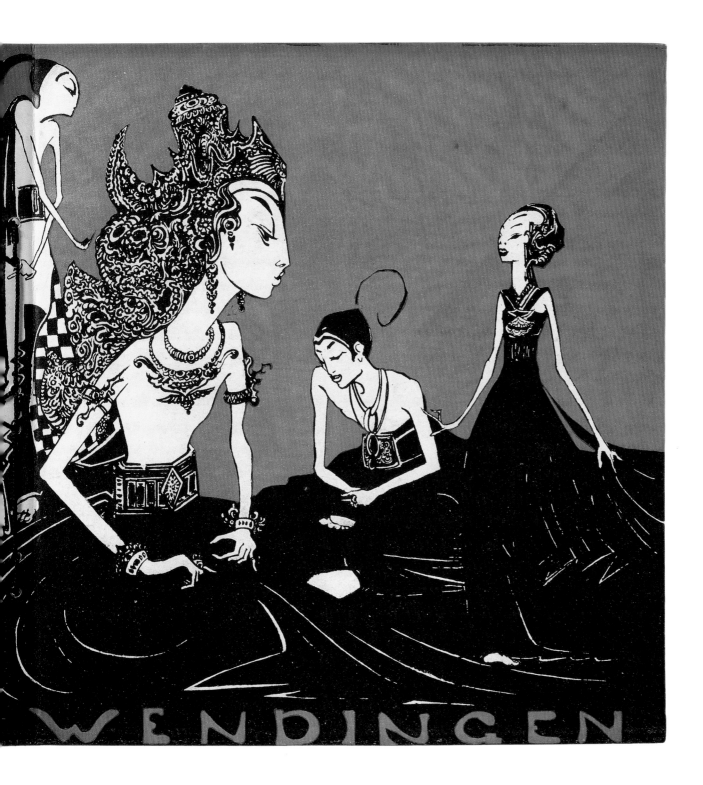

9-6/7 1928
Sculpture

Published November 1928
Introduction by L. Bolle.
Fifty-two illustrations of
work by the Dutch sculptors
A. van den Eynde, L. Bolle,
Theo van Reijn, H. Chabot,
Gijs J. van den Hof, Tjipke
Visser, F. J. van Hall, and M.
Andriessen. P. 1–36 text.

Cover Lithograph after a
drawing by N. J. van de Vecht
Publication versions *d*; *D*
Edition Ca. 1100 (*d*: ca. 1050;
D: ca. 50)
Price *d*: ƒ 7,50; *D*: ƒ 8,50
Illustrated *D*

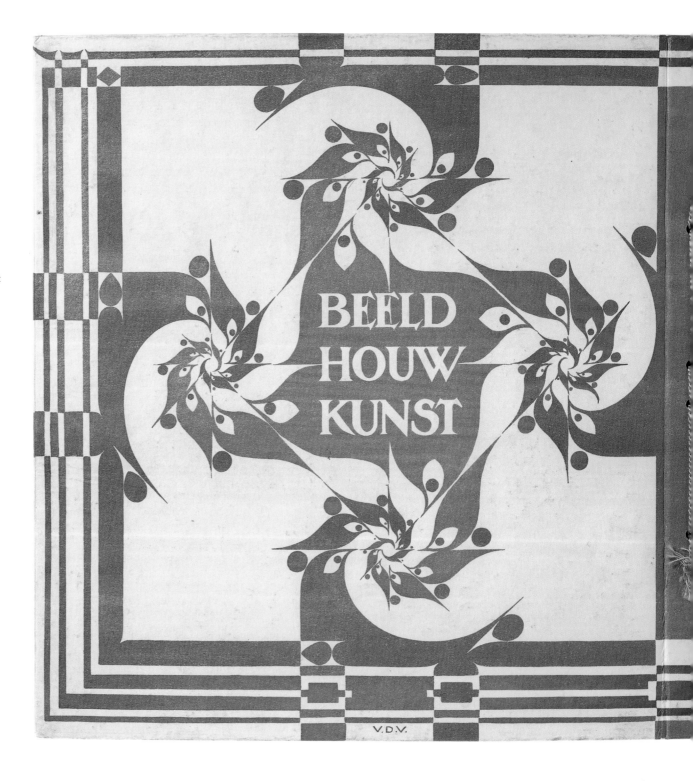

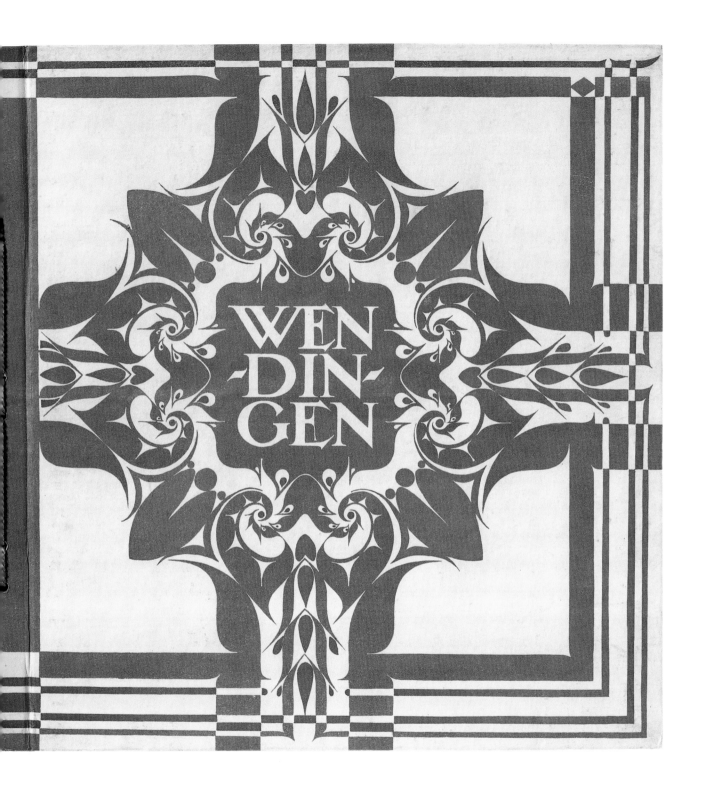

Published Ca. December 1928
Introduction by Just Have-
laar. Twenty-four reproduc-
tions of drawings, mainly
political cartoons.

Cover Lithograph after a
drawing by Albert Hahn Jr.
P. 1–24 text.
Publication versions d; D
Edition Ca. 1100 (d: ca. 1050;
D: ca. 50)
Price d: ƒ 5,–; D: ƒ 6,–
Illustrated D

9-9 1928
Johan Thorn Prikker

Published January 1929
Introduction by J. W. H. Leur-
ing. Sixteen illustrations of
work by Thorn Prikker
including decoration designs
for the Rotterdam City Hall,
mosaics for the Duinoord
Church at The Hague, and
other reproductions of deco-
rative drawings. P. 1–18 text.

Cover Lithograph after a
woodcut by Hildo Krop
Edition Ca. 1100 (d: ca. 1050;
D: ca. 50)
Price d: ƒ 5,–; D: ƒ 6,–
Publication versions d; D
Special characteristics Already in
1926, the editorial board was
asked by some A et A mem-
bers from The Hague to
devote a number to Thorn
Prikker.[135]
Illustrated D

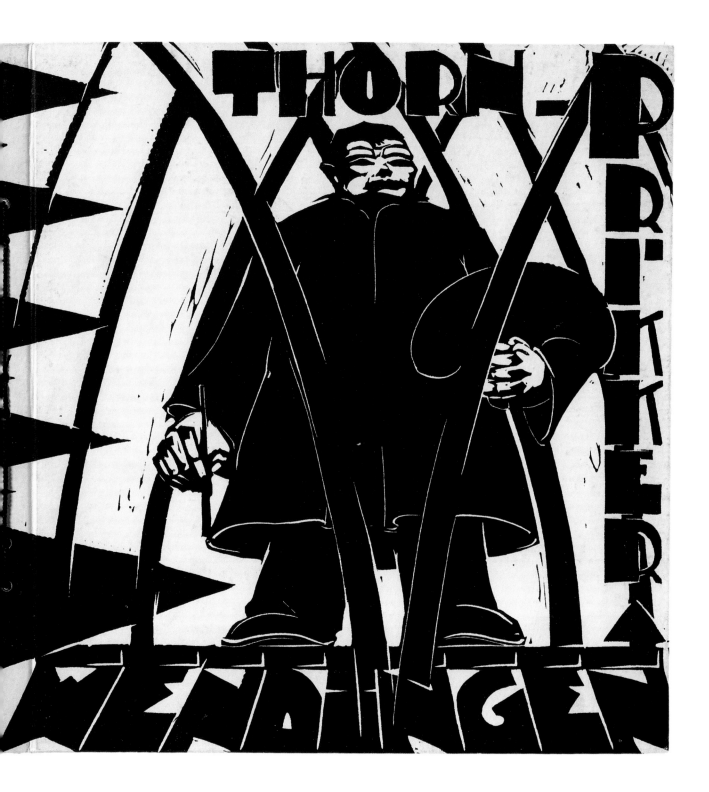

9-10 1928
Graphic Art

Published Ca. March 1929
Introduction by S. Moulijn.
Sixteen reproductions of
woodcuts, lithographs, and
etchings by Veldheer, Fokko
Mees, ten Klooster, Oepts
van Veen, Roland Holst,
de Mesquita, and others.
P. 1–18 text.

Cover Lithograph after a
drawing by S. Jessurun de
Mesquita
Publication versions d; D
Edition Ca. 1100 (d: ca. 1050;
D: ca. 50)
Price d: ƒ 5,–; D: ƒ 6,–
Illustrated D

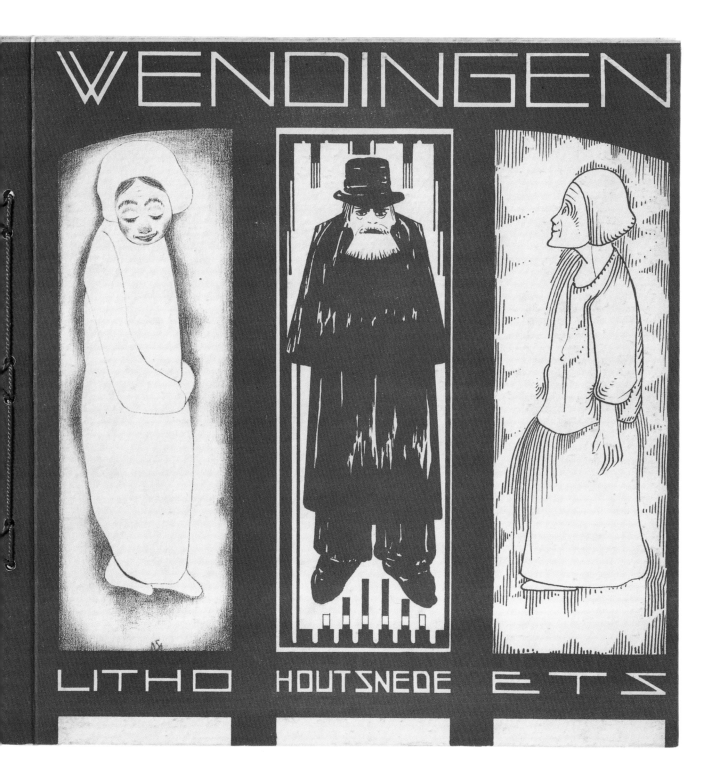

WENDINGEN

LITHO HOUTSNEDE ETS

9-11 1928
Dolls and Marionettes
by Grietje Kots

Published Ca. April 1929
Introduction by T. Landré.
Twenty illustrations of dolls
and marionettes by Grietje
Kots and a selection of pre-
liminary study reproduc-
tions. P. 1–18 text.

Cover Lithograph by
A. Kurvers
Publication versions d; D
Edition Ca. 1100 (d: ca. 1050;
D: ca. 50)
Price d: ƒ 5,–; D: ƒ 6,–
Illustrated D

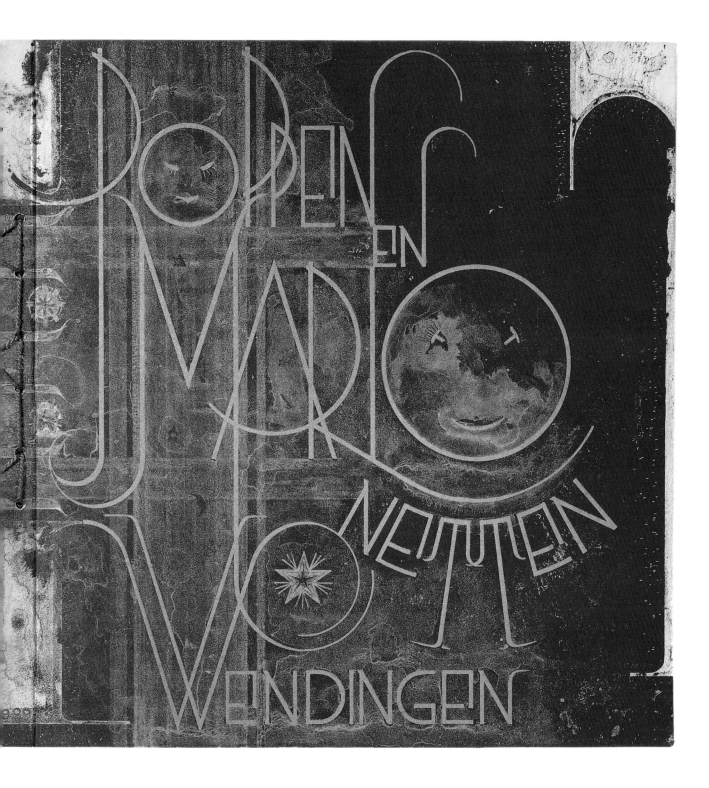

POPPEN EN MARIONETTEN

WENDINGEN

9-12 1928
Russian Icons

Published May/June 1929
Introduction by L. H.
Grondijs. Sixteen illustra-
tions of Russian icons from
the fourteenth and fifteenth
centuries.

Cover Lithograph after a
drawing by K. Katkof
P. 1–18 text.
Publication versions *d; D*
Edition Ca. 1100 (*d*: ca. 1050;
D: ca. 50)
Price *d*: ƒ 5,–; *D*: ƒ 6,–
Special characteristics This num-
ber was cited in *Het Vaderland*
on June 8, 1929. *D* appeared
with blank endpapers.
Illustrated *D*

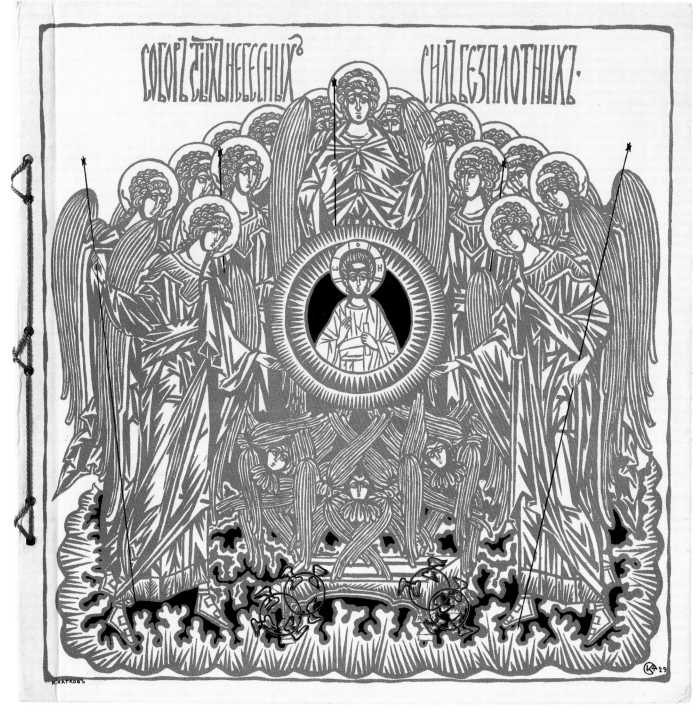

10·1 1929
Sculpture by Ossip Zadkine

Published July 1929
Introduction by van den Eeckhout. Sixteen illustrations of sculpture by the Russian sculptor Ossip Zadkine. P. 1–18 text.

Cover Lithograph after a woodcut by Hildo Krop

Publication versions *d*; *D*

Edition Ca. 1050 (*d*: ca. 1000; *D*: ca. 50)

Price *d*: ƒ 5,–; *D*: ƒ 6.–

Illustrated *D*

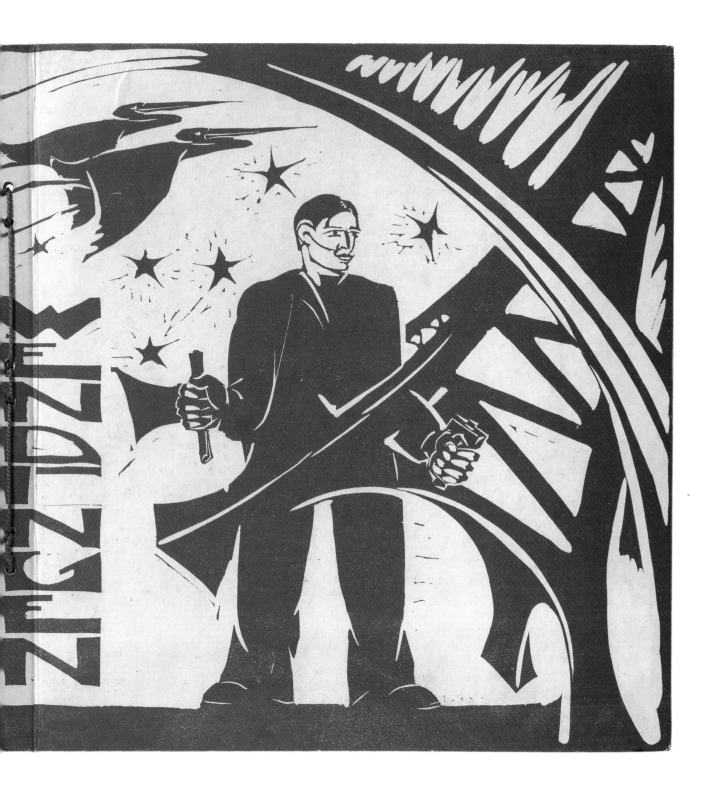

10-2 1929
Glass by Chris Lebeau

Published Ca. September 1929.
The introduction by Just
Havelaar precedes Sixteen
illustrations of glass decora-
tive designs by the artist
Chris Lebeau. P. 1–18 text.

Cover Lithograph by Chris
Lebeau
Publication versions d; D
Edition Ca. 1050 (d: ca. 1000;
D: ca. 50)
Price d: ƒ 5,–; D: ƒ 6.00
Special characteristics In D the
Wijdeveld endpapers are
bound inside out.
Illustrated D

211

**The Paintings of
Diego (de la) Rivera**

Published Ca. October 1929
Introduction and description
of Rivera's painting by H. P.
L. Wiessing, followed by
Twenty-four of murals by the
Mexican artist. These frescos
mainly relate to the revolu-
tion in Mexico between 1910
and 1925. P. 1–24 text.

Cover Lithograph after a
design by Vilmos Huszar
Publication versions *d; D*
Edition Ca. 1050 (*d*: ca. 1000;
D: ca. 50)
Price *d: ƒ* 5,–; *D: ƒ* 6,–
Special characteristics In *D* the
endpapers designed by
Wijdeveld are bound inside
out.
Illustrated *D*

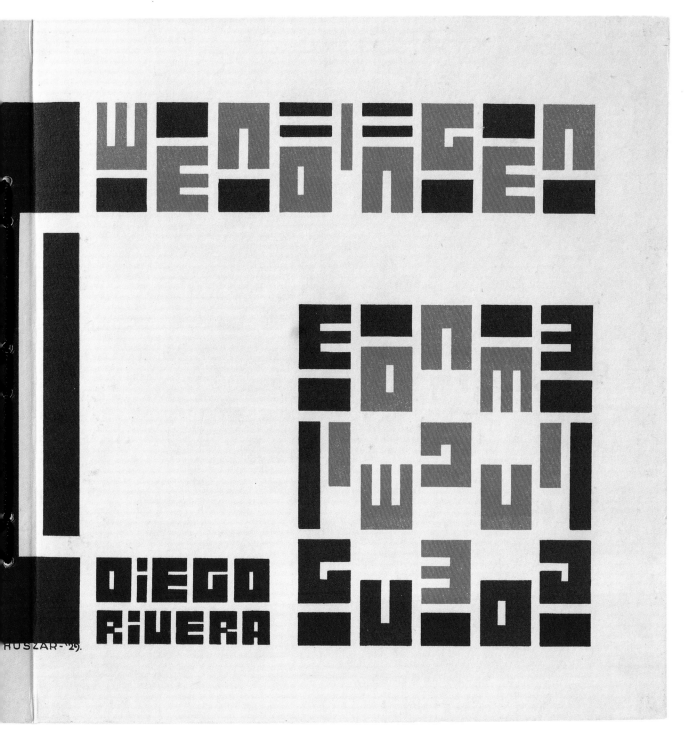

DIEGO RIVERA

HUSZAR-'29.

213

10-4 1929
Restoration of the St. Nicolas Church (St. Nicolaaskerk) at IJsselstein

Published Ca. November 1929
Accompanying texts by
Dr. Jan Kalf and architect
C. J. Blaauw. Seven illustra-
tions of designs for the
restoration of the St. Nicolas
Church tower at IJsselstein
by the late architect M. de
Klerk; Sixteen illustrations
of Hildo Krop's sculpture for
the capitals and two illustra-
tions of the new entrance
by the construction supervi-
sor, the architect Baanders.
P. 1–18 text.

Cover Lithograph by
J. S. Sjollema
Publication versions *d*; *D*
Edition Ca. 1050 (*d*: ca. 1000;
D: ca. 50)
Price *d*: ƒ 5,–; *D*: ƒ 6,–
Illustrated *D*

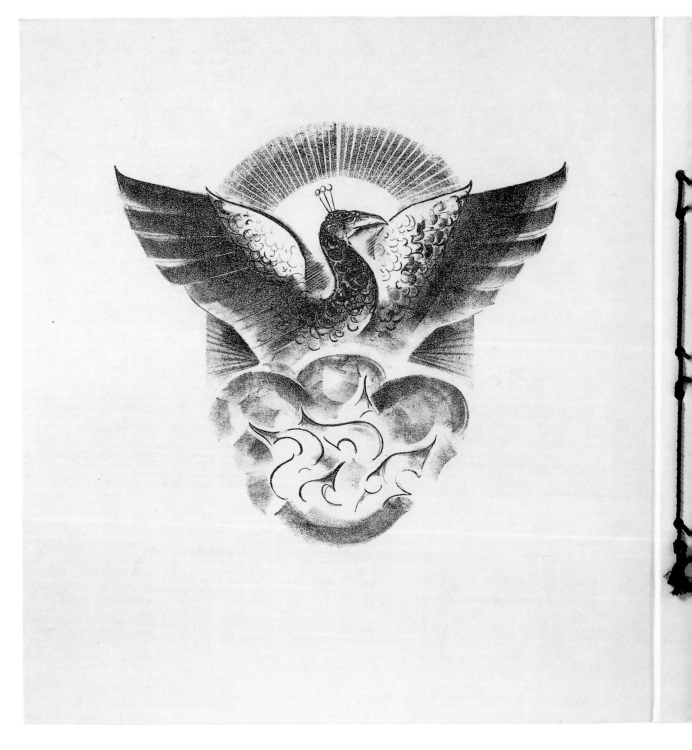

214

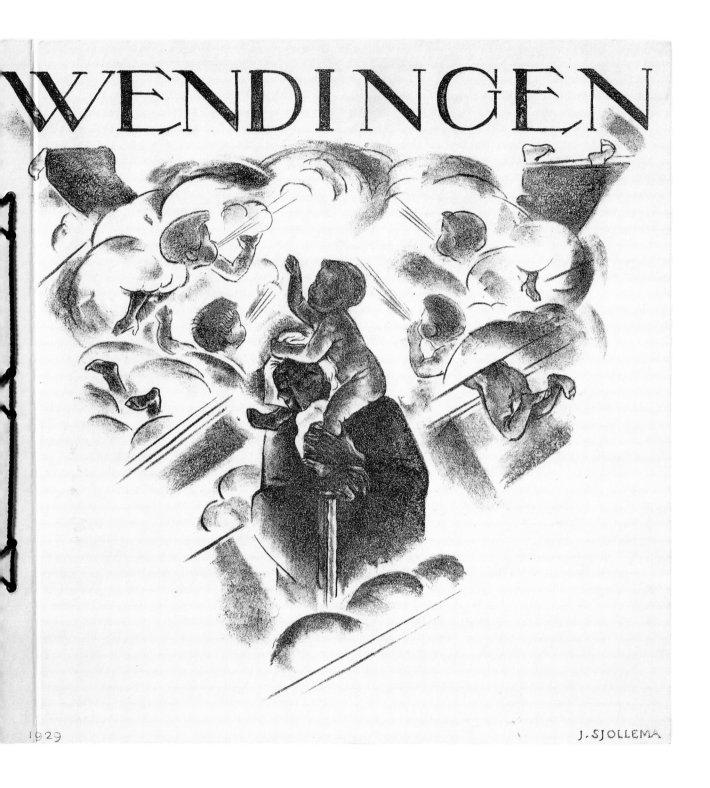

WENDINGEN

1929

J. SJOLLEMA

10-5/6 1929
The Architecture
of J. F. Staal

Published Ca. January 1930
Introduction by A. J. van der
Steur, engineer. Forty-two
illustrations of both executed
and yet to be executed com-
petition designs by the archi-
tect J. F. Staal including the
De Telegraaf building, the Auc-
tion House Aalsmeer and the
competition for the Amster-
dam Museum Theater.
P. 1–36 text.



Cover Lithograph after a
drawing by Margaret
Kropholler
Publication versions *d*; *D*
Edition Ca. 1275 (*d*: ca. 1200;
D: ca. 75)
Price *d*: ƒ 5,–; *D*: ƒ 6,–
Illustrated *D*







216

Paintings by Lyonel Feininger

Published February 1930
Introduction by Dr. Redslob.
Sixteen images by the
graphic artist and painter
Lyonel Feininger. P. 1–18
text.

Cover Lithograph by Tine
Baanders
Publication versions d; D
Edition Ca. 1050 (d: ca. 1000;
D: ca. 50)
Price d: f 5,–; D: f 6,–
Illustrated D

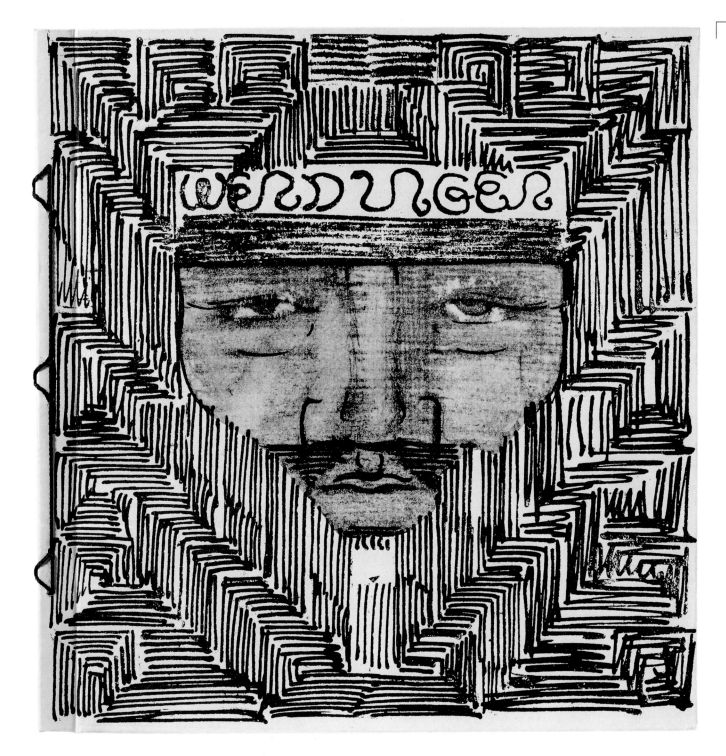

10-8 1929
J. L. M. Lauweriks

Published Ca. April 1930
Introduction by architect Jan
de Meyer. The contents con-
sist of illustrations of
graphic work, metal work,
interior designs, and archi-
tecture by the architect
J. L. M. Lauweriks. P. 1–24
text.

Cover Lithograph after a
design by J. L. M. Lauweriks
Publication versions *d*; *D*
Edition Ca. 1050 (*d*: ca. 1000;
D: ca. 50)
Price *d*: ƒ 5,–; *D*: ƒ 6,–
Special characteristics This num-
ber appeared on the occasion
of the inclusion of the arts
and crafts school Quellinus,
of which Lauweriks was
director, into the reorga-
nized Institute for Arts and
Crafts Education. Lauweriks
would also direct the
Institute for Arts and Crafts
Education together with
J. B. Smits. This number was
proposed at the A et A board
of directors meeting on
November 29, 1929.[136]
Illustrated *D*

10-9 1929
Classic Italian Art

Published Ca. June 1930
Introduction by Jan Poorte-
naar. Seventeen reproduc-
tions of Italian paintings
from the fifteenth century
and earlier, including Pol-
laiuola, Cimabue, Lorenzetti,
Giotto, Fra Angelico,
Pisanello, and others.
P. 1–18 text.

Cover Lithograph by Jan
Poortenaar
Publication versions *d; D*
Edition Ca. 1050 (*d*: ca. 1000;
D: ca. 50)
Price *d*: *f* 5,–; *D*: *f* 6,–
Special characteristics In *D* the
Wijdeveld endpapers are
bound inside out.
Illustrated *D*

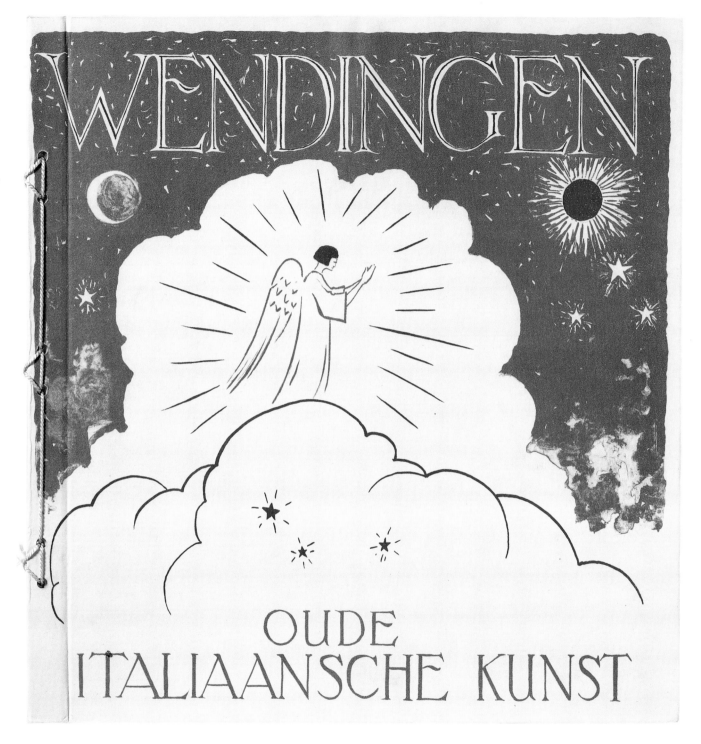

Published Ca. August 1930
Introduction by H. P. L.
Wiessing. Wiessing writes
about the development of the
Russian theater and the the-
ater reformers Stanislawski,
Meyerhold, and Taïroff. The
article is illustrated with
twenty-four photographs of
modern Russian scenery and
theater. P. 1–24 text.

Cover Lithograph after a
woodcut by S. Jessurun de
Mesquita.
Publication versions *d*; *D*
Edition Ca. 1050 (*d*: ca. 1000;
D: ca. 50)
Price *d*: ƒ 5,–; *D*: ƒ 6,–
Illustrated *D*

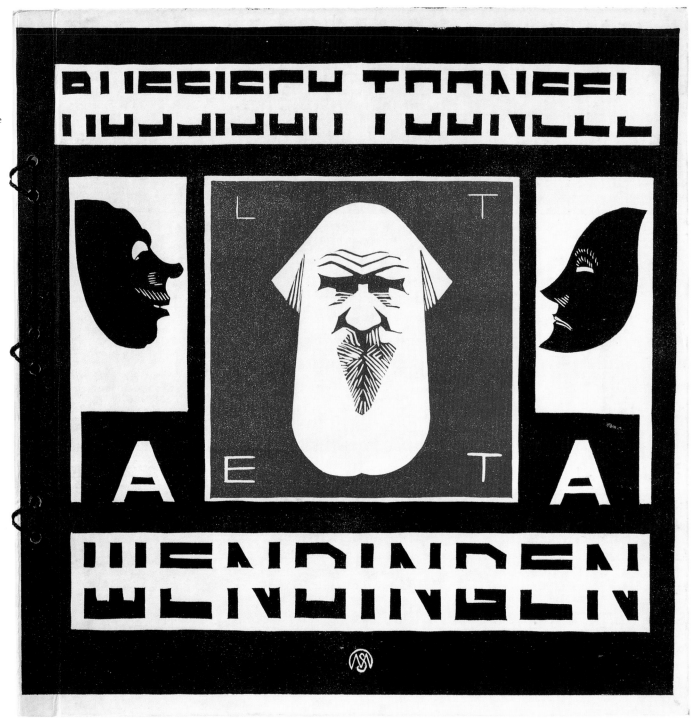

10-11/12 1929
Architecture in the Amsterdam Plan-South

Published Ca. October 1930
Introduction by H. T. Zwiers,
engineer. Twenty-eight illus-
trations of architecture in
the Amsterdam Plan-South
by the architects A. J. Wester-
man, G. J. Rutgers, Ph. A.
Warners and the Amsterdam
Public Works Department.
P. 1–30 text.

Cover Lithograph after a
design by H. T. Zwiers,
engineer
Publication versions d; D
Edition Ca. 1050 (d: ca. 1000;
D: ca. 50)
Price d: ƒ 5,–; D: ƒ 6,–
Illustrated D

Published Ca. November 1930
Introduction and sixteen
photographs of Rothenburg
ob der Tauber by H. C.
Verkruysen. P. 1–18 text.

Cover Lithograph after a
design by A. P. Smits
Publication versions d; D
Edition Ca. 1000 (d: ca. 950;
D: ca. 50)
Price d: f 5,–; D: f 6,–
Special characteristics In D the
Wijdeveld endpapers are
bound inside out.
Illustrated D

WENDINGEN

ROTHENBURG

227

11-2 1930
Van Nelle Factories

Published End of 1930
Introduction by H. T. Zwiers,
engineer. Thirty-five illustra-
tions (including four plans)
of interiors and exteriors for
van Nelle's Office and factory
buildings at Rotterdam by
the architects J. A. Brinkman
and L. C. van der Vlugt.
P. 1–24 text, p. 25–30 adver-
tisements.

Cover Lithograph after a
design by L. C. van der Vlugt
Publication versions *d*; *D*
Edition Ca. 1275 (*d*: ca. 1200;
D: ca. 75)
Price *d*: ƒ 5,–; *D*: ƒ 6,–
Enclosures *d*; *D*. 1: (A substitute
dark blue and silver cover) *d*;
D. 2: (An advertisement for
Vredestein Loosduinen
printed in light purple)
Special characteristics Originally
the publication had a cover
printed in light and dark
blue. Obviously, this did not
meet with the designer's
approval.
A separate cover, printed in
dark blue and silver was
printed as a replacement
and was probably sent to the
subscribers along with 11-3.
11-2. *D* had the light blue as
well as the silver cover.
Reproduced is *D* in silver
and dark blue, the one
evidently preferred by the
designer. The advertise-
ments are for companies
that had contributed to the
building and furnishing of
the van Nelle factories.

228

2 1930

WENDINGEN

D appeared with advertise-
ments on pages 25–30 but
without the Wijdeveld
endpapers.

11·3 1930
The Dutch Pavilion
at Antwerp

Published Ca. January 1931
The Dutch Pavilion at the
Antwerp Exhibition by archi-
tect H. Th. Wijdeveld. This
number consists of fifty-eight
illustrations of plans and
interior and exterior pho-
tographs of the Dutch Pavil-
ion. The introduction is by
J. P. Mieras. P. 1–24 text,
p. 25–28 advertisements.
Cover Lithograph after a
design by W. Roozendaal.
Publication versions *d*; *D*
Edition Ca. 1250 (*d*: ca. 1200;
D: ca. 50)
Price *d*: ƒ 5,–; *D*: ƒ 6,–
Special characteristics The adver-
tisements are for companies
that participated in the
Dutch Pavilion. These were
also bound in *D*.
Illustrated *D*

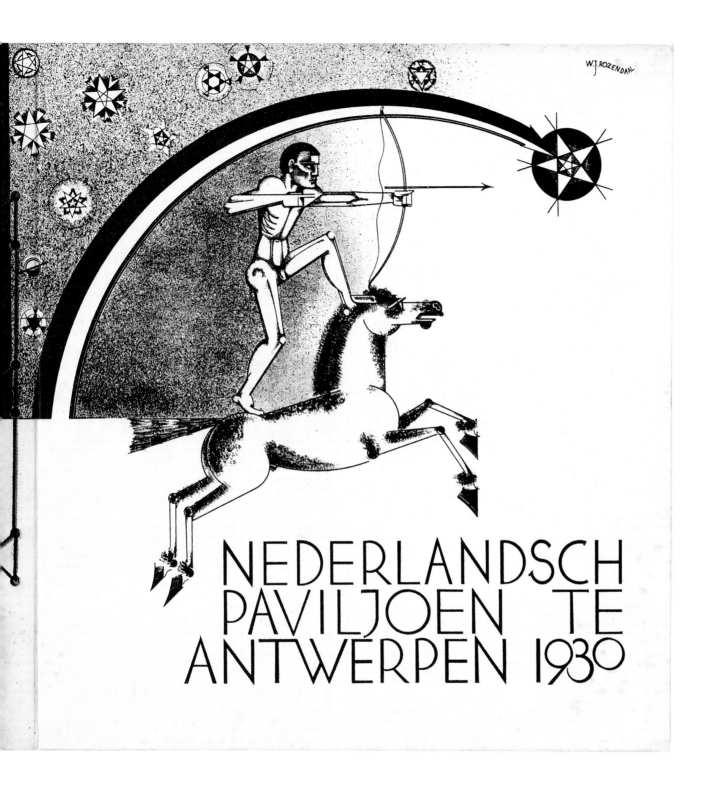

NEDERLANDSCH
PAVILJOEN TE
ANTWERPEN 1930

W.J.ROZENDAAL

11-4 1930
Bourdelle

Published March 1931
Introduction by van den
Eeckhout. Forty-two illustra-
tions of sculpture and a
painting by the French sculp-
tor Antoine Bourdelle, who
died in 1929. P. 1–24 text.

Cover Produced typographi-
cally after a design by
J. Zietsma
Publication versions *d*; *D*
Edition Ca. 1000 (*d*: ca. 950;
D: ca. 50)
Price *d*: *f* 5,–; *D*: *f* 6,–
Special Characteristics Attention
had already been given to
Bourdelle in *Architectura* xxx,
June 19, 1926 no. 25, p. 289.
Illustrated *D*

11·5 1930
Aerial Photographs

Published Ca. April 1931
Introductions by architects
J. Boterenbrood and
J. M. Corsten. Twenty-nine
aerial photographs of Dutch
cities and landscapes made
by KLM. P. 1–18 text.

Cover Lithograph after a
design by Arthur Staal
Publication versions *d*; *D*
Edition Ca. 1000 (*d*: ca. 950;
D: ca. 50)
Price *d*: *f* 5,–; *D*: *f* 6,–
Illustrated *D*

234

Stad

Wendingen

235

11-6/7 1930
**Glass Paintings
and Portraits by
R. N. Roland Holst**

Published Ca. June 1931
Introduction by A. M. Ham-
macher. Thirty-three repro-
ductions of work by R. N.
Roland Holst: portraits and
studies and reproductions of
executed glass paintings.
These include windows and
window details for the Am-
sterdam City Hall, windows
in the Amsterdam Lyceum,
and a window in the Utrecht
Cathedral. P. 1–34 text.

Cover Lithograph by
J. S. Sjollema
Publication versions d; D
Edition Ca. 1000 (d: ca. 950;
D: ca. 50)
Price d: f 5,–; D: f 6,–
Illustrated D

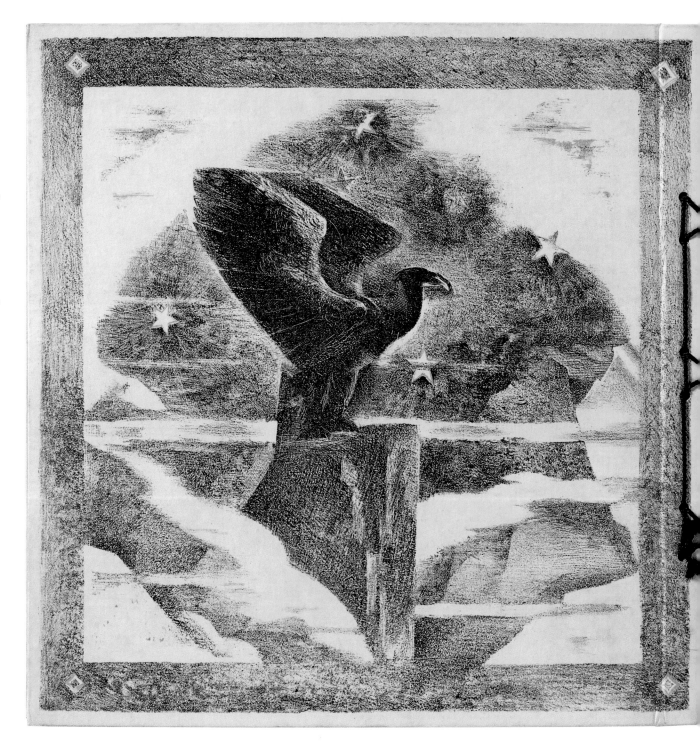

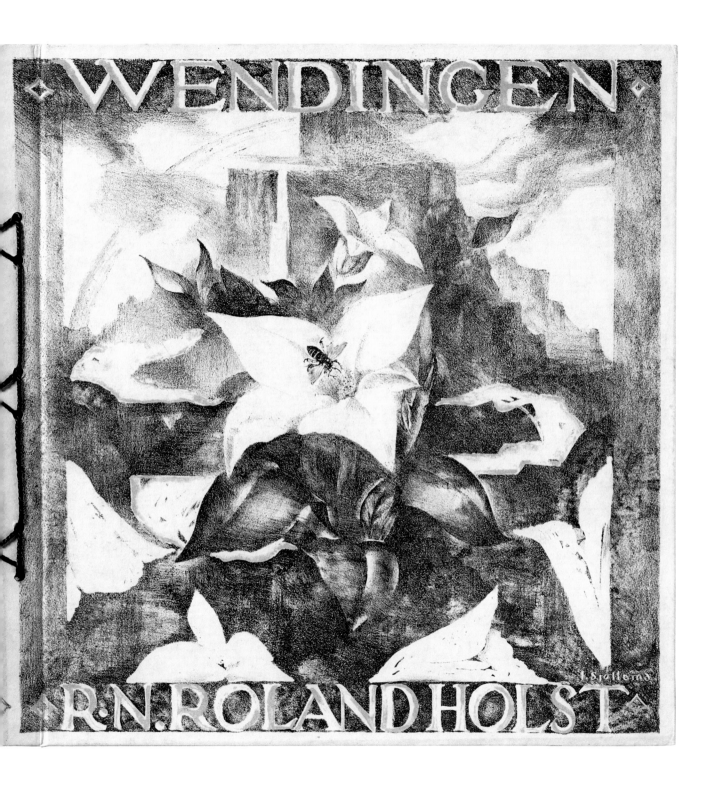

WENDINGEN

R.N.ROLAND HOLST

W. M. Dudok, the
Rotterdam Bijenkorf

Published Ca. July 1931
Introduction by G. Friedhoff,
engineer. Forty illustrations
including fourteen plans and
photographs of interiors and
exteriors of the department store
Bijenkorf in Rotterdam by the
architect W. M. Dudok. P. 1–24
text, p. 25–30 advertisements.

Cover Lithograph after a design
by Arthur Staal
Publication versions d; D
Edition Ca. 1000 (d: ca. 950;
D: ca. 50)
Price d: ƒ 5,–; D: ƒ 6,–
Special characteristics The advertise-
ments are mainly for companies
that contributed to the building
and furnishing of the Bijenkorf
in Rotterdam. They were also
bound into D; For the Bijenkorf
opening in 1930, a photo album
for the new department store
was published that resembled a
Wendingen number; it had
almost the same format and a
similar binding method. How-
ever, the pages are not printed
on folded sheets, and the typog-
raphy is not in the Wijdeveld
style. The cover is blue. This pub-
lication was probably instigated
by Dudok with the help of Staal
(who, for example, designed an
advertisement) because *Wendin-
gen* was so far behind schedule
that the Bijenkorf number would
not be out in time for the open-
ing. See also [137] 11-11/12.
Illustrated D

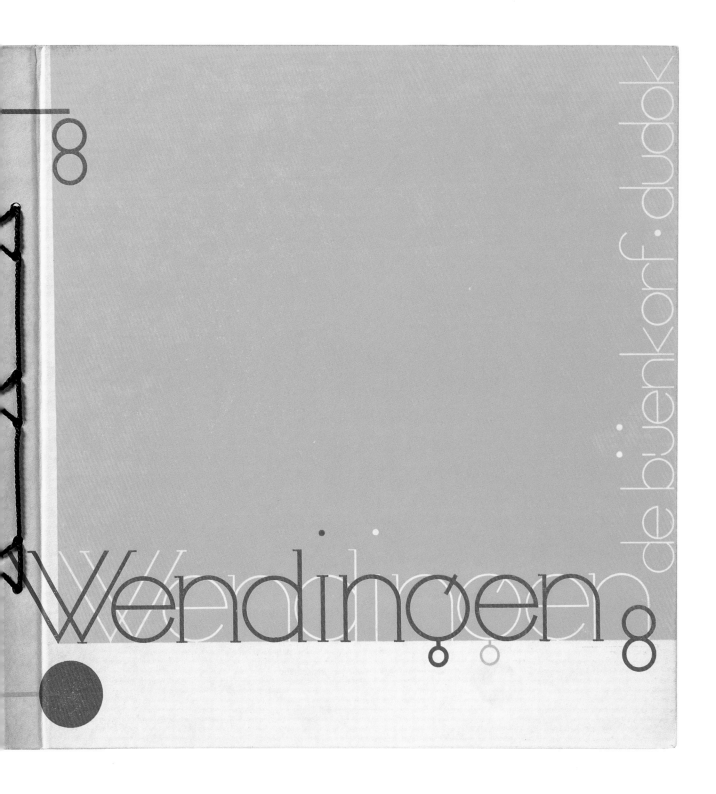

Wendingen 8

de bijenkorf · dudok

Published Ca. August 1931
The introduction is written
by Peter Alma. Thirty-five
illustrations including Gerd
Arntz (Vienna), reproduc-
tions from the atlas:
Gesellschaft und Wirtschaft;
work by Krinsky (Soviet-
Union), Helios Gomez
(Spain), and a number of
illustrations from Peter
Alma's series *Eight portraits.*
P. 1–18 text.

Cover Lithograph after a
design by Peter Alma
Publication versions *d; D*
Edition Ca. 1000 (*d*: ca. 950;
D: ca. 50)
Price *d*: ƒ 5,–; *D*: ƒ 6,–
Illustrated *D*

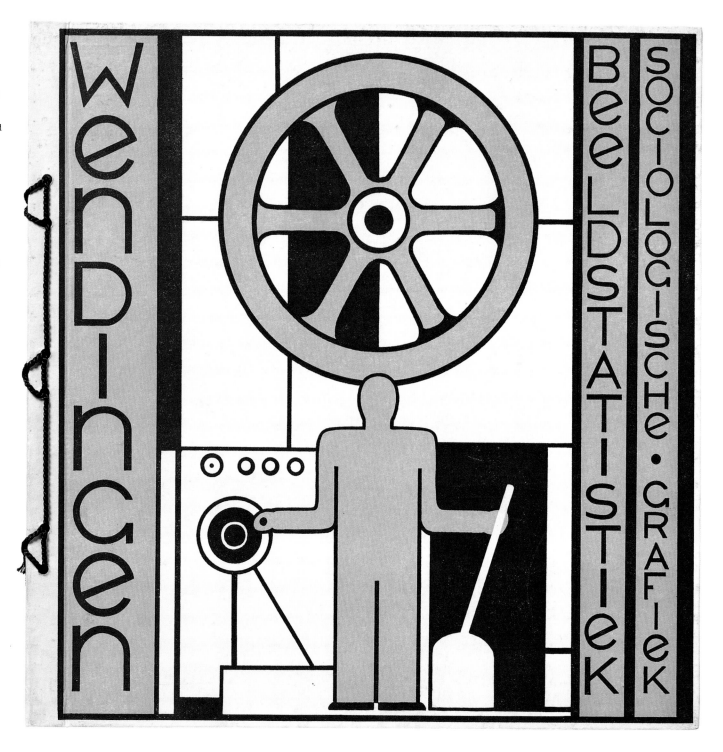

11·10 1930
Leerdam Glass

Published Ca. October 1931
Glass from the Leerdam
Glass Works at Leerdam,
South Holland. Introduction
by Karel Wasch. Twenty-eight
large photographs of glass
pieces by A. D. Copier, Dr.
H. P. Berlage, Lucienne Bloch,
and Stef Uiterwaal. P. 1–24
text.

Cover Lithograph after a
design by A. D. Copier
Publication versions *d; D*
Edition Ca. 1000 (*d*: ca. 950;
D: ca. 50)
Price *d*: ƒ 5,–; *D*: ƒ 6,–
Special characteristics The cover
of *D* is printed in a darker
blue tint than the one for *d*.
Illustrated *D*

243

**The Hilversum City
Hall of W. M. Dudok**

Published Ca. November 1931
Introduction by H. T. Zwiers,
engineer. Fifty-five illustra-
tions and floorplans of the
Hilversum City Hall design.
P. 1–36 text, p. 37–44 adver-
tisements.

Cover Lithograph after a
design by W. M. Dudok
Publication versions *d; D*
Edition Ca. 1000 (*d*: ca. 950;
D: ca. 50)
Price *d: f* 7,50; *D: f* 8,50
Special characteristics The
advertisements are mainly
for businesses that partici-
pated in the building and
furnishing of the Hilversum
City Hall. These were also
bound into 11-3. *D.* Together
with 6-8, 9-1 and 11-8, this
number was made available
in buckram binding with
red title by the publisher.[138]
Illustrated *D*

dudok, raadhuis hilversum

vereeningen

12-1 1931
The Art of S. Jessurun de Mesquita

Published January 1932
Introduction by A. M. Hammacher. Twenty-one woodcuts and six drawings in watercolor by the Dutch graphic artist S. Jessurun de Mesquita. P. 1–18 text.

Cover Lithograph after a design by S. Jessurun de Mesquita
Publication versions d; D
Edition Ca. 950 (d: ca. 900; D: ca. 50)
Price d: f 5,–; D: f 6,–
Illustrated D

WENDINGEN

247

12-2 1931
Dutch Posters

Published Ca. February 1932
Introduction by Dr. G. Knuttel Wzn. Twenty-seven
posters by K. Vegter,
W. H. Gispen, N. P. de Koo,
S. H. de Roos, A. Kurvers,
M. C. A. Meischke,
S. L. Schwarz, A. Pieck, Funke
Küpper, H. Th. Wijdeveld,
S. van Ravesteyn, engineer,
H. Moerkerk, H. A. Henriët,
engineer, N. Sickenga,
P. Schuitema, Chr. Lebeau,
H. F. Bieling, Vilmos Huszar,
Jac. Jongert, Dolly Rudeman.
P. 1–18 text.

Cover Lithograph after a
design by S. L. Schwarz
Publication versions *d; D*
Edition Ca. 950 (*d*: ca. 900;
D: ca. 50)
Price *d*: ƒ 5,–; *D*: ƒ 6,–
Special characteristics This number was reviewed in *De
Reclame* 1932–18 (May 3) p. 10.
Illustrated *D*

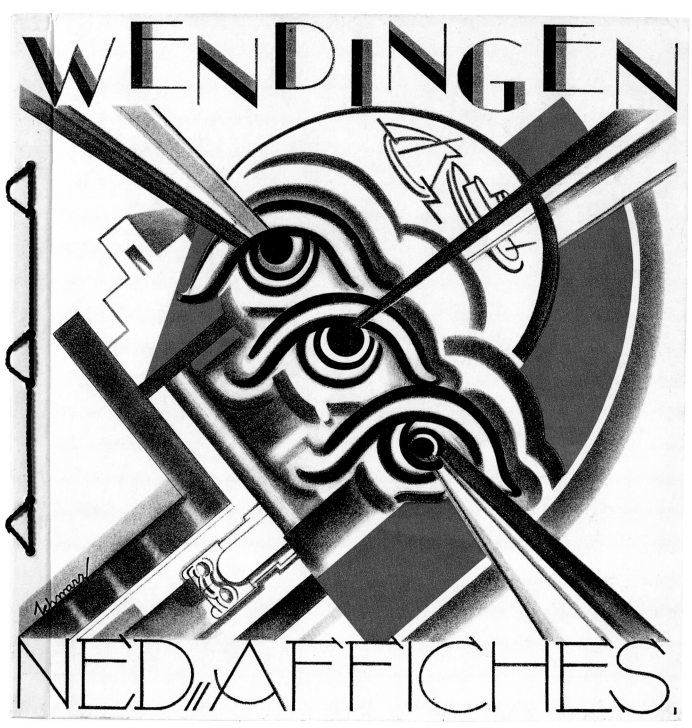

Stained Glass Windows by Joep Nicolas

Published March 1932
Introduction by A. van der
Boom. Thirty-three illustra-
tions of stained glass win-
dows by the Dutch glass
maker, Joep Nicolas: the
Nieuwe Kerk at Delft, the
Canisius Hospital at
Nijmegen, the Breda City
Hall, the Dutch Pavilion at
the Milan Trade Fair, the
Philips' office building at
Eindhoven, the Hilversum
City Hall, and private houses.
P. 1–18 text.

Cover Lithograph by Joep
Nicolas
Publication versions *d*; *D*
Edition Ca. 950 (*d*: ca. 900;
D: ca. 50)
Price *d*: ƒ 5,–; *D*: ƒ 6,–
Illustrated *D*

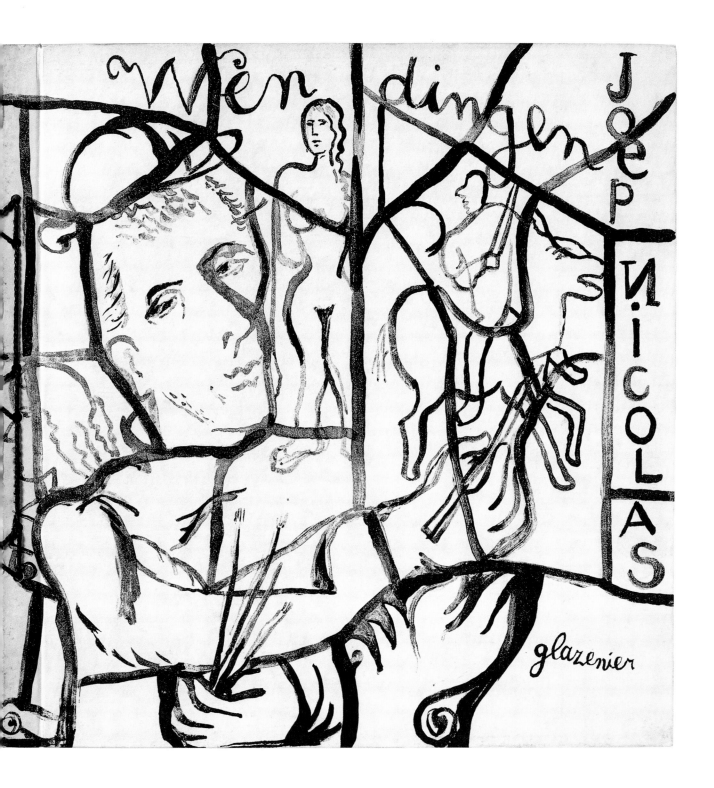

Published April 1932

Introduction by H. T. Zwiers,
engineer. Thirty-five illustra-
tions and floorplans of Dutch
country houses by F. A.
Eschauzier, G. Feenstra,
Wouter Hamdorff, A. P.
Smits, and Van der Linde,
Dr. J. H. Plantenga, engineer.
P. 1–18 text.

Cover Lithograph after a
drawing by H. T. Zwiers,
engineer

Publication versions d; D

Edition Ca. 950 (d: ca. 900;
D: ca. 50)

Price d: ƒ 5,–; D: ƒ 6,–

Illustrated D

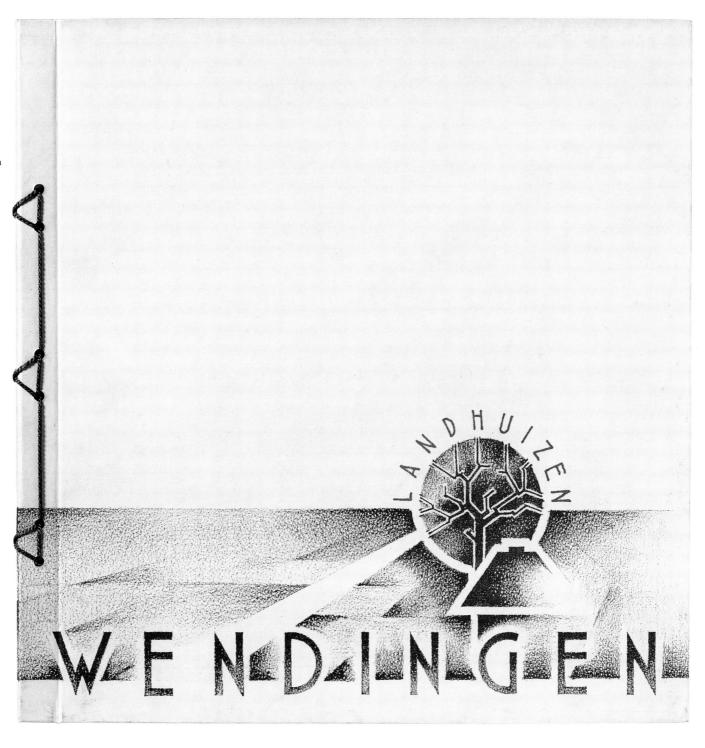

12-5 (1931-5/6)
Sculpture by Hildo Krop

Published Ca. May/June 1932
Introduction by A. M. Hammacher. Twenty-seven illustrations of portrait busts and other sculpture by the Amsterdam municipal sculptor Hildo Krop. P. 1–24 text.

Cover Lithograph after a design by Hildo Krop

Publication versions *d*; *D*

Edition Ca. 775 (*d*: ca. 750; *D*: ca. 25)

Price *d*: ƒ 5,–; *D*: ƒ 6,–

Special characteristics This is the first number that appeared after the ending of the contract with the publisher. The volume would still be completed, but in order to reduce costs, the publisher insisted that part of the remaining numbers be printed on a paper of lesser quality.[139]
See 12-6.

Illustrated *D*

12-6 (1931-6)
Paintings by Koch, Postma, and Willink

Published July 1932
Introduction by J. Greshoff.
Forty-one illustrations of oil
paintings by Pijke Koch, Kor
Postma, and A. C. Willink.
P. 1–24 text.

Cover Lithograph after a
drawing by Arthur Staal
Publication versions *d*; *D*
Edition Ca. 775 (*d*: ca. 750; *D*:
ca. 25)
Price *d*: ƒ 5,–; *D*: ƒ 6,–

Special characteristics This num-
ber was produced on the ini-
tiative of Arthur Staal, who
selected the images in con-
sultation with the painters.
According to Staal, this was
the first publication showing
the work of these painters.[140]
In the period after April 1932
there were intense negotia-
tions between the publisher
on one end and the A et A
committee and editorial
board on the other regarding
completion of the unfinished
volume. Agreements made
during this time probably led
to the decision to let 12-5/6
serve as a single number and
to proceed with 12-6.
See 12-5.
Illustrated *D*

Published Ca. September 1932
Introduction by H. T. Zwiers,
engineer. Forty illustrations
and floorplans of Dutch
Schools by A. van der Steur,
engineer (Rotterdam Public
Works Department),
P. Vorkink (conservatory,
music school, and audito-
rium in Amsterdam), Jans
and Henneke (Elementary
Agriculture Schools in Steen-
wijk and Lonneker), and
J. Wiebinga, engineer (Exten-
sive Elementary Education
School in Aalsmeer). P. 1–30
text.

Cover Lithograph after a
design by H. T. Zwiers,
engineer
Publication versions d; D
Edition Ca. 775 (d: ca. 750;
D: ca. 25)
Price d: ƒ 7,50; D: ƒ 8,50
Illustrated D

12-9 1931
Statues

Published Ca. October 1932
Introduction by T. Landré.
Nineteen reproductions of
statues from various periods
and countries. P. 1–18 text.

Cover Lithograph by
Theo van Reijn
Publication versions *d; D*
Edition Ca. 775 (*d*: ca. 750;
D: ca. 25)
Price *d*: ƒ 5,–; *D*: ƒ 6,–
Special characteristics The cover
leads one to suspect that it
was actually designed for an
unpublished portrait
number.
Illustrated *D*

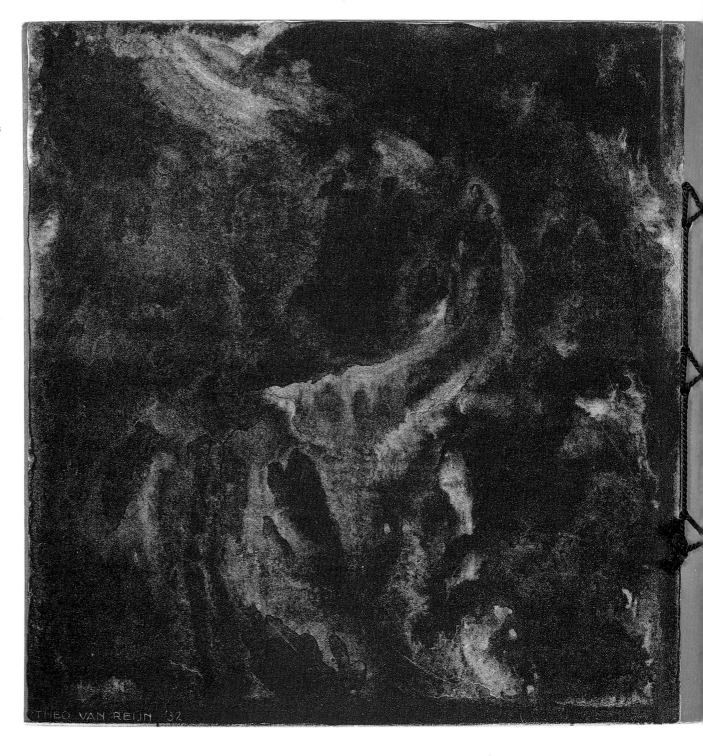

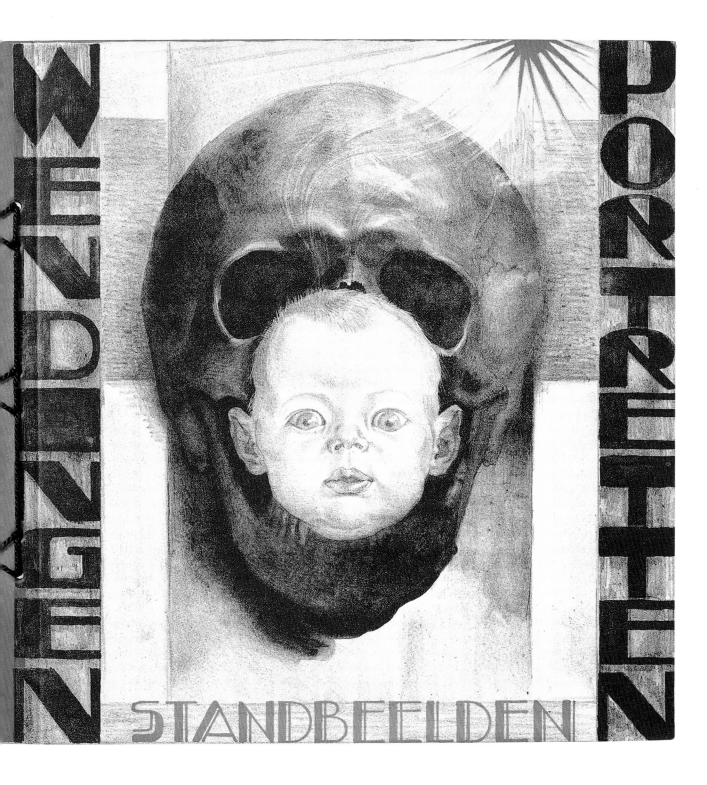

Published December 1932
Introduction by
J. L. M. Lauweriks. Nineteen
illustrations and floorplans
of the Parkhotel Haus Rechen
in Bochum and the Rhenania
Ossag (Shell building) in
Berlin by the German archi-
tect Prof. E. Fahrenkamp.
P. 1–18 text.

Cover Lithograph by
Otto B. de Kat, 1932
Publication versions d; D
Edition Ca. 775 (d: ca. 750;
D: ca. 25)
Price d: ƒ 5,–; D: ƒ 6,–
Illustrated D

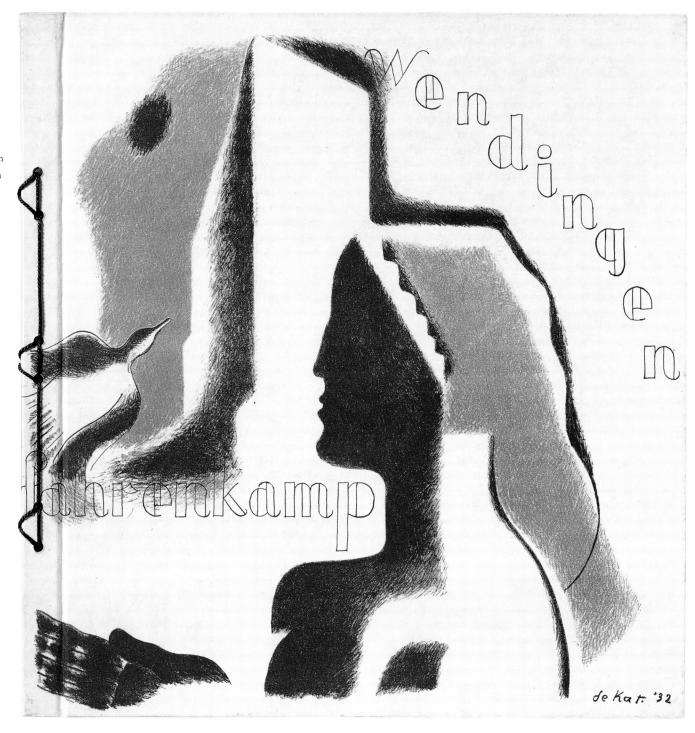

12-11/12 1931
Church Architecture

Published February 1933
Introduction by G. M.
Leeuwenberg, architectural
engineer. Roughly thirty-six
illustrations and floorplans
of churches in The Nether-
lands by the architects
Boeyenga, van Dongen,
Hendriks, van Moorsen and
Koldewey, Kraayvanger,
Kruyswijk, van der Laan,
Rothuizen, Stuivinga,
Tholens, and others. P. 1–36
text.

Cover Lithograph after a
drawing by J. Zietsma
Edition Ca. 775 (d: ca. 750;
D: ca. 25)
Price d: ƒ 7,50; D: ƒ 8,50
Publication versions d; D
Special characteristics The Ω on
the back of the cover indi-
cates that this was intended
to be the last issue.
Illustrated D

1 Because *Wendingen* was increasingly appearing too late, beginning with 5-5/6 the term "annual volume" was replaced by "series."

2 *De Bedrijfsreclame* (*Business Advertising*), January 1918.

3 *De Bedrijfsreclame* (*Business Advertising*), February 1918.

4 Although this number never appeared, it was probably intended to have a *Wendingen* issue devoted to the competition of a new academy building (see 4-12). There is also a preserved subscription form that mentions ƒ 15,– + a 50% war supplement.

5 *De Bedrijfsreclame* (*Business Advertising*) VI-6, August 1919

6 See: advertisement in *Wendingen 1918–1931, Amsterdamer Expressionismus,* page 21.

7 C. A. Mees wrote to architect P. Kramer on August 7, 1926 informing him that beginning with the new volume he could receive the hardbound edition on glossy paper for an extra payment of ƒ 10. Kramer accepted this offer in a letter dated August 11, 1926.

8 Just before the completion of this volume, it was offered for this price in the publisher's catalogue. A volume of bound numbers cost ƒ 45.

9 As stated in a prospectus published after number 9-3/4. Since the price for regular numbers remained unchanged, it is plausible that the subscription price also remained the same throughout the last volume.

10 There is no indication that the numbers did not appear in the proper sequence.

11 Preserved printing proofs of the covers for numbers 6-3, 6-8, 7-2, 7-4, and 7-11/12 indicate the number of covers which were printed. Except for 6-8, these can be found in the Museum Joh. Enschedé in Haarlem. This number probably equals the edition. Furthermore, it is known that all A et A members and donors were sent a copy, which provided the edition with a minimum run. When membership numbers were not recorded by the *Genootschap Architectura et Amicitia 1855–1990,* these can be found in the Technical Section (2-12.*d.*2, for example), *Architectura,* or from the publisher's archive in the collection of Mea Verwey, at the University Library, Amsterdam. One can also extract membership information and contributions to the *Wendingen* publisher from ledgers (archives A et A) and annual financial reports of *Architectura,* published in *Bouwkundig Weekblad* (*Architectural Weekly*). From Wijdeveld's recollections (Fanelli, page 7) and Arthur Staal (letter dated April 5, 1991 to the writer, followed by a verbal account) it appears that they began with a edition of 150 (Wijdeveld) for non A et A members (addition by Arthur Staal). Also, see Wijdeveld's written introduction in Fanelli.

Special numbers which were also of interest to non A et A members had a larger edition, such as the Toorop number 1-(11/)12, for example. This was mentioned at the A et A board of directors meeting on October 31, 1919.

In a letter from publisher C. A. Mees to Wijdeveld dated July 22,1925: "All inclusive, I never produced more than 1500 copies of *Wendingen.*"

At the A et A board of directors meetings on July 28 and October 19, 1931 it was announced that the contract with publisher Mees would end on April 1, 1932 after a period of five years. The contract was initiated on the basis of 1300 numbers (thus in 1927), but during the last years an average edition was around 1050.

A copy of the *Wendingen* survey published by Mees was saved with information regarding stocks of diverse numbers still available at the publisher (collection of the writer and archives of Mea Verwey). This survey was probably made on behalf of the fund and liquidation auction on December 28, 1934 (with a follow-up on September 18, 1935). Auction catalogues such as those preserved in the KVB library, Amsterdam, state the numbers offered.

From the number of English language copies still available at the auction (for example 4-3.*e*: 104, 4-4/5.*e*: 120, 5-1.*e*: 257, and 5-3.*e*: 261) the English edition must have been fairly large. A survey in the publisher's archive of German purchasers (mostly book dealers who probably took the publications in consignment) provides an idea as to the size of the German language edition.

An estimation of the size of the edition can be made by comparing numbers remaining with the publisher with data such as printers' annotations on the covers or from other data separately recorded for each number. This "rough" estimation is indicated by "ca."

12 Honorary members, outside members, and donors are included in the number of A et A members.

13 In the minutes of the A et A board of directors meeting on December 24, 1918, it is recorded that the publisher printed 100 extra copies at the expense of A et A to give joining members a chance to acquire the entire volume.

14 The contract with the publisher ran to April 1, 1932 and was not extended. It made more sense to him to print no more than he could sell on the short term. This seems clear from the inventory made after 1932 of remaining numbers still in stock.

15 The omission of van Loghem's name on the title pages of 4-9/10 and 4-11.*d* is an error.

16 Palmer's name appears formally only in 4-7/8 and in 5-1 through 5-4. A stamp with his name is also found in some 4-1/2.*e* numbers (Oxford Bodleian Library) and 4-4/5.*e.*

17 *De Bedrijfsreclame* (*Business Advertising*), January 1918.

18 See: 1-2.*d.*1, beginning.

19 *Wendingen* 1-8, page 6. "As Roland Holst acknowledged in his *Wendingen* cover drawing, it was quite appropriate to place the architect in the middle of the many-sided radiance of a diamond. For such is architecture. The diamond is at the same time crystal clear and transparent. On all sides it reflects the inner core, always expressing the form and surface aspects while simultaneously displaying its inner value through outer attributes."

20 Fanelli, page 25. Iram, the Supreme Architect, who holds in his arms the model of a temple, is shown between two pillars (the temple of Salomon) in the center of a crystal.

21 *De Bedrijfsreclame* (*Business Advertising*), February 1919.

22 Collection Rijksprentenkabinet (Rijks Print Collection).

23 Collection "Philip J."

24 Collection library of the Stedelijk Museum Amsterdam.

25 Published on the occasion of Toorop's sixtieth birthday. The etchings are printed on machine-made paper without watermark, format 27.7 x 33.3 cm. Given the extreme rarity of the edition, probably no more than ten-twenty copies per etching were printed. On the lower left-hand corner of each plate is mentioned that this etching is an enclosure for the Toorop number.

As far as it is known, the etchings were not signed by Toorop. Bound between pages 2 and 3 in the normal edition is an announcement from the editorial board that this was meant to be a double number for November/December.

D contains the advertisements and is signed by Toorop in the middle of page 2. These issues are numbered. The lowest number known of by the writer is 115 and the highest is 433. A small number of deluxe presentation numbers (ca. ten copies) is not numbered as indicated by a copy in the writer's collection signed by de Klerk.

Toorop was offered an honorary membership in A et A on the occasion of his sixtieth birthday. As evident in a letter to Wijdeveld dated December 5, 1918, Toorop was very flattered by the publication and extremely satisfied with the printing quality of the etching.

26 On page 25, Fanelli gives a complete description of the cover: "In this cover the symbols of the Ram's initiation and assignment are clearly distinguishable; the great initiator, who gives the bond of love to all creatures, and who, after having fathomed the secrets of the pyramids, applies them to society and gives art's ideal to the people. Along four sides of the cover we read the following sentences: In the beginning is the word / And the word is from God / As is life / And life is light.

The Word, the Light which makes all things fertile, is represented by the sun placed in the center of the design barely visible under the other forms and signs. Dominating the design is a swastika, the symbol of Agni, love, that gives the world life, the sight of closed lips from which every creation comes, the Four sided nature of the Power, drawn to matter in the East, West, South and North, the crucifixion of the Word, the conclusion of Life, the enchantment of this God and his resurrection in a Son of Light the Beloved Messiah, the Wisdom and the restorer who must form the spirit of the world. Finally, it is the image of the house, the basis of social Brotherhood and sanctuary from which the son is created, the young God of the Future.

Under the four corners of the swastika is a man / woman figure referring to the redemption of woman by Ram, of her elevation to the heavenly duties of wife and mother and priestess of the hearth. Going counter-clock-wise, in the angular ends of the corners there are stars with seven, six, and five points as well as a Greek cross. These are symbols of the initiation of Ram who continually appears through his legends. The star with seven points is the symbol of the seven transformations of Light and the cosmic Lyre, but also the lyre which every man carries within and the art of which he, should he desire to attain perfection, must learn in order to sing all of the chords. The star with six points is the symbol of the Development and Conclusion of the eternal embroilment of power and matter of which rhythm is the product. The five point star symbolizes the human microcosmos and as well as the man who triumphs over flesh and the serpent's destructive mentality.

The interpretation of the Greek Cross is problematic in that in this special symbolic context geduld kan worden (it can be seen as) as two pillars arranged in a cross, that is to say, man crucified on the Cross of Good and Evil. Finally, power and matter, which cast their light and shadow in the universe are united in the rhythm of Life.

27 Collection Matthijs Erdman.

28 It was probably a hurriedly executed job, for on February 28, 1919, Toorop wrote to Wijdeveld saying that he could no longer produce the drawing for the dance number but that he could make a lithographic cover for one of the next *Wendingen* numbers.

29 As evident in a letter from Toorop to Wijdeveld dated June 16, 1919, the poster number was not finished at that time. See advertisement in *De Bedrijfsreclame* (*Business Advertising*), October 1919.

30 See advertisement in *De Bedrijfsreclame* (*Business Advertising*), October 1919.

31 See minutes of A et A members meeting on October 23, 1919. The number was reviewed by J. G. Veldheer in *De Nieuwe Amsterdammer* on December 13, 1919.

32 At the liquidation auction in December 1934, there were 229 unbound d numbers and 434 unbound D numbers.

33 Minutes of the 1419th A et A members meeting on September 23, 1919.

34 Ibid.

35 Ibid. An English or German copy has not been found.

36 See also 2-3. A letter from Toorop to Wijdeveld dated June 16, 1919 reveals that Toorop's finger was caught in the door of his train cabin and because of this he could not have the

lithograph ready on time. "This painful index finger greatly hinders me in working."

37 Other examples can be found in 4-11, page 13/15 and in 7-3/9, pages 38/39 and 142/143.

38 Collection Wijdeveld NAI.

39 Contemporary annotation on a proof print in possession of the writer: de Groot, Wijdeveld. Essers also mentioned on Wijdeveld's copy in the NAI.

40 Museum voor het Boek (Museum for the Book), ex-collection Radermacher Schorer.

41 See: Ype Koopmans, page 77.

42 See letter dated January 25, 1921 from publisher Wiessing to Berlage in Berlage archives NAI. "Now, I have also encountered opponents to what I consider a fine design. But when I asked if de Klerk and others would hold out against you for over a *hundred* years, the best of them said, "no, probably certainly *not*." So it is not *Wendingen* but Turmoil which is the art of *today*. I remain greatly attached to your creation." It is not known if the design was saved.

43 Catalogue of Wijdeveld exhibition at the Stedelijk Museum, Amsterdam 1953, no 36.

44 Reviewed in *Bouwkundig Weekblad* (*Architectural Weekly*) 42nd series, no. 41, dated October 8, 1921.

45 Collection of the Applied Arts Department, Stedelijk Museum, Amsterdam.

46 *Architectura*, 1922, no. 2, page 1.

47 An explanation has not been found.

48 *Architectura* 1922, no. 25, page 4.

49 *The Times*, May 27, 1922.

50 Minutes of the A et A board of directors meeting on June 19, 1922.

51 Ibid.

52 *Architectura* 1922, no. 25, page 3.

53 Minutes of the A et A board of directors meeting on June 19, 1922.

54 Sophie Lissitsky-Küppers, *El Lissitzky*, London, reprint 1980, ill. 70.

55 Perhaps Lissitzky stayed with Behne. There is a preserved letter dated 18.09.1922 from Behne to van Doesburg on which Lissitzky had written something (archives van Doesburg R.K.D.). Also, see references to Behne in *El Lissitzky*.

56 See letter from Wijdeveld to G. W. B. Borrie dated June 1968 (copy in Mea Verwey archives).
It is mentioned on page 99 in the Darmstadt catalogue that Wijdeveld had become acquainted with Erich Mendelsohn and Adolf Behne during 1918/9 in Berlin.

57 *El Lissitzky*, page 374.

58 *Elseviers Maandschrift* (Magazine) 1921, page 220–224. From a letter dated January 17, 1923 from Berlage to Frank Lloyd Wright it appears that Berlage had been introduced to the work of Wright ten years earlier during Berlage's visit to the United States.

59 See undated letter from Jan Wils to Wijdeveld (December 1968) in Wijdeveld Archives NAI.

60 Comprehensive letter from Wright to Berlage dated Taliesin, November 30, 1922.

61 In *Architectura* 1922, no. 25, page 3 the cover was referred to as a design only by Duiker.

62 Letter from Roland Holst to Wijdeveld dated February 1, 1923: "Let me begin by saying that I very much like the cover, I am especially fond of that arabesque-like and the clarity of uncomplicated forms. I don't know exactly what Jongert means precisely, but I do know that the direction is good and correct."

63 *Architectura* 1923, no. 20, page 108.

64 *Architectura* 1923, page 182.

65 Wijdeveld exhibition catalogue, Stedelijk Museum, Amsterdam 1953, no. 50.

66 *Lissitzky*, 1980, page 356.

67 These numbers were bought by Roebert at the second liquidation auction on September 18, 1935. Also a copy of 2-12 with the same stamp is known to exist. In June 2000, Roebert's son said that his father stamped all of the books he bought at auctions in this manner.

68 Reviewed in *Bouwkundig Weekblad* (*Architectural Weekly*) 45th series, no. 18, dated May 3, 1924.

69 *Architectura* 1924, no. 14, page 57-59.

70 *Architectura*, 1923 no. 38.

71 Annotation in the Mees catalogue next to no. 6-9/10.

72 Reviewed in *Bouwkundig Weekblad* (*Architectural Weekly*) 45th series, no. 28, dated July 12, 1924.

73 As signed on a printer's example of the cover. Nothing else is known regarding the five extra copies.

74 Found in the Wijdeveld archives with a number of other Finsterlin drawings.

75 Reviewed in *Bouwkundig Weekblad* (*Architectural Weekly*) 45th series, no. 33, dated August 16, 1924.

76 Reviewed in *Bouwkundig Weekblad* (*Architectural Weekly*) 45th series, no. 41, dated October 11, 1924.

77 Eileen Gray offered to design the cover in a letter to Wijdeveld dated November 17,

1923. In a letter from Wijdeveld to Gray dated July 21, 1924 Wijdeveld rejected her cover design: "Comme ca reste encore ... la couverture! Peut-être j'hésitais un peu de vous en écrire parce que je m'en suis pas toute à fait content! Si vous désirez je veux l'accepter tel quelle est, mais si vous permettez je voudrais bien vous expliquer, pourquoi je la voudrais avoir changée. Pour moi, votre oeuvre doit son charme pour un grand part à sa simplicité, à son achèvement sublime, à sa noblesse des formes. Je sais aussi, que dans le peu des spécimens que j'ai vu, la couleur est plein d'accents chaux et fort prononcés, je sais, que tout ca résulte d'une vue de vie très supérieure et subtile et j'ai compris, que vous diriger tout ca vous-même ... et en disant tout ca j'arrive à l'esquisse pour la couverture et ... il me faut confesser, que j'n'y trouve pas une réprésentation du contenu résumé. Le dessin n'a pas l'achèvement qui donne tant de charme à vos meubles et vos intérieurs et l'action de "La Couverture" lui manque. La couverture devrait être l'idée de couvrir, cacher, embrasser, comme par example on s'enveloppe dans som manteau. ... Pour ca je désirais comme couverture une composition très soignée pour les deux pages."

78 Letter from Wijdeveld to Eileen Gray dated October 10, 1923.

79 Letter from Mea (Nijland) Verwey to Wijdeveld dated September 7, 1968. As the town of Hilversum unexpectedly took 100 copies, the number was quickly almost sold out. From later copies, it appears that many were again available.

80 Fanelli, page 18.

81 In a letter dated January 27, 1925 from C. A. Mees to Wijdeveld, Mees mentioned that on the back of the cover a greasy thumb is printed over at least 1400 times and that he will ask Enschedé to make the lowest part on the back black. It is plausible that the other numbers of the de Klerk series had the same edition.

82 Reviewed in *Bouwkundig Weekblad* (*Architectural Weekly*), 46th series, no. 24, dated 13 June 13, 1924.

83 Letter from C. A. Mees to A et A (Boterenbrood) dated April 4, 1925. It seems that at the last moment it would be impossible to print the satinwood board. As evident in a letter from Wijdeveld to Mees dated February 10, 1925, the original plan was to have the cover designed by Toorop.

84 See the catalogue for the Wijdeveld exhibition at the Stedelijk Museum, Amsterdam, 1953, no. 36.

85 Letter from Wijdeveld to C. A. Mees dated March 3, 1925.

86 See the advertisement in 6-11/12.d opposite page 52. This number was reviewed in *Bouwkundig Weekblad* (*Architectural Weekly*), 46th series, no. 25, dated June 20, 1925.

87 Minutes of the A et A board of directors meeting on March 20, 1925.

88 Reviewed in *Bouwkundig Weekblad* (*Architectural Weekly*), 46th series, no. 29, dated July 18, 1925.

89 As evident in a letter from Wijdeveld to Mees dated July 19, 1925, the cover was intended as a temporary solution on the possibility that the number would eventually be bound as a book.

90 Annotation on a cover for 7-4 (printer's copy).

91 See advertisement in 6-11/12.d opposite page 52. It is not improbable that the subscription price was raised to ƒ 25, as seven numbers were published instead of the original six.

92 Letter dated August 7, 1926 from C. A. Mees to architect P. Kramer. In a letter from C. A. Mees to architect C. J. Blaauw dated December 4, three versions are mentioned: Illustration quality paper with binding ƒ 30, glossy paper with linen binding ƒ 35, and heavy glossy paper in vellum ƒ 45.

93 In addition, the regular numbers could be bound as a book.

94 In a letter from Mees to Wijdeveld dated January 27, 1926, it was revealed that 5000 pages had to be reprinted because of an incorrectly printed photograph on page 94. To avoid a delay, the newly printed sheets (together eight pages) were attached to part 7. It was originally intended to have part six end with page 102. In a letter from Mees to Wijdeveld dated September 8, 1925, it appears that Mees had reserved 3000 copies to be printed on glossy paper and 250 copies for heavy glossy paper. Due to a lack of interest, the remaining 240 numbers on heavy glossy paper were probably bound in regular linen. Perhaps these are the numbers (a remainder of 200 unbound copies on heavy glossy paper) from which 160 copies were later bound in linen and sold to Kroch in Chicago in 1949. Also, see the letter from N.V. Uitgeverij v/h C. A. Mees to the book dealer A. A. Balkema in Cape Town dated February 25, 1948.

95 In a letter from Berlage to Frank Lloyd Wright dated January 17, 1923 is stated that Wright sent a large package of photographs and a portrait of himself. Berlage wrote: "(I am) sending the photographs to the publisher of the magazine *Wendingen* who are now preparing a special edition of the whole collection." In a letter dated December 6, 1923 from the publisher uitgeverij de Hooge Brug to Wijdeveld the edition and price of the Wright Book was discussed. It was to appear apart from *Wendingen*. That plan was cancelled due to the failure of de Hooge Brug.

96 Wijdeveld insisted that the cover be produced typographically and not by lithography as with 6-8. Since the printer Enschedé did not have the proper rounded corners and also would not have them especially cast, the cover was printed elsewhere. Letter from Wijdeveld to Mees dated Augustus 22, 1925.

97 Undated letter from Wijdeveld in Frank Lloyd Wright Archives, Taliesin, no. W044A10, and a letter from publisher C. A. Mees to Wijdeveld dated July 22, 1925.

98 Undated letter from Wijdeveld in Frank Lloyd Wright Archives, Taliesin, no. W044A08. As indicated by pieces in the Mea Verwey archives at the University Library in Amsterdam, in The Netherlands the book was bound by Elias P. van Bommel on Kerkstraat in Amsterdam at least until 1931. After 1945, it was bound by L. van Wijk & Zoon in Utrecht (Oudwijk).

99 Other than the rarity of x, a confirmation has not been found.

100 Letter from Wijdeveld to C. A. Mees dated October 23, 1925.

101 Letter to Wijdeveld dated October 30, 1925, in Frank Lloyd Wright Archives, Taliesin, no. W044A06.

102 Letter from C. A. Mees to Wijdeveld dated November 10, 1925.

103 Letter from Mea (Nijland-)Verweij to Bestelhuis voor den Boekhandel in Amsterdam dated November 27, 1947. As shown by a copy of a letter to the publisher N.V. Uitgeverij v/h C. A. Mees dated November 4, 1949, Kroch took another remaining stock of 160 bound books in 1949.

104 Letter from William Helburn Inc. to C. A. Mees dated February 4, 1946. In a letter from the publisher N.V. Uitgeverij v/h C. A. Mees to the Amsterdam firm J. Brandt dated May 19, 1947, there is mention of another shipment of 300–400 unbound books to Helburn, but these could be the numbers eventually bought by Kroch.

105 *Architectura* xxix 1925, page 420–423 and xxx 1926, pages 78–82; 133–140; 145–152; 193–204.

106 *Architectura* xxix 1925, page 145 and following.

107 Letter from Berlage to Frank Lloyd Wright dated September 16, 1924?, Berlage archives NAI.

108 Letter from Wijdeveld to Frank Lloyd Wright dated August 26, 1931, in Frank Lloyd Wright Archives, Taliesin, no. W057A01/2.

109 Letter from the Frank Lloyd Wright Archives to the writer dated April 18, 2000.

110 Library of Congress 65026722. A cheaper version of this reprint was published by Bramhall House in New York, ISBN 0-517-K02468.

111 Letter from Wijdeveld to Olgivanna Lloyd Wright Easter 1966 (archives Mea Verwey, University Library Amsterdam).

112 ISBN 0486272540.

113 ISBN 0517119188.

114 Mees Catalogue.

115 Minutes of the A et A board of directors meeting on March 24, 1926.

116 Minutes of the A et A board of directors meeting on November 1926.

117 Letter from the A et A board of directors to C. A. Mees dated July 1, 1927.

118 Letter from the publisher Uitgeverij v/h C. A. Mees to The Craftsman Bookshop, Sydney, Australia, dated April 16, 1940.

119 Letter from C. J. Blaauw to C. A. Mees dated April 29, 1927.

120 Letter from C. A. Mees to P. L. Kramer dated April 15, 1926.

121 Letter from C. A. Mees to Wijdeveld dated 3 June 3, 1926.

122 Letter from P. L. Kramer to C. A. Mees dated September 27, 1926.

123 *Bouwkundig Weekblad* (*Architectural Weekly*) and *Architectura*, March 19, 1927, page 6.

124 Letter from C. A. Mees to A et A dated August 18, 1927.

125 Letter from A et A to C. A. Mees dated August 30, 1927.

126 *Architectura* xxx 1926, page 193.

127 Although it is known that a separate English text was available, an example for this and other numbers of series eight has not been found.

128 Letter from architect Prof. Dr. Ir D.F. Slothouwer to C. A. Mees dated October 5, 1927, where it is also revealed that the translation of this and subsequent numbers was probably handled by Gerlof Verweij, brother of Mea Mees-Verweij who was living in New York City at the time.

129 Letter from architect Prof. dr Ir D.F. Slothouwer to C. A. Mees dated October 4, 1927.

130 There is no indication of a German edition.

131 Letter publisher C. A. Mees to A et A dated May 31, 1928.

132 Ibid and *Bouwkundig Weekblad* (*Architectural Weekly*) *Architectura*, June 23, 1928.

133 Letter from Mea Nijland-Verwey to Wijdeveld dated September 7, 1968.

134 As stated in the catalogue of the liquidation auction on December 28, 1934.

135 Minutes of the A et A board of directors meeting on March 24, 1926.

136 See In Memoriam J. L. M. Lauweriks, *Bouwkundig Weekblad* (*Architectural Weekly*) *Architectura*, April 23, 1932, no. 17, and minutes meeting in *Bouwkundig Weekblad* (*Architectural Weekly*) *Architectura*.

137 The opening of the Rotterdamse Bijenkorf took place on October 16, 1930.

138 Letter from publisher N.V. Uitgeverij v/h C. A. Mees to the Government Information Service dated April 19, 1946. Copy in the estate of Dudok (Mrs. Rethmeier-Dudok). On the cover W. M. Dudok is stamped in red.

139 Minutes of the A et A members meeting on April 25, 1932.

140 Annotation by A. Staal on a proof print of the cover, archives A. Staal NAI.

Principal Consulted Sources and Literature

Archives of Wijdeveld, Berlage, de Klerk, Dudok, Arthur Staal and Architectura et
 Amicitia, Nederlands Architectuur Instituut (Dutch Institute of Architecture),
 Rotterdam
Theo van Doesburg Archive, Rijksbureau voor Kunsthistorische Documentatie
 (Government Bureau for Art Historical Documentation), The Hague
Archive of Dr. Mea Nijland-Verwey, University Library, Amsterdam

Magazines
Architectura 1893–1926
Maandschrift voor Vercieringskunst (Decorative Arts Monthly), 1896
Bouw- and Sierkunst (Building and Decorative Art), 1898
Bouwkundig Weekblad (Architectural Weekly) 1918–1935
De Bedrijfsreclame (Business Advertising) 1918–1921
Wendingen 1918–1932

Books and articles
Genootschap Architectura et Amicitia (Society Architectura et Amicitia), Jeroen Schilt a.o.,
 uitgeverij 010 (Jeroen Schilt and others, Publisher 010), Rotterdam, 1992
Mijn eerste eeuw (My First Century), H. Th. Wijdeveld, Ravenberg Pers (Ravenberg Press), Oost-
 erbeek, 1985
50 jaar scheppend werk (50 Years of Creating Work), Wijdeveld exhibition catalogue, Stedelijk
 Museum, 1953
Wendingen 1918–1931, Amsterdam Expressionism, exhibition catalogue, Museum Künstler-
 kolonie Darmstadt, 1992
Letters from the Avant Garde, Ellen Lupton and others, Princeton Architectural Press,
 New York 1996
"Amsterdamse School," in: *Ons Amsterdam (Our Amsterdam)*, xxv-10 October 1973
Architectura, exhibition catalogue, Architecture Museum, Amsterdam, Uitgeverij
 (Publisher) Van Gennep, Amsterdam 1975
Amsterdam School, exhibition catalogue, Stedelijk Museum, Amsterdam, 1975
Wendingen 1918–1931 Documenti dell arte olandese del Novecento, exhibition catalogue,
 Florence, 1982
Wendingen, Giovanni Fanelli e.a., Franco Maria Ricci, Milan, 1986
Cultuur and Kunst verzamelde opstellen (Culture and Art, Collected Papers) 1917–1929,
 H. Th. Wijdeveld, De Spieghel, Amsterdam, 1929
Concerto Grosso, H. Th. Wijdeveld, Elckerlyc, Lage Vuursche, 1944
VANK Jaarboeken Serie *De toegepaste kunsten in Nederland* (VANK Annual series, *The Applied
 Arts in The Netherlands*), *Batik* etc. by Herman Hana, W. L. & J. Brusse, Rotterdam, 1925
Serie *De toegepaste kunsten in Nederland, het Schoone Boek (The Applied Arts in The Netherlands
 Series, The Beautiful Book)* by A. A. M. Stols, W. L. & J. Brusse, Rotterdam, 1935
"Wijdeveld Typography," Hans Oldewarris in *Forum* xxv-1, 1975
"Wijdeveld," in: *Bouwkundig Weekblad (Architectural Weekly)* LXXXIII-19, September 24, 1965
El Lissitzky, Sophie Lissitsky-Küppers, Thames and Hudson, London, reprint, 1980,
J. L. M. Lauweriks, exhibition catalogue, Museum Boymans-van Beuningen, Rotterdam, 1987
H. A. van den Eijnde, Ype Koopmans, exhibition catalogue, Drents Museum, Assen, 1994
Art Nouveau and Art Deco in The Netherlands, Frans Leidelmeijer and Daan van der Cingel,
 Meulenhoff/Landshoff, 2nd printing,1986

Illustrations

Pages 3 and 59 (3), Wijdeveld Collection, Nederlands Architectuur Instituut (Netherlands
 Architecture Institute), Rotterdam
Page 60 (4), Collection Stichting Archief Leids Studentenleven (Leiden Student Life
 Foundation Archive), Leiden
Other illustrations: Martijn F. Le Coultre Collection, Laren

Acknowledgments

This publication would not have been possible without the support of many individuals.
They are as follows:
Arthur Staal, Otto de Kat and Joop Sjollema who provided me with first hand accounts
about *Wendingen*.
Bernice Jackson who put me in touch with Earl Maxwell Coleman of the Da Capo Press.
Earl Maxwell Coleman who conveyed to me Wijdevelds enthusiasm, and the antique book
dealers Wouter van Leeuwen (Amsterdam), André Swertz (Utrecht), and John Vloemans
(The Hague) all of whom together with Paul Breman have kept interest in *Wendingen* alive.
Finally, Alston Purvis for his art historical contribution to this book, individuals who pro-
vided access to their *Wendingen* collections, and family members of Wijdeveld and Dudok
and the publishers Wiessing and Mees.